Praise for

Bright Eyes

"*Bright Eyes* by Bridey Thelen-Heidel is a memoir that every parent and anyone responsible for children must read . . . I want to celebrate the author's strength, resilience, patience, kindness, and focus."

—*Readers' Favorite*, 5-star review

"This is not just a book of how Thelen-Heidel survives, but how she ultimately thrives in the life she creates from the rubble . . . Readers of Mary Karr and Cheryl Strayed will recognize an important new voice in American memoir. *Bright Eyes: A Memoir* plays the music of despair, but also of shining, satisfying redemption. Heidel is its fearless singer."

—Alice Anderson, author of
Some Bright Morning, I'll Fly Away

"At once tender and fierce, *Bright Eyes* is an astonishing story of perseverance and the power of hope. In clear, sharp prose, Bridey Thelen-Heidel reclaims the narrative of her life from the monsters who shaped her early years. *Bright Eyes* is engaging, essential, and impossible to put down."

—Jennifer Bryant, Editor, *MUTHA* Magazine

"Bright Eyes: A Memoir hooks you from the start with its vivid and often heartrending scenes . . . Bridey's triumphant story is a strong illustration that sometimes, the best revenge is to flourish."

—Bobi Conn, author of *In the Shadow of the Valley-A Memoir* and *Someplace Like Home*

"... Although the understory of *Bright Eyes* is one of trauma, the greater narrative is about mustering the courage to break family ties to salvage a sense of self and daring to dream big, seemingly unreachable dreams—that eventually come true. Honest to the bone, this memoir will keep you turning the pages until its final, hard-won, uplifting moments."
—Suzanne Roberts, author of *Animal Bodies:*
On Death, Desire, and Other Difficulties

"Bridey's vivid and evocative writing style makes you feel like you're right there with her on the 'constant crazy train'—never knowing what's coming next ... *Bright Eyes* is a testament to the human spirit's capacity for resilience and redemption."
—Stephanie Thornton Plymale, author of *American Daughter*
and CEO of Heritage School of Interior Design

"Bridey Thelen-Heidel has done *exactly* what a memoirist needs to do: take her life and turn it into a work of art. *Bright Eyes* is both a propulsive and engrossing read as well as a tender portrait of the challenges of growing up poor and in an abusive family ... Bravo!"
—William Kenower, author of *Everyone Has What It Takes:*
A Writer's Guide to the End of Self-Doubt

"Bridey Thelen-Heidel's thousands of fans begged Duran Duran's Simon LeBon to meet her even before she became a debut author. In her unputdownable memoir *Bright Eyes*, Thelen-Heidel mends the shards of a shattered childhood, forging a glittering gift for readers and survivors. Fans of *MAID* and *Tiny Beautiful Things* will devour Thelen-Heidel's pages full of her gripping storytelling, enduring strength, and "Duranie" heart."
—Ann Imig, Listen to Your Mother, founder/editor

"Bridey's book is one to experience, testing the reader's endurance through harrowing details just as Bridey survives one ordeal after another. Like the indomitable bond she forges and fiercely protects with her sisters, there is an unspoken promise from Bridey to her audience as soon as the first page is turned: 'what comes next will be hard, but we'll get through it together.' Sure enough, we do and we are richer for it . . ."

—Andrew Golub, Duran Duran Archivist and author of
Beautiful Colors: The Posters of Duran Duran

". . . an incredibly moving memoir about staying resilient and forging your own path in life, even if this journey requires difficult choices or possesses seemingly insurmountable obstacles . . . In the end, *Bright Eyes* asserts that betting on yourself is a powerful move, one that can even lead to forgiveness, healing and new beginnings."

—Annie Zaleski, music journalist and author of
33 1/3 volume on Duran Duran's Rio

Bright Eyes

SURVIVING OUR MONSTERS

AND LEARNING TO LIVE WITHOUT THEM

———

A MEMOIR

BRIDEY THELEN-HEIDEL

SHE WRITES PRESS

Published 2024
Printed in the United States of America
Print ISBN: 978-1-64742-738-2
E-ISBN: 978-1-64742-739-9
Library of Congress Control Number: 2024906626

For information, address:
She Writes Press
1569 Solano Ave #546
Berkeley, CA 94707

Interior Design by Tabitha Lahr

She Writes Press is a division of SparkPoint Studio, LLC.

For Bephens
The bravest person I know
I promised there would be light at the end of the tunnel
Now, we're standing in it together

Love you more

Author's Note

The stories here reflect my recollection of events. I've changed some names and identifying characteristics to protect the privacy of those depicted. Dialogue has been recreated from my memories, and sometimes feels almost photographic because of how trauma is remembered. It may not be the way others in the scene recall, and I'm happy to agree to disagree.

This memoir is about real life, which is usually messy and sometimes dangerous. While I've taken great lengths to write about the difficult subject matter with compassion and respect, the scenes depicting emotional, physical, and sexual abuse may be troubling and discretion is advised—especially if you identify as a Survivor. These memories are my own. We don't choose what we forget or what soaks into our souls and can't be wrung out. Writing it down has been cleansing, healing, and freeing. If you relate to my story, I hope you'll write yours and give your body and soul a chance to release it.

Write on.

EXCELLENT RESOURCES WHEN I HAD no idea how, or where, to start: *The Art of Memoir*, Mary Karr; *Bird by Bird*, Anne Lamott; *Big Magic*, Elizabeth Gilbert; *The Creative Act*, Rick Rubin; *Fearless Writing: How to Create Boldly and Write with Confidence*, William Kenower; and *Fast-Draft Your Memoir: Write Your Life Story in 45 Hours*, Rachael Herron.

Bright Eyes

A MEMOIR

CONTENTS

"Dorothy exclaimed: 'But you have not yet told me how to get back...'"

"Your Silver Shoes will carry you . . ." replied Glinda. "If you had known their power you could have gone back ... the very first day . . ."

"But then I should not have had my wonderful brains!" cried the Scarecrow.

"And I should not have had my lovely heart," said the Tin Woodman.

"And I should have lived a coward forever," declared the Lion.

—FRANK BAUM in *The Wizard of Oz*

PART ONE:

YES

CHAPTER 1

Yes

Lake Tahoe 1982

"*B*ridey! Come now! I need you!" Mom screams on the other end of the phone.

"Mom? What's wrong? Where are you?" Panicking because I haven't seen her since last night when she went out with her girlfriends, I look out the living room window like she could be calling from our yard.

"I'm. At. Debbie's," she says, choking on each word.

"I'm coming! I'm coming!" Slamming the phone on the receiver, I drop my Barbie on the oil stains Al's Harley-Davidson dripped on the carpet the last time he rode it out of our living room.

I leap off the porch and land on prickly pine cone pieces. "Ouch! Ouch!" I shout, hopscotching across the dirt driveway and pulling stabby bits out of the bottoms of my feet that don't have their summer callouses because school's only been out a week.

Sprinting to Debbie's house around the corner, I slip by the neighbor's wood fence where my initials *BT* are carved underneath the initials *BM*. The boy who scratched them into the wood acted

like he didn't know how to play doctor the first time I showed him. After the second time, he carved our initials together.

I push Debbie's front door open without knocking and see my mom slumped over the kitchen table, still wearing the burgundy blouse I picked for her to wear out. Crouching down on the gold-speckled linoleum next to her chair, I smooth her blonde curls away from her face. "Hey, Mom."

Her pink, puffy eyes stare into mine, like she's trying to remember who I am. "Hey, baby." She whispers, snot dripping onto her jeans.

"Hi," I whisper back, forcing myself to smile. "I'm here, Mom. It's okay now."

A big, deep breath sits her up straight, and she wipes her nose with the back of her hand. Tears stream down her cheeks as she shakes her head back and forth. "Oh, no, baby, it's not okay." She pulls me to her chest and sobs almost harder than I've ever heard her. Smothered in her Tabu perfume—which I usually love—my nose burns because it's soured overnight, but I'd never, ever pull away.

"Mom? Did someone die?"

She searches my face for her answer, then looks over her shoulder to make sure we're alone. Coming in so close her face is blurry, she whispers, "I'm pregnant."

"What?" I shake my head, not thinking I heard her right.

She coughs like she's unsticking the answer in her throat. "It's Al's."

His name knocks me on my butt. I shove it back at her with both hands, scooting myself across the cold linoleum—"No. No. No. No. No."

Mom reaches for me. "I know, baby. I'm sorry."

My back against the kitchen wall, I bury my head between my knees and try breathing—wheezing and gasping for air the way I did when Al lived with us. I close my eyes, but he's there—black eyes, black hair, black boots—waiting in the dark like always. My eyes snap open to get away, but she's there—teary eyes, sad face, hands

outstretched—hoping I'll come to her like always. With no way to get away from them, I wrap my arms around my knees and cry out to her, "Why'd you do this? It was so hard to get him to leave!"

"Come to your mama," she says in the hushed voice she started using when Al moved in.

My head shakes no, but my body can't help but go to her because she's all I have. I climb into her lap to let her hold me the way I've held her a thousand times. Wiggling into position, we both giggle because I don't fit anymore. Draped across her lap, my legs dangle over the side as my bare toes sweep back and forth over the cold linoleum. "Mom?"

"What, baby?"

"Please don't let him come back."

"He won't." She exhales what sounds like all the breath her body can hold and pulls me back on her chest, wrapping her arms around me, and sniffling back tears I know she's afraid to cry because she might never stop.

I stare up at Debbie's ceiling someone covered with popcorn kernels painted white. Counting the kernels feels as impossible as counting the freckles on my arms and reminds me that even though Mom said Al is Black Irish—whatever that means—he's not *Irish-Irish* like me and doesn't have freckles, so the baby probably won't. We won't match—at all.

The sun's gone from Debbie's kitchen, and goosebumps replace my freckles. "Hey, Mom? You wanna go home?"

She wipes her nose on the back of my T-shirt—already soaked in her tears and sticking to my skin—and then begins moaning the way I do when my stomach hurts. Her arms squeeze tighter around me as she rocks us in the heavy wooden chair. Her warm breath on my neck drops my eyelids closed, and I lose myself in the rhythm of the rocking—the two of us bobbing up and over waves that grow bigger as she moans louder. Floating in our ocean, Mom's hands slip down my sides and grip my T-shirt like she's holding onto a life jacket instead of wearing it. I'm saving her from drowning.

Again.

Some time later, I open my eyes, and the kitchen is almost dark. I move on her lap to loosen her grip and wake her from wherever she drifted off to. Under me, she whispers. "So, do you want to keep this baby?"

Keep the baby? I repeat her question to myself because I don't know what she means. But before I can ask what *not keeping* a baby means, my mom slides me off her lap and into the chair next to her. Sitting knee-to-knee, she mittens her hands with her sleeves and wipes her eyes and nose. Her pout bends up into a smile. "I have an idea!"

Copying her, I gulp some air and dry my eyes with my T-shirt. "What is it?"

"*You* can be the baby's dad!" Mom says, patting my thighs and smiling. Then, she crinkles up her nose like she ate something gross. "We don't need Al! I'll even put your name on the baby's birth certificate!"

"Huh?" I ask because her solution is even more confusing than the problem. "What do you mean *I* can be the dad?"

She points to herself. "You know, I'm the mom"—then she points to me—"and you're the dad. We'll raise the baby on our own!"

Her puffy brown eyes are begging me to understand, and I really want to, but this look that's happy and sad and scared and excited all at once is one I've seen too many times since Al moved in. Her confusion about him never made sense because I knew the first time we met that Al was a monster. And now she wants to have the monster's baby. "No Al? Won't he care?"

Mom holds my hands in hers and touches her forehead to mine. "I'm not gonna tell him I'm pregnant."

"What?" I quickly pull away from her and tug at the neck of my T-shirt, now soaked in tears and snot.

She leans back and smooths her blouse and hair, like she's finally ready to leave Debbie's kitchen. "We'll go back to Juneau and keep the baby a secret from him."

"Forever?"

She nods. "If he never knows there's a baby, he'll never come looking for us."

"But how can I be a dad? I'm not a boy." Snot drips onto my lip, and I wipe it off with my forearm—smearing the slippery slime across my freckles. "And I'm only ten."

Mom laughs. "I know you're ten, Bright Eyes, but we can do this!" She stands up. "Are you ready?"

I stare up at my mom, wishing I believed she wouldn't tell him, wishing I believed he wouldn't come back. But she always lets him back because she can't be alone, and I don't count. I'm also not allowed to say no to her—ever—so I answer the only way I can.

"Yes."

CHAPTER 2

When We Were Young

Juneau, Alaska 1975

"*R*ise and shine!" My mom sings, pulling open my yellow-flowered curtains and letting the sunshine spill across my bed. "Look what the Sandman left!" She holds a tiny mirror up to my face.

Silver stars sparkle under my sleepy blue eyes and over my freckles. I trace them with my pointer finger across my cheeks. "Mommy, why did he come?"

She leans down, and her blonde curls tickle as she dots kisses all over my face. "Because it's your birthday, Bright Eyes! You're four today!"

"Oh, yeah!" I squeal and bring her face down to mine, peeling a star off my cheek to stick on hers. "Now, we match!"

I LIVE WITH MY MOM AND DAD IN the "Pink House"—known to everyone in Juneau because its circus-pink paint pops up out of the dark green forest like a giant lollipop and can be seen from the highway.

"Hey, Cargill! Grab matches!" Mom yells to my dad, Jim, who everyone calls by his last name as she puts four candles on my pink cake she baked into the shape of an elephant and covered in rainbow sprinkles. "Do you have your wish?" she asks.

I smile and nod toward my Holly Hobbie doll next to me.

"Come on up, kid." Dad lifts me to standing on my chair as our best friends gather around the kitchen table. Mom lights the candles, and everyone sings, "*Happy Birthday to you . . .*"

"Okay, now, watch your hair," my dad warns in his low, slow voice I think sounds like Winnie-the-Pooh's friend, Eeyore. He holds my auburn hair back in a ponytail, and I close my eyes and make my wish.

I blow out all my candles at once, and everyone cheers. Mom whispers, "Don't tell anyone what you wished for, or it won't come true!"

I mouth *okay*, then promise myself not to tell my best friends, Nick and Louie. No matter how much they beg, they'll never know my wish is for Santa to turn my Holly Hobbie doll into a big girl like me.

"Watch out! Incoming!"

Before I can duck, a softball of soggy cornstarch splats on my cheek. "Gross!" I scoop the glob off my face to smoosh into a ball.

Nick points behind the couch. "It was Sanders! He's over here!"

I jump on the back of the couch. "Got ya!" I giggle and drop a handful of cornstarch goo on his face.

"And I got you!" my dad hollers as he blasts my back with pink Silly String.

"*Daaad!*" I whine and jump off the couch, grabbing the can out of his hand. My finger on the can's trigger, I order my dad to give up. "Put 'em up! You're under arrest!"

Dad chuckles, raising his hands over his head like the bad guys on TV when the cops bust them. "Okay, kid, you got me."

Louie and Nick run in, and the three of us wrap my dad in a web of pink Silly String.

After stuffing ourselves with cake, the boys and I head into the living room where the grown-ups are sitting in a circle on the floor. Louie's mom, Lianna, licks a tiny piece of white paper and rolls it into a skinny cigarette the grown-ups call a joint. The boys and I quietly wrap Silly String around our fingers, hoping the grown-ups will forget we're here and let us stay up late. Under a cloud of smoke, we listen to a woman on the record player singing about how she wishes the Lord would buy her a color TV, and I start wondering if I should've made a different wish because Nick has a color TV, and *Sesame Street* is way better when Big Bird is yellow and not gray.

Someone taps my shoulder. I turn to see a joint dangling in my face. Nick's mom, Honey—who is as sweet as her name—is holding it and talking to Lianna on her other side.

"Uh, what do I do with it?" I ask her.

"Shit! Shit!" Honey yells and drops the joint on the rug. "I'm so sorry, Bridey!"

Everyone laughs, and my face feels hot.

Mom points to my bedroom. "Time for bed, kids."

THE NEXT SUMMER, WHEN I'M ABOUT to turn five and start kindergarten, we move into a silver school bus I decide is magic like *Chitty Chitty Bang Bang*. Bouncing on the purple velvet driver's seat and pretending to steer, I yell to my dad as he hammers on the red restaurant booth that's gonna be our dinner table. "How do I make this thing fly?"

He chuckles. "Maybe ask it nicely?"

"Mom, look! I'm driving!" I grip the crystal doorknob she put on the shifter and pretend to move it back and forth.

In the long mirror above the steering wheel, she smiles hanging curtains she sewed with the Campbell Soup kids' faces on them. Mom said the company gave her the material for free because we eat so much soup. Outside of the bus, our Irish Setter is waiting for me to let her inside. It takes two hands to pull the lever and open the door. "Come on, Gracie!"

Dad waves his hammer. "Hey, kid! Wanna see your bed?"

Sliding off the velvet seat, I race to the bunk bed Dad built for me behind our bathroom and only a few feet away from our living room where Mom and Dad sleep on a couch they fold out into a bed at night.

MOST NIGHTS, MOM IS AT WORK downtown, so Dad cooks dinner. "Here's the ketchup, but don't use too much."

Turning the bottle upside down and shaking it with both hands, I cover the pile of liver that looks like slugs died on my plate. "Dad, I need a lot because it tastes gross!" I stab a slug with my fork and lift it to my mouth, but my lips won't let it in. I cry. "Can we pretty please with sugar on top have soup?"

"Sorry, kid. This is what we got, but it's real good for you." He swims the smallest slug through the pool of ketchup, then buzzes it around my head. "Open wide! Comin' in for a landing!"

I squeeze my eyes shut and open my mouth. The slug lands on my tongue, and I swallow without chewing—immediately barfing it up all over my plate.

The red restaurant booth is also where I'm learning to read. "See. Dick. Run." I say each word slowly to make sure I'm right.

"Good job!" Mom smiles. "Now, who's the girl?"

I sit up straight and tap my pointer finger on the words under the little girl with yellow curls. "See. Jane. Run."

"Yes! And what's the dog's name?"

"Spot!"

Mom kisses my cheeks. "You're gonna be the smartest kinder-gartner in the whole class!"

BECAUSE IT'S GETTING TOO COLD TO live in the bus, and we live "out the road"—meaning we're parked in the woods where the highway ends at the bottom of a big mountain where ice fields that go on for-ever and far away from where Mom serves cocktails and Dad works construction—we move downtown. We share our apartment above the Red Dog Saloon with a million cockroaches, an English couple

who sound like Mary Poppins and her chimney-sweep friend, Burt, and a wino named Crazy Carl who sleeps in our building's hallway and screams if we make too much noise.

Living downtown means I get to play with Nick and Louie more.

"Mom! We're gonna go see Grandmother!" I hurry to put on my rubber boots before the boys get theirs on because everything we do is a race. Stuffing my rabbit pelt in the skirt Mom made me from bell bottoms of her jeans, I yell to the boys, "Last one there's a rotten egg!"

Louie runs past me and grabs my fur. "Better come and get it!"

"Too bad I'm givin' your quarters to Nick if you don't give it back!"

When Nick and I finally catch up to Louie, he's spying on the winos in the alley next to the liquor store. Lined up against the wall and drinking their booze from paper bags, the guys kinda look like ladies sunbathing by a pool. "Shh!" Louie puts his pointer finger on his lips.

The three of us peek our heads around the corner, listening but not really understanding what the guys are saying because they're slurring their words through mouthfuls of missing teeth. "I'm going to the jewelry shop!" I slap Nick's back. "Tag! You're it!"

We slosh through puddles that never dry up because it's always raining in Juneau and run up the hill to the Baranof Hotel where my grandmother sells expensive jewelry in her fancy store. Seeing she's helping customers, the boys and I wait on the sidewalk until she notices us. Grandmother—the only name her grandchildren are allowed to call her—waves. "I'm going in by myself, but I'll get enough for all of us."

Grandmother keeps talking to her customers and opens her cash register for me to grab a handful of quarters. "Thank you," I whisper.

The boys and I race down the hill to Ben Franklin's Five and Dime to get free popcorn and as much candy as our quarters will buy. Chomping a mouthful of exploding Pop Rocks, I stop at the Triangle Club, the bar where my dad plays poker with the guys on his basketball team. "I'm goin' in!" I yell to the boys, feeling kinda

bad because the boys don't have dads to go see, but at least they have pockets full of candy.

Sitting at his usual table—under a painting of dogs playing poker—my dad looks up from his cards. "Hey, kid." I climb in his lap and check out his poker hand, pretending I know what I'm looking at.

He lays his cards face down on the green material. "Alright, guys, we're headin' home."

I run around the table, giving out hugs to Dad's buddies, and Uncle Pat gives me the biggest one. "Shirley Temples next time, kid." He smiles with round, rosy cheeks like Santa, and pretends to mess up my hair.

My dad lifts me up to his shoulders for the ride home, and I grab fistfuls of his shaggy brown hair to hang onto. "Giddy up, horsey!" I holler like a cowgirl and slap the hanging shop signs that are usually too high for me to reach.

Back at our apartment, Mom sees my crazy-cowgirl hair hanging in my face. "I'm trimming your bangs." She points to our kitchen chair with her scissors. She dips her comb in a cup of water and slicks down my hair. "This is gonna be so cute! You're gonna look like Batgirl!"

"Batgirl?" I look up, confused because I didn't know Batman had anyone else but Robin.

"Hold still!" Mom taps my head with the scissors, then starts snipping. Done, she waves the scissors like a magician showing off his trick. "Perfect! Go check 'em out!"

In the big mirror over the couch, I stare at my pointy bangs that come down between my eyes like a mask. I'm not sure I like it, but Mom is smiling, so I decide to try.

SOON AFTER SHE TURNS ME INTO BATGIRL, Mom comes into the kitchen, waving a red, sparkly bodysuit. "Look what I made for you!"

Setting down my freshly baked chocolate cake hot out of my Holly Hobbie Easy-Bake Oven, I squeal, "It's Wonder Woman!"

Wearing the red-sequined leotard and gold-sequined headband everywhere but the bathtub, I fly around our apartment in Wonder Woman's invisible jet, buzzing my kazoo with Gracie following. "Dad!" I fling open the bathroom door and see him reading on the toilet. "Hurry up! You're gonna miss my show!"

Dad looks up from his newspaper. "Can you gimme a minute? I'm on the john."

"Okay, but hurry because you always stay on there forever!" Leaving the door open, I spin around and jump up on the couch. "Can you see me?"

"Yes, I see you." He chuckles and pushes the door open wider. "I'll watch from here."

"Okay, here I go!" Leaping from the couch to the chair, I roll off the back and land on all fours. "One! Two! Three!" I spin around like Wonder Woman changing into her superhero costume, then chase Gracie. "Gotcha!" My invisible golden lasso around her, Gracie surrenders and sits. Mom claps from the kitchen and Dad from the toilet.

Removing the lasso from Gracie's neck, I kiss her copper fur. "Now you're Superdog! Let's go catch the bad guys!" Great Gracie Graffiti, my superhero sidekick, follows my heels as we fly to the kitchen to battle the cockroaches taking over my Easy-Bake Oven.

CHAPTER 3

Black Water

"Mommy! Look! I'm snortin' Coke!" Hovering above my glass of Coca-Cola, a red cocktail straw stuck up one side of my nose, I tilt my head to see if my mom and Hilly are laughing.

They're not. A hiccup shoots Coke up my nose, making me cough and dribble brown liquid in my glass.

Mom scoots close to me and whispers, "What are you doing?"

Stabbing the ice in my glass with my straw, I whisper back, "Tryna be funny."

Hilly, Mom's friend, whose hair I love brushing because it goes down to her butt, shakes her head at me. Mom slides my glass away from me. "Well, you're not."

Looking across the bar, I can tell that the people sitting at the bar are laughing at me. One of the ladies plays with the toy saloon the bartender keeps on the counter. The saloon doors open, and a doll the size of my Barbie lifts her skirt up, showing off lacy panties as she does the can-can.

Mom snaps her fingers in front of my eyes to get my attention. "It's bedtime." She points under the table.

We live just upstairs from the Red Dog Saloon, so sleeping here isn't weird. I duck under the table, smooth out stinky sawdust, and pile some into a pillow. Mom says my legs are long for a

kindergartner, so I tuck my knees to my chest to keep from tripping anyone and pull my rabbit pelt off the seat, plucking off a hunk of fur and rubbing it under my nose, while staring at Mom's ankles until I fall asleep.

MY DAD LEFT TO GO WORK ON THE Alaska Pipeline somewhere up around where Santa lives. Because he's not here to watch me, Mom says I have to stay with babysitters.

"But I don't know her," I whine, slipping my bare foot into my mom's high-heeled boot.

Ignoring me, Mom tucks her puffy shirt into her jeans. "She's nice. She works at the grocery store."

"When's Dad coming home?" I slip off her boot and hand it to her.

"I don't know. The Pipeline might take a while—"

"That sounds like forever!"

"Not forever." She kisses my cheek with her red lipstick. "There! Now you have my kiss on all night!"

On my tiptoes, I look in the mirror and wipe her lipstick off with my pajama sleeve, but Mom doesn't see because she's already in the hallway.

"Let's go," she whispers, not wanting to wake up Crazy Carl, snoring under his tan trench coat outside our apartment.

Mom knocks on the neighbor's door. As it opens, a warm wave of peppery perfume stings my nose. I slap my hands over my mouth and step away from the door. Mom brushes my hand down. "Say hello, Bridey."

"Hi—" I say and stare down at my socks. Mom and the neighbor talk while my eyes move from my feet to the lady's silky black robe touching the carpet. My gaze follows her robe up to her red lips and eyes lined like a cat. Her black hair is pulled into a crown on top of her head like an evil queen.

Mom scoots me into the scary lady's apartment, then kisses my forehead. "Be good. If you get tired, fall asleep on her couch." I

beg with my eyes for her not to leave me, but she doesn't care and steps into the hall. Crazy Carl moans under his trench coat, and for a second, I think about asking if he can babysit me.

The lady closes the door, locking me in. "You can watch TV." She points to a short stool in front of her television.

Sitting down and looking around, I notice there's no couch— only a bed on the other side of the room. Deciding there's no way I'm falling asleep, I scoot closer to the TV to stay awake. Starsky and Hutch look blurry because my nose is practically touching the screen, but I already know what's happening because all they do is chase bad guys in fast cars.

Behind me, the lady pulls something out of the oven that smells weird. All of a sudden, I can't help but think about the old woman in *Hansel and Gretel* who tries to cook the little boy and his sister. Stopping myself from getting too scared, I look at the pictures on her wall.

In a long, rectangular painting over the kitchen is a skinny man in a black suit with a pointy black beard and two tiny horns on his head. He's surrounded by a bunch of kids and mountains that are on fire. I once saw a Tom and Jerry cartoon with a guy who looked like the skinny man on Tom's shoulder telling him to eat his mouse friend, Jerry, and an angel on the cat's other shoulder telling him not to. That's how I know the man is definitely the Devil. I turn back to *Starsky & Hutch*, hoping Mom comes back before the show is over.

Mom screaming at the scary lady wakes me up. Somehow, I fell asleep on the stool and didn't fall off. "You let her watch TV all night?" Mom shouts and scoops me up. "You'll never watch Bridey again!"

"HOW LONG AM I STAYING WITH AJ and Cari?" I jump from plank to plank on the muddy trail leading to their cabin.

"A night or two," Mom answers. "Hustle up because it's starting to rain harder."

Surrounded by devil's club with pokey needles and stinky skunk cabbage as tall as me and Holly Hobbie—who Santa turned

into a big girl like I wished for on my birthday—I slosh through giant puddles.

Taking my wet jacket, Mom's friend AJ tugs gently on the leather chokers around my neck. "Frankie, we have to cut these off before Bridey hangs herself climbing trees with the boys."

"Don't you dare. She loves them." Mom hands AJ's girlfriend, Cari, my bag.

"Maybe we'll paint this weekend instead of climbing trees." Cari smiles at me, her green eyes sparkling like marbles. She knows I love painting in her room downstairs with the big windows because I can see all the way to the black water in the cove—although Cari told me it only looks that color because the sky is dark.

When Mom leaves, AJ's boys take me outside to play. Rocky cups his hand like a basket. "Step in here."

He lifts until my feet find a branch to stand on. "Got it!"

"Good job!" Rocky shouts under me. "Look around and lemme know when you wanna come down!"

"Okay." Gripping the branch, I see the trail Mom and I walked in, and the beach covered in a million rocks.

After the boys help me down, Lennie and I run to the water where he puts a rock in my hand. "See how smooth that is? You want it to be flat because it'll skip better. Watch me!" Lennie flings his rock across the top of the water. It skips . . . skips . . . skips . . . then sinks.

"Yeah! Three skips! My record is four." He smiles and nudges me to throw.

Excited to show him I can do it by myself, I fling the rock as hard as I can, but it sinks before skipping even once. "Darn it!" I grab another rock. "Lemme try again!" By the time Cari calls us for dinner, I'm at two skips.

THE NEXT DAY, AJ AND CARI HEAD to town for groceries and leave the boys to babysit.

"We're having a tea party if anyone wants to come!" I announce, heading downstairs with Holly Hobbie and a handful of rocks. Next

to where Cari and I paint, I prop Holly against a pillow and lay my rabbit pelt between us like a tablecloth. Two rocks are our "teacups" and two pieces of driftwood our "muffins." Sipping tea, I say in my fanciest voice, "That's delicious."

As I help Holly take a bite of her muffin, Rocky comes down the stairs. "Whatcha doin'?"

"Drinking tea." I hold up my rock cup. "Want some?"

"Maybe later. Wanna play something else?"

"Okay!" I hop up, figuring we're heading outside.

Rocky waves me over to where he's standing next to the washer and dryer under the biggest window in the room. "Come here."

He cups his hands for me to step in like I'm climbing a tree and lifts me onto the washing machine. My jean skirt slides up as I scoot across the cold metal. "*Brrrr*! It's freezing!"

"Here, I'll warm you up," Rocky says. Before I can ask what game we're playing, he leans me back and lies on top of me. His breath is hot, but I'm still cold. His hand rubs over my panties, making me wiggle because it tickles—but not in a good way. Rocky isn't talking, so I keep quiet and stare out the window—crying because I see all the rocks I wish I was skipping right now instead of this game I wish we weren't playing.

Suddenly, I'm freezing again. I turn away from the beach and see Rocky running up the stairs past Lennie, standing at the bottom, staring at me. He looks at me for a second, then follows his big brother.

Alone and cold, I slip off the edge of the washing machine, then pull my undies up and my skirt down. Walking my fastest across the carpet, I grab my rabbit fur, and Holly Hobbie and I tiptoe up the stairs—because we're still being quiet—then down the hall to the bedroom where I sometimes sleep between AJ and Cari. I pull the covers up over me and Holly Hobbie—sucking my thumb and crying for my mom.

"Hey, Bright Eyes! It's time to wake up."

I open my eyes to my mom smiling, but then she sees my neck and looks confused. Searching the sheets like she lost her

keys somewhere next to me, she rolls me from side to side. "Where are they?"

"Where are what, Mommy?"

"Your necklaces. Where are your goddamn necklaces?"

"AJ cut them off when—"

Mom hops off the bed before I finish and yells down the hall, "AJ! What the hell did you do?"

AJ shouts back, "Frankie, she was climbing trees with chokers around her neck! You want her to hang herself?"

"I told you not to cut them off! We're leaving!"

AJ hugs me at the door. "I was afraid I'd find you dangling from a tree!"

Mom grabs my arm. "I'm her mother, and I'll decide what's dangerous. Not you."

Cari's soft voice interrupts. "Frankie, here are Bridey's necklaces."

Mom grabs them. "Well, fuck you, very much!"

Walking the trail back to the car, Mom stops and says, "I'm sorry he cut your necklaces. We'll get you new ones." She brushes my hair back. "And don't worry, you won't be going there anymore."

I nod, sucking my thumb and deciding I'll tell her what Rocky did to me when she's not so mad.

"GO PLAY AND STAY OUT OF OUR HAIR!" Louie's mom, Lianna, shoos the boys and I away like flies. Mom unpacks food from brown paper bags while Honey spreads blankets on the giant lawn at the Alaska State Museum where our moms sometimes bring us when it's sunny.

"You'll never catch me!" I yell, tucking my rabbit fur into the waist of my skirt and running as fast as I can.

"*Tag!*" Nick pushes me hard, and I belly flop on the grass. Laughing, I flip over and start rolling across the grass until I'm dizzy and tangled up in my clothes. Hot and sweaty, I rip off my skirt and shirt and start running, waving my rabbit pelt over my head like a flag as the air cools me off.

Our moms laugh, and mine calls out, "Hey, naked jaybird! You're gonna get arrested for streaking!"

I keep running, zigzagging across the lawn until I can't run anymore, then stop next to our moms. I spread my arms out wide and spin around like Wonder Woman with my face tilted up toward the bright sunshine.

"Whatcha thinkin' about, Bright Eyes?" Mom asks.

"I dunno," I say, as a tingling starts in my fingers on one hand then moves up my arm, across my chest, and down to the fingers of my other hand—causing me to ripple my arms like a wave. "Just, doo-dee-*dahhh*."

CHAPTER 4

Mad Martha

"Mommy, please don't go!" I beg, hanging onto the driver's side window of Hilly's gray Nova parked in the middle of the street in front of the Triangle Club.

"It's okay, baby! Mommy and Hilly are gonna win!" she shouts over the Nova's rumbling engine.

Hoping Hilly will listen, I run around the car to her side and slap her window until she rolls it down. "Hey! Whatdaya doing?" she asks, leaning out and spilling her Rapunzel-long hair down the side of the door. Tempted to climb it like the prince sneaking into the tower, I tug on it to see if it'll hold me.

"Ouch!" Hilly laughs, pulling her hair out of my grip and back into a ponytail.

"You're gonna get hurt!" I cry, pounding my fists on the door, confused how a five-year-old is smarter than grown-ups. Every bit of me knows something bad is going to happen. "Don't race, Hilly!" I sob. "Please!"

Mom revs the Nova, farting a gray cloud of smoke that makes me cough. Hilly squeezes my hand. "It's okay! Your mom's a great driver!"

What Hilly means is that my mom *thinks* she's great because she's the daughter of a champion race car driver. My grandmother was the first woman to race against men in Alaska. When she beat

them, the other drivers nicknamed her "Mad Martha." I've never been able to imagine my grandmother, with all her red lipstick and gold bracelets, driving a stinky stock car.

The car Mom and Hilly are racing revs its engine, shaking the ground and scaring me back to my mom's window where I jump up, clinging to the edge of it like a cat and crying. "You can't go!" Someone pulls me off her door, so I start kicking as hard as I can. "Let me go! Let me go!"

"Come on, now," Sanders says, setting me down on the curb and sitting next to me. He brushes my hair off my face and wipes my nose with his coat. "Your mom'll be okay."

The crowd watching from the sidewalk starts clapping and cheering. I look up and see a woman I don't recognize standing between the two cars and waving a blue bandanna over her head. Sanders lifts me onto his shoulders like my dad does.

The woman stops waving and holds the bandanna in the air, stiff like a flagpole. The crowd begins counting—"Five! Four! Three! Two!"

On "One," she drops her arm and the bandanna lands on the street.

The car's tires squeal as Mom and Hilly peel out down the street—to their deaths. At least that's what I'm sure is going to happen as I slump over on Sanders and sob into his hair. He gently pulls me down off his shoulders and smiles. "I bet a Shirley Temple will make it all better."

WHEN I WAKE UP, A BUNCH OF PEOPLE are talking in our living room, and I realize someone moved my bed out here. Rubbing my eyes open, I see Mom and Hilly holding onto each other—their purple, puffy faces covered in bandages and Band-Aids like mummies.

Sanders laughs. "So, you two found the only boulder on Thane Road? Nova totaled?"

"Yep." Hilly's crooked smile is now missing teeth. "Nova's no more."

I hop off my bed and hide behind Sanders. Mom reaches for me, and some of her teeth are gone, too. "Hey, baby. *Ith* okay. Don't be *thcared.*"

I shake my head no and watch Mom and Hilly climb into my tiny bed and squish next to each other to fit. Mom asks Sanders, "Did my mom *thee* the *rayth*?"

"No," he chuckles. "Martha said, 'Tell Francis it's a stupid idea.'" Sanders picks up his camera and points at Mom and Hilly. "Say cheese!"

"*Cheeeth!*" the toothless race car drivers sing, proud to show off their goofy smiles.

CHAPTER 5

KISS

Two girls who look like junior-high schoolers walk into Lianna's kitchen. For whatever reason, I quickly decide I hope the one with blue eyes and blonde hair will be our babysitter. Her friend reminds me of Velma from *Scooby-Doo*, with her short dark hair and thick glasses.

Lianna says to the pretty blonde girl, "They'll be good for you, Jo." She then gives me and Louie the mom-glare. "Or else."

Jo pulls a purple comb out of her back pocket and feathers her hair. "Oh, they'll be fine. Stay out as late as you want."

My mom kisses my forehead. "Be good and don't wait up!" she says, knowing I always sleep on the couch with the TV on when she stays out late.

As soon as Lianna shuts the front door, Jo's friend pulls out a pack of cigarettes she was hiding. "Your mom got matches?" she asks Louie.

Already halfway up the pantry shelf, Louie hangs with one hand and grabs a pack of cookies with the other. "Prolly, 'cause she smokes." He jumps down and waves for me to follow him outside. "We're goin' to play."

Busy looking for matches, the girls ignore us.

It's summer, which means it's light outside until past midnight, so we play until our bellies tell us it's dinnertime. "We're starving!" Louie and I yell to the girls sitting on the couch.

Jo hollers, "Kitchen's closed!"

"But we haven't eaten!" Louie shouts, opening the fridge. "We can make it by ourselves!"

I stay quiet because Louie is always better at getting his way than I am. Jo stomps into the kitchen and slams the fridge door, almost squishing Louie's hand in it. "It's time for bed."

"Bed?" Louie whines. "It's too early! Do you think we're babies or somethin'?"

The ugly girl with big glasses grabs my hand. "I got this one!"

I try wiggling loose to reach the bowl of apples. "Can we at least take something upstairs?"

"No!" Jo says, pulling Louie's hand while he fights to get free. "You're going to bed!"

In Louie's room, the girls push us toward his bed. "Get up there and don't get down, or you'll be sorry," Jo says, and she's not kidding.

Louie and I bounce on our knees, chanting, "We're not tired! We're not tired!"

The girls push their way between us, climbing across the bed and out the window to the roof. Jo lights a cigarette and takes a puff.

Bored of bouncing, Louie and I lie down on top of his covers and study the KISS poster on the wall at the end of his bed. "The guy with his tongue out is gross!" I squish up my nose like one of those dolls they sell at the mall with the dried-out apple faces.

"Well, that guy's a cat!" Louie points. "See his whiskers?"

"Are they all animals?"

"Dunno."

Outside on the roof, Jo smashes her cigarette, then whispers in her friend's ear. I shove Louie's shoulder to get his attention, then close my eyes and fake snore, whispering, "Be asleep!"

Louie squeezes his eyes shut and moans like he's having a bad dream. I start cracking up and stick a pillow over my face to keep the girls from seeing.

The window opens, and the girls climb across our legs but stop before getting off the bed. One of them grabs my ankles. "Wake up, you fakers." It's Jo.

I lift the pillow up, and see Jo point to Louie. "Kiss her."

He shakes his head back and forth a bunch of times.

The Velma-girl laughs. "Don't you know how?"

"I don't wanna," Louie says.

Jo sings, "Tough titty said the kitty when the milk went dry."

"You can't make me." Louie turns toward the window. Before I can turn and look outside, too, Jo's hands slide up my legs. Without thinking about it, I squish my eyes closed and squeeze my knees together, but she pulls them apart. Squinting just enough to see what's happening, Jo's blonde hair goes under my dress. Closing my eyes again as tight as I can, I listen to the kids running and playing on the sidewalk outside where I wish Louie and I still were.

In the morning, we tattle on the babysitters—for smoking— and show Lianna the smooshed cigarettes on the roof as proof.

"Oh, they're gonna be in big trouble," she promises.

When my mom picks me up, I ask, "When can I be old enough to babysit myself?"

CHAPTER 6

He's Not a Goldfish

Shivering in the cab of our Toyota truck Mom nicknamed Yota, I'm confused why she's not letting me go upstairs to our apartment because it's way past my bedtime.

Then she tells me—quickly and without warning, the way she taught me to rip off a Band-Aid because then it only stings for a second—"Cargill isn't your *real* dad."

"What?" I turn and look at her in the dark. Her face glows blue and red from the neon beer signs hanging in the windows of the Billiken Bar, where we moved when my mom and dad broke up.

"Bridey? Do you understand what I mean by *real* dad?"

I nod that I do, but I'm not really sure. I mean, I'm six and a half and know *real* is the opposite of fake—like the garter snake living in our fern is real, but Louie's rubbery snake is fake—but what I don't understand is how a dad can be fake? Cargill taught me how to ride my blue banana seat bike, cooks me dinner, reads me books, and always introduces me as his daughter. His brother, Uncle Pat, buys me Shirley Temples, and Uncle Pat's wife is Aunt Mary who bakes rhubarb pie with me and their son, Cousin Carson—who taught me how to pull the legs off daddy longlegs and flick their bodies across the yard.

They all feel very real to me.

As I watch the windshield wipers push the rain off the glass, tears fill my eyes. I want to cry, but I want to wait until I'm in my bed where I can remember more real stuff about my dad by myself. Suddenly, Mom rips off another Band-Aid—from exactly the same spot. "Cargill and Rhonda are starting their own family. They don't want you around anymore."

It burns like the Band-Aid ripped off too much skin. I shake my head, loosening my tears to run down my cheeks. I can't stop myself from crying—harder than I ever have—into my rabbit pelt. I don't hear what Mom is saying because in my mind I'm listening to the football game I watched last night with my dad and Rhonda— his new girlfriend who looks exactly like Wonder Woman. I was gonna show her my costume, but now maybe I can't.

Mom squeezes my hand. "I know you're sad, baby, but there's good news, too!"

Afraid she's about to rip off another Band-Aid, I stay quiet and hope she will, too.

"You get to meet your *real* dad!" She smiles way too good for all this bad. "And you won't believe this, but his name is Jim, too! Isn't that funny?"

I suck my snot and wipe my nose with my fur. "Whatdaya mean?"

But I don't care and stop listening because I'm thinking about when Nick's goldfish died. Honey poured another one out of a plastic bag into the fish tank. When Nick asked her what she did with the first one, she told us she flushed it down the toilet—saying there was no difference because a goldfish is just a goldfish. Nick and I watched the new one swim around the tank and agreed we couldn't tell this one from the other one.

But my dad is not a goldfish.

MOM MOVES HER NEW BOYFRIEND IN right after she takes my dad away. "Don't you think Jeff looks like a surfer?" she asks, watching him blow-dry his hair upside down.

"Why does he always stare at himself in the mirror?"

"Because he's hot to trot!" Mom giggles like one of the girls in my second-grade class when she has a crush on a boy and acts stupid about it.

"I think Jeff looks like Gracie when he sticks his head out of the car window."

"The wind spikes his hair the way he likes it," she says, sounding sassy. "Hey, come here! Check it out!" Mom slides her mirrored closet doors open, showing me a baby's crib mattress on the floor. "I made you a bedroom! Lie down!"

On the mattress, I stare up at Mom's clothes hanging above me, as she slides the door closed. "Mom, no! It's pitch-black."

She laughs. "It's a bedroom, Bridey. It's supposed to be dark."

Although the closet doors block out all the light, they don't block any of the noises Mom and Jeff make now that he sleeps over every single night. Even with a pillow over my head, it sounds like he's hurting her and makes me cry.

IT'S THE FIRST DAY OF SECOND GRADE, and my new friends, Andrew and Kathy, meet me in front of the Billiken Bar to walk to school.

When we get close to the little market that's on our way, I stop. "You guys want gum?"

Kathy shakes her head. "I don't have any money."

Andrew shrugs his shoulders because he doesn't, either.

"Yeah, my mom's boyfriend caught me stealing change from her jar and moved it, so I don't have money, but I have an idea." I glance around to be sure we're alone. "I can get the gum if you guys talk to the grocery man."

Andrew asks, "You're not gonna pay for it?"

I shake my head back and forth extra slowly and smile. The three of us nod a silent agreement and walk toward the market with the confidence of kids who have pockets full of change.

Andrew and Kathy start talking to the grocery man, while I head to the back and climb onto the freezer. I reach across for two packs of pink Bubblicious—one pack for my pocket, and one that

I put back on the shelf, making sure to announce loud enough that the grocery man hears me, "I changed my mind. I don't want this gum!" I hop down and wait for him to see that my hands are empty.

Still in the parking lot and stuffing our mouths full of Bubblicious, none of us notice my mom pull up until she hollers, "Bridey! Get your ass over here!"

Shocked to see her awake this early, I gag on my gum and spit my pink glob on the pavement. She walks toward us with her hands on her hips, her eyes burning mine. "Where'd you get the money to buy the gum?"

"Uh," I stammer, "I had it."

"Don't lie to me, Bridey." She lifts my chin. "You know my rule. If you lie, you'll be in way more trouble than if you tell the truth."

"I'm sorry, Mom—" I cry.

"Cut the crap and tell me what you did."

"I pretended I didn't want the gum and put it in my—"

"You *stole* the gum?" She cuts me off. "Are you telling me *my* daughter is a thief?"

Terrified about the spanking I'm gonna get, I start crying even harder. "I'll never do it again. I promise."

"You bet your sorry ass you won't," she says, pulling my arm toward the market and yelling back to Andrew and Kathy, "Get to school before you're late! And I'm telling your moms!"

After apologizing to the grocery man, Mom drives me to school and tells the principal why I'm late, adding, "Please be sure to tell her teacher."

My brand-new second-grade teacher shows me where to sit, then reads the note from the office that I'm positive is telling her what a bad kid I am. She folds the note just as the principal's voice comes over the loudspeaker. "Mrs. Apple, I apologize for interrupting, but Bridey was late because she got caught stealing gum."

I open my desk and pretend to organize nothing inside of it, avoiding the stares of the kids in class who will definitely go home and tell their parents about the bad kid in their class.

I'VE BEEN A SECOND GRADER FOR A week when I get home and find Mom packing a suitcase.

"Where are you going?" I ask.

"Nowhere, but you are!" She smiles and folds one of my shirts.

"Me? Where am I going?"

"Surprise!" She hugs me. "You get to meet your real dad!"

"My dad?" I'm confused why she's bringing him up because she hasn't talked about him since that night in the truck. "Where's your suitcase?" I look around the room that is both our living room and her bedroom.

"Oh, I can't go."

"You're not coming with me?"

"No, but it's okay because one of my best friends is picking you up from the airport."

"Your best friend? But all your friends live here."

Mom closes my suitcase and sets it by the door. "Not all my friends!" She laughs. "You remember Rennie, right?"

I lie on my crib mattress and slide the closet door shut. "No, I don't know who that is."

FOR THE TWO-HOUR FLIGHT FROM Juneau to Seattle, I play with my Alaska Airlines coloring book, drink two cans of Coke, and eat peanuts until I'm sick.

A pretty stewardess in a blue uniform walks me off the plane, and we see a blonde bush of hair and pink lipstick flapping her hands in the air at me. "Bridey! It's me, Rennie!" Before I can say hi, my mom's best friend who I've never seen before smooshes me between her big boobs. "I'm so happy you're here!"

In the car, Rennie sounds like my mom—saying "real dad" this and "real dad" that—while I suck my thumb to keep from crying. She pulls into a parking lot of a big store and announces, "This Goodwill is the best! We're getting you a pretty dress to meet your real dad in!"

Not sure what kind of dress a girl wears to meet her *real* dad, I try on a bunch and finally pick a circus pink one that reminds

me of our old house. Rennie slides shiny white shoes and white tights under the dressing room door. "These will match the ruffles on your dress!"

At Rennie's house, she sits me down in her kitchen and rolls my auburn hair in pink and yellow curlers, promising, "Toni home perms are the best! You're getting very special hair for a *very* special occasion!"

"It doesn't smell special." I plug my nose and hold my breath.

"No pain, no gain!" she teases.

My hair fluffed and pink dress on, I twirl in Rennie's bedroom mirror, trying to imagine what it's gonna feel like when I see my dad for the first time because I've never even seen a picture of him. All I know is that he's really tall because Mom told me she used to have to stand on a chair to kiss him.

Rennie calls from down the hall. "You ready? Your dad should be here any minute!"

"Coming!" Smoothing the lace on my dress one last time and pulling my tights up because they're a little small makes me wonder if my dad has seen pictures of me or knows I'm tall like him?

As if she hears what I'm thinking, Rennie hugs me from behind and says, "You know, sweetie, you have your dad's blue eyes and long legs."

From the living room, I see a red car with a black top pull into the driveway that reminds me of the ones they drive on *Starsky & Hutch*. The sun is too bright to see who's driving, so I scoot closer to the window because I want to see him the second that he gets out of the car. I tuck my still-stinky curls behind my ears and stand up straight like Mom says I should when meeting new people.

A man with a beard and sunglasses gets out of the car and puts on a white cowboy hat. As he walks up Rennie's steps, I swallow and make myself smile—even though I'm really nervous.

Knock, knock, knock.

Rennie scoots by me. "Here he is, honey! You ready to meet your dad?" She opens the door, and he's taken off his hat and sunglasses. His eyes are blue like mine.

He smiles, squats down, and opens his arms wide. "Hey, baby doll."

I'm not sure why, but I don't feel nervous anymore and run right into his arms.

CHAPTER 7

Playgirl

"\mathcal{N}ext stop, California!" Mom cheers as we head south on the freeway.

Jeff, driving without his shirt on, sticks his head out the window and yells into the wind that's spiking his hair back. "Sunshine and palm trees!"

They packed what could fit in our new car, a white Plymouth Valiant Mom nicknamed Valerie, and took the ferry from Juneau to Seattle to pick me up from Rennie's. Mom didn't tell me we were moving, so I never got to say goodbye to my second-grade teacher, my grandmother, or my first dad—which is what I call Cargill now.

Wedged between black garbage bags packed with our clothes, Gracie and I share the back seat—her head in my lap while I read my *Archie and Jughead* comic book to her. "Hey, Mom? Did you tell my dad—Cargill, I mean—that we were moving?"

She turns around and shakes her head. "No, why would I? You have your real dad now."

"Oh, yeah. I guess." I look down at Archie sitting on a bench with Jughead and think about how sad my dad will be when he finds out I left.

Mom sits on her knees, facing me. "So, whatdaya think of Jim Thelen?"

35

"I like him." I point at the bag under my feet. "He bought me a cowboy hat like his."

"Too cool! Who else did you meet from the family?"

"Uncle Bobby and Uncle Tommy—and my grandma, Mary!"

Mom claps. "I bet she loved you!"

"You know she has a store called 'Mary's Pop-Ins'? Isn't that funny? Because her name is Mary, and she said people *pop in* to buy fancy clothes! She even let me try on a fur coat!"

"That sounds like her. She was always nice to me." Mom runs her finger down my nose. "You have her eyes."

"I do?"

"Yep. Your eyes are far apart like hers. Your dad still have a beard?"

"Yeah."

"He grew it because he gets a double chin when he lies. You do it, too, you know?"

"I do?"

"*Uh-huh*, when you lie—and when you pout." Mom puffs up her cheeks. "Makes you look like a bullfrog."

I stretch my neck out to prove how skinny I can make it.

"You have his body, too," she says, eyeing me up and down. "All arms and legs. You should have seen your dad dance! Jimmy Jet loved to dance!"

"Who's that?"

"Your dad's nickname he got when he went to jail."

"Jail?" I repeat to make sure I heard her right. "For what?"

"Drugs."

"Like what you do—"

She snaps her fingers in front of my face. "That's enough." Jeff laughs.

"Sorry, Mom. I don't know—"

"That's right, you don't know." She turns around to sit back down but stops. "And wherever we end up moving, you better not tell anyone what you *don't* know. You remember what I told you to say if anyone asks you questions?"

I nod that I do.

"What do you say?" She raises her eyebrows.

"I tell them, 'I don't know,' or 'Ask my mother.'"

"Good girl." She smiles like my teacher when I give the right answer in class.

WHEN WE GET TO JEFF'S FRIEND'S HOUSE in Sacramento, Gracie runs away—probably back to Juneau where I wish I was, too. We find her walking along some train tracks a few days later, and she's as fried from the hundred-degree heat as we are. Jeff's friend suggests we drive to Lake Tahoe to cool off because it's only a couple of hours away.

"Holy shit! It's beautiful!" Mom shouts, as we come around the mountain summit and see the gigantic blue lake.

"Mom! Look how high we are!" I point down at the valley of pine trees below us.

"It's just like Juneau!" Mom starts crying. "We're staying here!"

"Here?" I stop myself before asking, *If you wanted to live somewhere that looks like Juneau, then why did we move in the first place?*

South Lake Tahoe, California 1978

MOM OPENS THE DOOR TO ROOM 8 at the Bee Vee Motel. "Home sweet home!"

"This is home?" I ask.

"For now, yes." She glares at me, and I know all she wants to hear is how much I love it. "The manager says there's a room with a kitchenette we can move into soon."

Because the closet isn't big enough for me to sleep in, Mom piles blankets on the floor behind a dresser. "There you go! You and Gracie have a bedroom."

The dresser works as bad as the closet door did in blocking the hurting noises Mom makes when she and Jeff do "it." Two pillows over my head kinda helps.

Mrs. Jones is my second, second-grade teacher, and her black hair and red lipstick remind me of Snow White. "Boys and girls," she says on my first day, "this is Bridey, and she moved here all the way from Alaska! Do any of you know where that is?"

Hands shoot up in the air, and one kid blurts out, "Did you live in an igloo?"

Another kid asks, "Yeah, and did you have a pet polar bear?"

The kids all laugh, and Mrs. Jones pulls me close to her. "I'm sure Bridey will answer all your questions during recess."

While the other kids are working at different stations around the room, Mrs. Jones sits next to me and opens a textbook to a story about otters. "Can you read a little for me, Bridey?"

I sit up straight and make sure to pronounce every word perfectly, stopping after a few lines to see if she's smiling because I want to make sure I'm getting it right.

"You are a very good reader, Bridey," she says and closes the book.

"Thank you," I say, feeling proud of myself. "My mom taught me on our school bus."

"A school bus?" Mrs. Jones asks, like I've said something weird.

"Yeah, we lived on it. My mom taught me how to read before I went to kindergarten."

"Well, that's wonderful. She did a good job."

Because I want to practice for the next time Mrs. Jones asks me to read to her, I sneak the otter book in my jacket to take back to our motel room.

The snow has started to fall by the time we finally move into the room with a kitchen.

"Check it out! A real bed!" Mom says, waving her hands at the bed squeezed between the small fridge and the wall like she's showing me a prize I've won on a game show. "It's a rollaway, so you can fold it up in the morning. I'm gonna hang curtains to make it feel more like a bedroom."

"Thank you," I say, wishing I had a real wall because a piece of material won't block the noises she makes with Jeff.

Mom leaves to grab more stuff from the other motel room, and I hear Jeff yell, "Come on, you son of a bitch. Zip!"

I turn around and see Jeff on the other bed, pulling at his zipper. "Whatdaya doing?"

"Zipping my pants. What does it look like?"

"Why are they wet?"

He grunts and pulls at the zipper again. "Shit. I don't have time to answer your stupid fuckin' questions. Just hand me the pliers over there."

"Over where? And what are pliers?"

He points to a bag by the door. "In there! The pointy metal tool."

I find the pliers and hand them to Jeff, then ask what I think is obvious. "Why don't you get bigger pants?"

"Why don't you shut up?" He yanks one last time. "Got it!"

Before I say anything to get in trouble, I lock myself in the bathroom and turn on the faucet to keep him from hearing me. My hands on my hips, I imagine I'm looking at Jeff's stupid, spikey hair in the mirror, then stick out my tongue and tell him how I really feel. "I don't shut up, I grow up, and when I look at you, I throw up!"

IT'S NEARLY CHRISTMAS WHEN I'M STOMPING through the snow to the bus stop, making Bigfoot tracks with my blue Moon Boots. Jeff passes me in Valerie, which seems weird because he's never up this early after waiting tables all night, but when he sees me, he slams on his brakes and skids to a stop on the icy street.

He rolls down his window and hollers, "Get your ass over here!"

I drag my feet as slowly as I can to him.

"What the hell do you have on? Is that lipstick?"

I touch my lips. "Yes, it's Mom's."

He makes a face like I stink. "You're not allowed to wear lipstick to school. And you look like a little hooker!" He points to the back seat. "Get in. We're going home, and you're gonna wash that shit off your face."

I open the car door and slide onto the seat, crying because I'm gonna miss the bus. Looking at the back of Jeff's head, his hair is frozen in little icicles, and I realize he was driving around with his head out the window when he saw me. Thinking about how dumb he is for freezing his hair when he's supposed to be drying it stops my crying. I wipe my eyes and nose with my coat, smearing red lipstick on my sleeve—the same color Mrs. Jones wears, and the same color the hooker who my mom brought home for dinner when we lived above the Red Dog Saloon wore.

Mom had told me she saw the lady and her son digging in the trash for food and felt sorry for her because her boy was five, like me. While our moms made dinner together, the boy and I played *Happy Days*. I pretended to be Pinky Tuscadero (although I found out her name was really Atascadero, but that didn't change what I called her) and held onto Fonzie's back while we rode his motorcycle around my mom's bedroom, then kissed like they do on the show. My mom laughed when she called us for dinner and saw our red, sweaty faces. A couple days later, I got itchy bumps between my legs that Mom called scabies and said I probably got them from the little boy.

Jeff can barely wait until my mom is in the door from work to be a tattletale. "She tried to go to school lookin' like a hooker, but I caught her."

"Hookers are pretty," I blurt out before I can stop myself.

"What did you say?" Mom glares at me.

"I mean the hooker who came for dinner with her son. She was pretty."

Mom walks toward the kitchen. "You're still getting spanked."

"Mom, no, please! I'm sorry!" I start crying before the spanking even starts.

"Get over here." She motions with the plastic spatula.

"Mom, no! Please," I plead, backing up against the motel room's front door.

"Now, or it's gonna be worse."

"Please don't use that, though." I point at the spatula.

"You're getting too big. Hurts my fuckin' hand too much."

Whack! Whack! Whack! She smacks my butt and the backs of my legs, then throws the spatula in the tiny sink. "Hookers are pretty, my ass! And we better never catch you wearing lipstick to school again!"

OUR NEW HOUSE ON SAN FRANCISCO Street is long and skinny like a trailer but without the wheels. I love it because my bedroom is on the opposite end from my mom's room, so I can't hear her and Jeff doing it.

"Is that your dad?" Jennifer, a girl from my second-grade class, asks when she sees Jeff carrying groceries into the house.

I set my cassette player down on the driveway. "No, my dad is way nicer. That's my mom's stupid boyfriend who thinks he's too cool for school. I heard my mom tell her friend on the phone, 'He's young, dumb, and full of cum.' I don't know what that means, but she got the dumb part right, for sure. Anyway, let's work on our dance!" I push play on my cassette deck, and Donna Summer sings "Hot Stuff" while Jennifer and I choreograph moves we'll teach our friend Lulu.

When Mom gets home from work, she comes in the kitchen looking for Jeff. "Oh, *Jeffeee*, where are *youuu*?"

"Why do you talk like that now?" I ask, dropping the dish sponge and drying my hands on my shorts.

"Like what?"

"You sound like girls at school when they're running away from boys but really want to be caught." I laugh, hoping she'll think I'm kidding and not smack me.

"Good!" She shimmies her shoulders and puckers her lips. "Better than sounding like an old lady!"

"I guess, but I kinda wish you'd sound like a mom."

She sticks out her tongue and heads to her bedroom, yelling over her shoulder, "Wish in one hand, shit in the other, and see which fills up first!"

"PEDAL AS FAST AS YOU CAN!" Jennifer screams, tearing around the corner on her red Big Wheel that matches mine.

It's always a race to get by the dry cleaners before the scary teenage sisters who live there see us and chase us down. They've never caught us, but I don't even wanna think about what they'd do if they did.

"We made it!" Jennifer and I cheer once we're safely in her driveway. We walk in her house, and Jennifer yells to her mom in the kitchen. "Can Bridey stay for dinner? Her mom's not home."

Her mom looks up from under her brown bob she curls under like Sabrina from *Charlie's Angels*. "Of course!" She smiles and waves at us with her wooden spoon. "Hi, sweetie!"

Jennifer and I head upstairs to play. "What should we do?" she asks.

"Let's play Mailman!"

"What's that?"

"I'll be the mailman and bring you deliveries."

We hang up blankets, and Jennifer climbs into the fort. "I'm waiting for my mail!"

"Okay, special delivery! *Knock, knock!*"

Jennifer pitches her voice high like a lady. "*Whooo izzz* it?"

"Mr. Mailman!"

I slip into the fort, and even though we didn't talk about the rules of the game, we both seem to know they involve kissing. We take turns being the mailman until Jennifer's mom calls us for dinner.

"Girls, your faces are bright red!" her mom says, setting the table. "How hot is your room, Jennifer? You should open the windows."

After dinner, her mom lets us watch a movie called *The Jerk* because she thinks the actor in it is funny. Jennifer and I are talking about what it would be like to live at the carnival like the guy does when his parents read a letter he sent telling them he got a job: a *blowjob*.

"Mommy, what's a blowjob?" Jennifer asks.

Her mom shoots a look at her, then at me, then back to her. "It's a guy who blows up balloons—"

"No, it's not," I correct her.

Her mom glares at me. "Yes, it is."

"But I know what it is," I say, defending myself, like the proud *know-it-all* my mom says I am.

"Bridey, in our house, it's a guy who blows up balloons," she says in that way moms do when they don't want you to say another word.

Because I love coming over here, I keep my mouth shut but know I'll tell Jennifer later because that's what best friends are for.

CLOSE ENCOUNTERS OF THE THIRD KIND is the next movie we watch, although at my house. After it's over, Jennifer and I decide we're going to pile all my clothes and toys in a mountain in the middle of my room just like the weird guy in the movie who's trying to talk to aliens does with all his stuff.

We rush around my room in a frenzy, pitching toys and books into the mound that's growing higher and higher with each shirt, teddy bear, and blanket. "Look at my Wonder Woman Underoos!" I shout, wearing my undies like a fancy hat.

Suddenly, my bedroom door whips open, sending a *whoosh* of cool air over us. "What the hell are you two doing in here!" Jeff yells, then notices our mountain. "Jesus Christ! Your mom is gonna be home soon. You better get this shit picked up before she gets here!" He slams my door and stomps to his bedroom at the other end of the house.

Standing on top of the heap and holding my teddy bear over my head, I proclaim, "I'm King of the Mountain, and he's not my dad! We don't have to listen to him!" To make it official, I toss an armful of clothes in the air that come down like confetti.

"You've got to be kidding me!" Mom says, seeing my room. "Clean it up, now!" She slams my door.

When Mom opens my door again, she slaps a magazine on top of my dresser. "When this room is spotless, you girls can look at this." The door shuts, and she and Jeff laugh on the other side.

Jennifer scrambles over the clothes and grabs the magazine. "*Playgirl?*" She flips it open—"OH MY GOD!" She screams and chucks the magazine at me like we're playing hot potato.

I pick it up. "What's in it?"

"Don't look at it!" Jennifer squeezes her eyes closed. "They're naked!"

I flip through a few pages and see a man wearing only a hard hat and a tool belt. He's resting on a few pieces of wood he's using to build a house.

"*Ewww!*" I squish up my face like I just ate liver and show Jennifer the picture. "His weenie is all flopsy-mopsy." I toss the magazine at her. "I don't wanna look at it."

Jennifer doesn't catch the *Playgirl* because she's zipping around my room, stuffing clothes and toys under my bed and in my closet.

"You look like the Tasmanian Devil from Bugs Bunny!" I laugh and pick up some toys to help. Sweaty and satisfied with her prize, Jennifer studies the glossy pages of my mom's dirty magazine like Mrs. Jones is gonna give us a test on it.

JENNIFER ALWAYS LIKES HELPING ME with my chores now because she's hoping for another magazine. When she comes over to help me do the dishes before my mom gets home, we have to hurry because we also want to play in the bathtub.

"What if we do the dishes while we take a bath?" I suggest.

"You mean do the dishes *in* the tub with us?" Jennifer asks, making sure she understands.

"No, that's gross!" I say, piling dirty plates in my arms. "We'll wash them in the toilet because that water is clean."

"*Ohhh.*" She grabs some bowls and silverware. "Good idea!"

I stack plates up to the toilet bowl rim, drip blue dish soap on the pile, and flush. "Abracadabra! Clean dishes, ladies and gentlemen!"

Deciding three flushes gets the dishes sparkly clean, I lay the first load on a bath towel to dry and put in another, while Jennifer makes us a bubble bath with the dish soap. We strip off our clothes and hop in, drawing pictures on each other's backs with soap and taking turns to reach over and flush the toilet.

At dinner, Mom is impressed. "The house looks great, Bridey."

"Thanks. Jennifer helped." We giggle, looking down at our plates—not because we've done anything wrong, but because we got away with playing *while* cleaning.

Jennifer can't hold in our great idea any longer and blurts out, "We took a bath and washed the dishes—AT THE SAME TIME!"

Jeff drops his fork on his plate. "What did you say?"

She repeats herself slowly because she knows Jeff isn't that smart. "We *washed* the dishes *while* we took a *bath*."

"You washed the dishes in the tub?" Jeff asks, proving how dumb he is.

"Oh, no!' Jennifer shakes her head. "That would be gross! In the toilet because the water's cleaner." She and I smile at each other, waiting for Jeff and my mom to tell us we're geniuses.

"Jesus Christ!" Mom says, grabbing our plates. "You've got to be kidding me, Bridey!" She says to Jennifer, "It's time to go home."

Because I don't know exactly which dishes we washed in the toilet, Jeff makes me wash every plate, bowl, glass, and piece of silverware.

IT'S THE MIDDLE OF SUMMER AND almost my eighth birthday when I catch the worst cold I've ever had in my entire life.

"I'll dump this then leave it in the living room," Mom says, taking away the pan I barfed in. "I made a bed for you out there to sleep in while we're gone."

"Gone?" I ask, confused because it's her day off.

"Jeff has to go to Reno, and I'm going with him."

"You're leaving me all by myself?" I start crying because I can't believe she's not staying to take care of me. "Mommy, please don't go."

"Come on," she says, helping me up. "Let's get you to the living room."

Still crying as she lays me down on the blankets she piled by the door, I whine, "Why can't he go by himself? He's a grown-up."

"*Shhh*, just rest." She sets the phone by my head and wipes my nose with the blanket. "I'll call you later. Here's a pitcher of lemonade. You should try to drink all of it."

I fall asleep without hearing her leave and wake up when it's almost dark outside. The pitcher of lemonade is empty, but I don't remember drinking it. Wondering what time it is, I reach for the phone to call the *POPCORN* number to tell me. Before I can dial, Mom opens the front door.

"Oh, good! You're awake! Look what I brought you," she says, setting a white bunny on my blanket. "His name is Mugsy. Isn't he cute? But he's not like your rabbit pelt, so don't go plucking his fur off."

She laughs, like it's funny that I'm the only second grader I know who still sucks her thumb. "Thanks for Mugsy." I pet his soft fur, wishing I could tell her I would've rather had her stay home than get me a bunny.

I TURN EIGHT AT THE END OF SUMMER, and Mom bakes the same pink elephant cake she did when I turned four at the pink house. Although it's not exactly like my other one, I'm hoping my wish for Jeff to disappear works as well as my Holly Hobbie wish did. Jennifer and I eat half the cake, then go outside to play with Mugsy and his new girlfriend, Loretta, a brown bunny twice his size.

"Chrissy! Her name is Chrissy! That fuckin' punk can't keep it in his pants!" Mom screams inside the house to someone she must be talking to on the phone because no one else is here.

"Sorry," I say to Jennifer. "They've been fighting a lot. Maybe that girl is why."

"It's okay." Jennifer shrugs her shoulders and picks up Loretta. "She's so fat!"

"Too many carrots!" We laugh and chase the bunnies around the yard.

NOT LONG AFTER MY BIRTHDAY, I'M TRYING to finish my chores when Jeff yells from their bedroom. "Hey, Bridey! Come here!"

I hate when he tries to boss me around, so I yell back, "What?" He doesn't answer.

"What do you want?" I shout louder, not caring if I get in trouble because I'd rather pick up Gracie's dog poop than do anything Jeff wants me to.

"I said *come here!*"

Knowing I'm probably busted anyway, I stomp my feet as loud as I can down the hall to their bedroom but stop in the doorway. Jeff is in bed—naked—except for the towel across his waist. His hair is wet. "Yeah?"

"Come here for a minute," he says, in a soft voice I've never heard him use, and reaches for my hand, which is weird because we've never held hands before.

The room feels hot because the sun is shining through the sliding glass door, and it's kinda sticky and sweaty from the shower Jeff must've just taken. "I gotta finish my chores."

"Just come over here."

To show him how annoyed I am, I drag my feet across the carpet and make sure he sees me roll my eyes. "What?" I ask, standing at the side of the bed.

Jeff grabs my hand and slides it under his towel.

"DON'T LEAVE!" MOM SCREAMING OUT in the living room wakes me up. "You can't fucking leave me!"

My bedroom is dark, except for the light from the dry cleaners across the street.

Mom screams again, "Don't you go! Don't you go to her!"

The front door slams, shaking the whole house, and I hear Valerie start up and drive away. I open my door slowly and see my

mom curled up and crying into the couch cushion. I run and put my arms around her. "Mom? It's okay. He's gone."

She sobs, slobbering on my shoulder. "He can't go, Bridey. What am I gonna do without him?"

The front door flies open, and Jeff pulls my mom off the couch by her shirt.

"You're hurting me!" she cries.

I scream, "Leave her alone!"

He gets down in her face and shouts. "Why'd you fucking call her, Frankie?"

"Because I love *youuu*." Mom pulls at his T-shirt.

Jeff shoves her away, and as she stumbles to keep from falling on the carpet, I see his white sneaker kick her in the back—landing her flat on her face in front of my bedroom door.

Scrambling off the couch, I crawl across the floor to her. "*Shhh*, Mom, it's okay. I'm here." Rubbing her back, I scream over my shoulder at Jeff. "Why did you do that to her?"

He laughs at us and leaves.

CHAPTER 8

Cabaret

*M*om puckers her lips and sticks her butt out. "How do they look?"

"Cute, Mom. But do you have to wear my *new* jeans?" I ask, pulling a pair of jeans out of her dresser. "I don't think you're supposed to wear your fourth grader's pants." I hold a pair of hers up. "Can't you wear these?"

Ignoring me, she cranks her head around to check out her butt. "Can you believe they fit!"

I put her pants back in the drawer. "Yeah, Mom, because you don't eat."

"Very funny." She sticks out her tongue. "Brat!"

We're the same height and wear the same size shoes, but she's never been able to wear my clothes until Jeff left her for the cocktail waitress Mom was yelling about to her friend on the phone that day. Since Jeff moved out, Mom drinks most of her meals from a jug labeled *RED WINE*.

Suddenly, I remember another reason why we don't share clothes. "Mom! Take 'em off!" I pull on her back pocket. "You're not wearing underwear!"

"You're such a prude, Bridey. Get over yourself." She scoots by me and goes into the bathroom to dry her hair upside down, like Jeff taught her.

IT'S BEEN A COUPLE OF MONTHS since my mom and I moved into our little yellow house that she bought with money from a car accident she was in and some money from my grandmother. Moving to Osborne Street meant switching schools again, but we're still in Tahoe, so my friends can come over.

"Mom!" I groan. "The rooster's poop is gross! You clean it up, and I'll pick up the bunnies' raisins! And shouldn't KFC be outside in a chicken coop or something? He's too big now to be in the house."

Mom comes out of her bedroom, wearing a tank top but no bottoms. "Are you kidding? The neighbor dogs will get him."

"Mom!" I look away. "Can't you please buy some underwear?"

She blows a raspberry with her lips and strolls slowly past me and into the kitchen. "For God's sake, Bridey, you've seen my crotch plenty of times."

EVEN THOUGH MOM DECORATES every place we live the same way—peacock feathers in a vase, macramé and crystal prisms in the windows, and Maxfield Parrish prints from thrift stores on the walls—every inch of this yellow house feels different to me because it's just the two of us. The smells and sounds are ours—Mom's spicy Tabu perfume in the air and Billie Holiday and Liza Minnelli singing us awake and asleep.

On the days when I come home from school and hear Billie's blues as she asks where her Loverman is, I grab a pot from the kitchen and go right to my mom's room. "Here, in case you puke," I whisper and set the pot on the floor next to her bed. Then I lie down and wrap my arms around her, while she cries and asks questions I don't know how to answer. *Why doesn't Jeff love me, baby? What did I do wrong? When is he coming back, Bright Eyes?*

The best days, though, are when I hear Liza before I even get in the house. I run up the brick path and open the door into the *Cabaret* where Mom and I dance around the living room, belting out every word on the movie's soundtrack. We eat dinner in front

of the TV, then curl up in her bed together—falling asleep without crying or a puke pot on the floor.

One night, Mom accepts Liza's invitation. "I'm going out!" she says, popping her head in my bedroom door. "Don't wait up!"

I watch my mom dab Tabu behind her ears and between her boobs, fluff her blonde perm upside down, and gulp the rest of her red wine from the small jelly jar that is our fanciest glass.

"Don't stay out *all* night because I won't be able to sleep," I say, starting to cry because she's never left me alone at night in this house.

She wraps me in the smell of her perfume. "You're nine now, Bridey, and that's old enough to stay by yourself. Just lock the door, and you'll be fine."

Blowing a kiss as she shuts the door, I know the sweet spell we've been living under the last couple months is over. I turn the lock, flip on all the lights in the house, and go into the kitchen to cook ramen noodles.

The national anthem playing on TV wakes me up on the couch, which means all the TV shows are over for the night. Mom still isn't home. An American flag waves on the screen, then the picture changes to a buzzing-staticky snow that puts me back to sleep.

THE REST OF FOURTH GRADE BECOMES A competition between me and my mom's boyfriends. First prize is her attention. But the game is rigged because no matter how spotless I keep the house, or how many As I get on my report card, Mom chooses them—every time—no matter what.

She names the boyfriends like she does our cars—maybe to be cute or maybe to help us remember them after they're gone: Tommy "Travolta" has black hair and dances with my mom around our living room in his white suit, like the one John Travolta wears in *Saturday Night Fever*; "Marlboro Man" has a thick mustache like the cigarette cowboy and drives a blue Datsun 280Z Mom jokes has "horsepower"; and "Tree Eater" talks to trees when we walk in

the woods and once ate a piece of bark to show us we could if we ever got lost.

I didn't care when Travolta or Marlboro Man disappeared, but when Mom tells me she's breaking up with Tree Eater, I want answers because he's my favorite of them all.

"Too boring?" I repeat what she said about him. "What does that mean?"

"He's just—you know—boring." She shrugs.

"Because we eat dinner at the same time every night?"

"Jesus, Bridey. Give me a break, will ya?" She folds her arms and rolls her eyes.

"But Mom, he's the only boyfriend you've had who made me breakfast before school and helped me with my homework. And what about his puppy?"

"Then you date him."

"I just don't understand. They were all nice, Mom."

She lets out a big breath. "I'm sorry. I really am because you're right. Marlboro Man *was* nice—but maybe *too* nice."

"What about Tommy Travolta? What was wrong with him?"

"Well," she snickers, "Tim was too . . . big."

"Huh? Too big for what? His britches?" I laugh at my own joke.

"Actually," she pauses, "that's exactly what he was. Too *big* for his britches."

She sees I'm not getting it. "Look, Bridey, you're old enough to know how important good sex is in a relationship."

"No, Mom. I'm not old enough, at all." I cover my ears.

"I actually feel bad for the guy. It's not normal."

"Okay, Mom! I get it!" I run to my room and find my Barbie, whispering to her in my sassiest voice, "He's too boring, he's too nice, and you're too stupid!" I fling her across the room, and she lands on a row of rabbit turds.

"GOOD MORNING, STARSHINE!" Mom says, sitting at her sewing machine.

"Mom?" I rub the crust out of the corners of my eyes. "It's so early. Why are you up?"

Her machine whirrs as her foot pushes its pedal, moving the sewing needle up and down. She shouts over the noise. "I haven't been to bed yet, but come see what I made!"

Next to her machine are a few tiny jackets with matching pants. I pick up a purple set. "How cute."

"I made them for your Barbies. Don't you love 'em?"

"You made all these since I went to bed?"

"Yep!" She stands up. "You hungry for breakfast?"

"Breakfast? You never make me breakfast before school."

"Well, today's your lucky day, Bright Eyes!" She slaps my butt.

Mom is at work when I get home from school that afternoon. After my chores and *Spiderman* cartoon, I head into her bedroom to play in her jewelry box. I pull her silver snake bracelet out of one drawer and wrap it around my wrist. From a second drawer, I stack gold rings from my grandmother's jewelry shop on my fingers. In the bottom drawer is a note folded like the ones my friends and I pass at school. When I open it to see who's writing my mom notes, white powder spills off the paper. "Shoot!" I quickly brush it back onto the magazine page, refold the note, and put it back where I found it—next to a rolled-up dollar bill.

"JUSS EAT IT! CHEW IT QUICK!" My puckered smile tries to convince my friend Lulu that Gracie's dog food squishing between her sweaty fingers won't taste gross if she just hurries up.

She sniffs the brownish goop smooshed in her hand. "Bridey, you crazy!"

Because neither of us are girls who would turn down a dare—let alone a double-dare—I stare her down and give her the ultimate challenge: "Lulu, I *double-dog* dare you!"

She stamps her bare feet on the porch and groans. "*Ugh.* Now I haftoo! No fair!"

Scooping up a handful of dry nuggets, I smile. "I secretly double-dog dared myself, too, so we'll do it together!" I glance across our yard to the street. "We gotta hurry, though, because my mom's gonna be home soon, and we still hafta make her poster!"

"Okay! Okay!" Lulu shouts, sealing the dare.

We count together, "One, two, three, go!" and shove the dog food into our mouths—immediately spitting it out all over the porch and running inside to rinse out our mouths.

"Hey, Lulu! Let's go spy on the boy next door! He's going into fifth grade like us, but he's only here on vacation, so we gotta do it now before he leaves."

"Is he cute?" she asks with her hand on her hip and her head cocked to the side, like she's only gonna go with me if he is.

"Yes! Very!" I raise my eyebrows up and down a bunch of times and giggle.

"Does he like you?"

"I dunno." I turn back toward my house. "Wanna make prank calls instead?" I don't tell Lulu the boy and I played doctor a couple times because she might think it's weird.

Lulu dials "O" and holds the phone up between us.

"Hello, you've reached the Operator," says a woman who sounds like she's pinching her nose.

Lulu talks fast. "Is your refrigerator running? Then you better go catch it!" She slams the phone down, and we both fall over laughing—until the phone rings.

"Hello?" I answer, thinking it might be my mom.

"Young lady, the phone is not a toy. You called the Operator, and this line is for real questions and emergencies only. Let me speak to your parents."

"They're not home—I'm sorry—we'll never prank you again!" I say as quick as I can, then hang up and smother the phone with a couch cushion. Lulu and I laugh so hard I can barely breathe. "I have to pee!"

In the bathroom mirror, I stare at the perm Mom gave me after cutting my hair into a mullet she swore was cool but makes me look

like a stupid poodle. I'm tempted to find the scissors and cut it off before she gets home. Patting down the curls, my finger dips into a pool of wetness on top of my head. "*Ewww!*" I wipe the oil on my shorts. Running my head under the faucet, I can't remember the last time I showered.

I head to the living room with paper and crayons. "We gotta finish the poster! It's almost five, and that's when she said she'd be home!"

"How long she been gone?" Lulu asks, taping the paper together until it's as long as our living room window.

"A few days." I start outlining letters. "We gotta make 'em big, so she can read the words from the street."

"Well, she's gonna like our sign," Lulu says, coloring. A few minutes before five, we hang the poster under the window, then practice the cheer we made up for my mom. "Wel-come home! Wel-come home! Wel-come home!"

Lulu spots the big yellow taxi coming around the corner. "There she is!"

Too excited to be home, Mom doesn't even wait for the cab to stop before opening the door. As she runs toward the house, I open my arms for the biggest hug because I know she's missed me, too.

But she runs right past me and rips down our sign, crumpling it up and throwing it at my feet. "I can't believe you girls did this!"

Frozen, except for my quivering chin, I whisper, "Mom, we thought you'd like it."

"Like it?" She throws her hands in the air. "Are you fucking kidding me, Bridey?"

She goes in the house, slamming the front door behind her. "We're moving back to Juneau. Pack your shit."

Confused but knowing I can't ask her questions right now, I see Lulu turning the corner on her bike to go home. I sit down on the grass and smooth out the sign—still thinking it was nice of us to make it: WELCOME HOME FROM JAIL, MOM!

CHAPTER 9

Meeting the Monster

Juneau, Alaska 1981

"You didn't bring much," Grandmother says, stacking my shirts into my uncle's closet.

"Mom didn't say how long we'd be here." I look over at Gracie curled up on the bed of blankets I made under the window. "It was nice of Uncle Killian to share his room with us."

"Juneau is your home, baby. You and Gracie can stay at Grandmother's as long as you want—which might be a while because your mom needs to pull it together." She raises her eyebrows like *pull it together* is the nicest thing she can say about her daughter right now. "Let's get you some food."

My grandmother lives a fancy life in a fancy condo, and except for making pecan pie on Thanksgiving and fudge on Christmas, I've never seen her cook. Dinner is takeout she gets on her way home from the jewelry store or the flower shop she owns, but her kitchen is full of food because my uncles are still in high school and eat a ton. She points her cigarette. "Get whatever you want."

Her pantry has all the food from the commercials—Twinkies, Oreos, and Kraft Macaroni and Cheese—unlike our cabinets that

are filled with generic food that has yellow labels with black lettering: Peanut Butter, Grape Jelly, and Red Wine.

I grab the Skippy peanut butter and hear myself say, "*Ooohhh . . .*" as it spreads like melted butter across the bright white Wonder Bread, unlike the chunky stuff we buy that rips holes in the bread, forcing me to roll the slice into a ball I choke on when it gets stuck in my throat and has to be soaked with whole milk to get it all the way down.

Mom comes back to the condo the next morning but is barely through the door when she starts yelling, finishing the fight she and Grandmother must've started yesterday. "I'm always gonna be a disappointment to you, aren't I? But Lynne can do no wrong. Isn't that right?"

In the kitchen, my grandmother refills her coffee cup, permanently stained on the rim with her red lipstick. "Fran, I love you and your sister the same. You've just made your life harder." She takes a drink and reaches for her pack of Virginia Slims. "I'm wondering when you're going to learn your lesson?" Dropping my Pop Tart in the toaster, I pretend not to listen but kind of like hearing my mom getting in trouble for once.

"Learn my fucking lesson?" Mom walks toward the kitchen. "What lesson? That I shouldn't have left this town? Shouldn't have made a life for myself that doesn't involve you?"

Grandmother takes a drag of her long, skinny cigarette and looks around her condo. "Well, you're not exactly out of Juneau now, are you?"

Mom throws her hands in the air. "Jesus Christ! You can't give me a break, can you? I bought a house in Tahoe, didn't I?"

"Yes, you did." Grandmother sips her coffee. "With my help."

"It's my goddamn house!" Mom yells, starting to cry. "But you're gonna hold the money you gave me over my head for-fucking-ever, aren't you?" She points around the room. "You give your boys everything! But you never did anything for me and Lynne—except leave us!"

My Pop Tart pops, but I leave it because I'm trying to stay invisible, so I don't get sent upstairs and miss out on this fight. Grandmother sniffs the air. "Have you been drinking, Francis? It's a little early, even for you, isn't it?"

Mom clenches her fists and starts shaking, like she's either gonna hit my grandmother or have a tantrum. "*Fuckkk!* Why did I come back? Don't I get any credit?" She points at me. "At least I did that right—and all on my own! Can't even take a break and send her to her dad because the son-of-a-bitch won't pay his child support. But you don't give a rat's ass about that, do you?"

Grandmother smooshes her cigarette in an ashtray next to the sink. "Are you about done? I need to get ready for work."

"Yes." Mom picks up her purse. "I'm very done. Fuck you, very much." She kisses me on top of the head. "Sorry, baby, but Mama can't stay here. I'll come back when she's gone."

She slams the front door and yells, "*Fuckkk!*" again outside.

ASLEEP ON MY GRANDMOTHER'S COUCH, I'm woken up by a man rubbing himself across the back of my jeans. His weight pushes me into the cushion, but I'm too scared to move or to try to see who's on top of me. The kitchen light is on, but nobody else is home because they all went out for the night. The guy stinks like beer. I pretend I'm waking up and yawn loudly.

"Oh, shit!" he shouts and scrambles to get off me and the couch. It's not my uncle's voice, but I'm still not sure who it is. I wish my grandmother would come home.

I roll halfway over to see his face, but he's looking in the fridge. He turns around.

"Stevie?" I call out, not knowing if I should but not sure what else to do. My uncle Killian's best friend squints under the kitchen light, like it's hard to see me.

"Uh, yeah? Who are you?"

What a faker. You've known me my whole life, Stevie.

"It's Bridey," I answer, surprised at how grown-up I sound.

"Bridey?" He fumbles his leftovers. "Oh, wow. I thought you were Kill's girlfriend."

Liar—and gross because you'd do that to your best friend. "No, it's me."

Stevie keeps his head down, mumbling as he walks out of the kitchen. "*Ummm,* sorry 'bout that. I drank too much tonight. I'm gonna go . . . to bed."

Grandmother's steps have no back and look like they're floating. I watch Stevie's socks taking the stairs two at a time. The clock on the wall says it's almost three in the morning, but Grandmother and her sister, my aunt June, were all dolled up in matching mink coats and red lipstick when they left and didn't say when they'd be back. I crawl down on the floor and lie with Gracie, figuring I'll hear them when they get home. They're both gonna be really mad when I tell them what Stevie did.

Grandmother and Aunt June come in, screaming.

"Goddamnit, June!"

"Kiss my ass, Martha!"

They don't notice I'm on the floor when my grandmother smacks her sister across the face. "I've had it with you! You need to leave tomorrow!"

They're drunk, but they're also best friends, so I know everything will be okay in the morning, but I decide I'd rather tell my mom about Stevie the next time I see her—whenever that is.

"BRIGHT EYES! I'M HERE!" MOM SHOUTS up the stairs, waking me up.

Letting Grandmother sleep, I slip out of her bed and tiptoe across her bedroom. Racing down the stairs, I whisper-yell to my mom, "I have to tell you how brave I was last night!" Taking a few more steps, I skid to a stop on the linoleum because there's a strange man sitting at the kitchen counter—a mop of black, curly hair hunched over a coffee cup.

"Bright Eyes, this is Al. Say hello."

"Hi," I spit out quickly, wondering who he is.

Al looks up—his black hair falls back enough for me to see glasses that are way too big for his face. He doesn't smile, but his mouth moves—maybe saying hi or telling me what he's doing here. I can't hear him, though, because the skull-shaped rings on his fingers and giant knife on his belt are screaming at me.

Mom rubs his shoulder and laughs. So that's where she's been? With him.

Grandmother is coming down the stairs, and I run to warn her about Mom's ugly, new boyfriend. Meeting her at the bottom step, I wrap my arms around her silk robe and breathe in the Giorgio perfume she always wears.

"Hey, Brid." She pats my head. "I saw you slept with Grandmother. You okay?"

"Yeah." I smile, tipping my head toward the kitchen. "Mom's back."

Grandmother shakes her head.

"Can I watch cartoons?" I ask, not wanting to miss whatever is about to happen between her and my mom.

"Of course."

Ignoring Mom and her boyfriend because Grandmother is in charge now, I turn on the TV—keeping the sound down because the show in the kitchen is what I'm actually gonna watch.

"Good morning, Francis. Glad you could finally make an appearance." Grandmother lights a skinny cigarette and points with it. "Which one is this?"

"This is Al." My mom puts her hand on his back. She's biting the inside of her cheek, which tells me she's nervous. "Al, this is my mother, Martha."

Al mumbles something I can't hear, and Grandmother drops her head and looks over her glasses at him. "Nice to meet you, Al." She turns to Mom. "You moving in with him, Fran?"

"It's not like I can stay here."

"Well, that's not true." Grandmother takes a puff off her cigarette. "Anyway, you can go, but you're not taking Bridey. You've dragged that little girl around enough."

"She's my kid, and I'll say where she goes!" Mom grabs her purse and steps toward me but stops. "I'll let you stay here for now because Al's apartment only has one bedroom, but I'm your mom, not her. When it's time to leave, I don't want any shit. Got it?"

I nod yes but mean no because there's no way I'm living with that guy. Without saying goodbye, Mom follows Al to the door, practically stepping on his heels like Gracie does when she's excited that I'm taking her for a walk.

WHEN MOM SHOWS UP A FEW DAYS later, without Al, I'm hoping they broke up.

"Pack for the night," she says. "You're coming with me to Al's."

"Do I have to?"

"Yes."

"What am I supposed to do there?" I whine.

"Quit your pouting. You look like your father."

"Good," I mumble under my breath.

"Cut the shit and get your stuff."

Al's upstairs apartment is cold and stinks like Gracie when she comes in wet from the rain. Mom points across the tiny living room. "There's a TV. Just mess with the rabbit ears until you find the channel."

"Find *the* channel? He only gets one?" I ask like a kid who's had cable television her whole life and not just for the past few weeks at the condo. Mom doesn't hear me because she's already in Al's bedroom. "Thanks a lot," I whisper toward his door.

With nothing to watch, except the news, I holler, "Mom! Are we eating dinner here?"

She opens his door. "Al says the TV is too loud. Turn it down."

"Turn it down?" I look at the black screen. "It's already off. And what about dinner?"

"There's leftovers in the fridge."

Not wanting to eat food Al might've touched, I decide to starve. His apartment is on the second story, so I check the street for kids playing because it's summer and still light outside, even

though it's way past dinnertime. "Mom?" I knock on the bedroom door. "I'm bored."

She sticks her head out. "Go outside and play."

"There aren't any kids here."

She blows out all her breath, obviously annoyed, and points to Al's records. "Play some music. Just keep it down."

"Can I please call Grandmother to come get me?"

"No." She shuts the door.

I plop down on the carpet, feeling like I'm about to cry because I'm cold and hungry. Pulling a stack of records out of a wooden crate, I fling a couple across the carpet like I'm skipping rocks. An album with cowboys riding little motorcycles on the cover catches my eye. The band is called Showdown, and the album is *Welcome to the Rodeo*. I put it on the record player and lower the needle.

"*Well, it's forty below and I don't give a fuck—*" a man sings quickly, like a guy who sells stuff at auctions.

"Shoot!" I whip the needle off the record—probably scratching it—and giggle about the cussing. I peek over my shoulder to see if Mom heard, but the door is still shut, so the coast is clear. I turn the volume all the way down and scoot as close as I can to the speaker—keeping my hand over the needle in case my mom comes out.

"*You piss me off—you fucking jerk—get on my nerves!*"

I pull my sweatshirt up over my face to keep my mom from hearing me laugh.

"*Well, here comes Johnny with his pecker in his hand, he's a one-ball man and he's off to the rodeo—*"

I play "The Rodeo Song" over and over, singing along until I know every word by heart. Deciding the spanking I'm gonna get is worth it, I crank up the volume and belt out the greatest line in the greatest song I've ever heard: "*You piss me off—you fucking jerk—get on my nerves!*"

Mom whips open the bedroom door—hands on her hips. "What the hell are you doing out here?"

I point at the record player, pretending to be confused about why she's mad. "Just listening to music like you told me to."

She hears the singer finish the song, and I can't stop myself from giggling. "*You piss me off—you fucking jerk—get on my nerves!*"

Mom doesn't laugh. "You're cruisin' for a bruisin'. Knock it off and go to bed."

Proud of myself for annoying her because she does it to me all the time, I don't even care that I'm starving to death as I lie down on Al's smelly couch and pull the scratchy blanket over my head to block out the sun that's still up, even though it's probably midnight. Of course, I whisper-sing myself to sleep. "*You piss me off—you fucking jerk—get on my nerves!*"

IT'S A FEW DAYS AFTER MOM'S THIRTIETH birthday when she shows up to Grandmother's condo.

Before I can tell her how much I love my fifth-grade teacher, and that I'm gonna be a cheerleader for Halloween, she announces on her way up the stairs, "Tell your teacher tomorrow is your last day!"

"What?" I shout. "I don't wanna go! I like it here!" I close my math workbook and run after her. "I have Mrs. Orbin and everything!"

My grandmother hired Mrs. Orbin to watch me after school. She's the kind of grandma who bakes cookies, makes homemade soup, and watches *Ripley's Believe It or Not* with me while I finish my homework.

My mom is in Uncle Killian's room, packing. "I love Mrs. Orbin, too. She watched me and your Auntie Lynne when we were little," Mom says and throws me a black trash bag. "Put your clothes in there that you can't fit in your suitcase."

Even though I'm crying, I know my mom's mind is made up, so I start stuffing my clothes in the garbage bag. "Is Al coming?"

My mom glares at me. "Of course, he's coming."

"Mom, why? He doesn't even like me."

"Oh, knock it off, Bridey. You two will be fine when you get to know each other."

BECAUSE I'M PRETTY SURE WE'LL COME back to Juneau at some point, I ask my uncle to help me bake cupcakes for my class because maybe then they'll remember me, and I won't be the "new girl" next time. When the meanest boy in the fifth grade hates my cupcake and pitches it at my face—sticking it to my cheek—the whole class laughs. One by one, they toss their cupcakes in the trash, along with the goodbye notes I wrote to each of them.

After school, I walk in the door, ready to tell my mom what happened, but she looks too sad. "I have to tell you something." She pats the couch next to her. "Come sit."

"What is it?" I ask, hoping Al changed his mind and isn't coming.

"Oh, baby, I don't know how to say this." Mom takes my hand, and tears slip down her cheeks. "We have to put Gracie down."

"What? No, Mommy. Please, no." I start crying.

"I know," she says, rubbing my back, "but, she's too old to make the trip. Do you know how old Great Gracie Graffiti is in dog years? She's older than Mrs. Orbin!" Mom tries to laugh.

"Too old to sit on the ferry?" I pull away from her. "It's not like Gracie has to *run* to Tahoe."

"You're right, but there's no room in Al's truck for her to sleep. Al says—"

"I knew it!" I run to the bathroom and lock the door, yelling, "You're letting him take my sister! You can go, but I'm staying because then Gracie doesn't have to get killed!"

AFTER THREE NIGHTS OF HIDING IN THE ferry's movie theater to avoid sleeping next to Mom and Al on the solarium with the other passengers who can't afford a room and have to sleep outside, we dock near Seattle. I know my real dad lives here somewhere, but Mom doesn't say anything about me seeing him, so I don't ask.

Al's brown truck is full of trash bags stuffed under our feet, behind the seat, and packed all around his black Harley-Davidson in the back. "Look," I whisper to my mom and lift up my sneakers. "Gracie woulda fit perfectly right there."

"That's enough," she says, giving me the stink eye.

Al mumbles something to my mom that I can't hear over the truck's engine, but I don't care because he never talks to me anyway. I watch the trees pass the way I did when we drove this same freeway with Jeff and hope my friends in Tahoe still remember me.

Mom flinches next to me. "Oh! You scared me," she says to Al who reached across her to get something out of the glove box. Her fake laugh tells me she's nervous. She starts picking her cuticles, which are as bloody as mine, because we both bite our nails all the way down.

"Here." I hold her hands. "Now we can't bite our nails."

A few hours later, we pull into a dirt driveway in front of a small white house with busted bikes and rusted cars in the yard. I tug Mom's sweatshirt. "Where are we?"

"Al's friend's house."

"Can I please wait in the car?"

"No." She grabs her purse and scoots me out of the truck. "Come inside and be polite."

Following her heels up the dirt path, I look up just enough to see that the front and sides of the house are covered in moss and mud, making it look like it's either sinking into the ground or being swallowed by it. Walking into the house, we practically have to duck to avoid getting yellow fly strips hanging from the ceiling caught in our hair.

"Mom?" I nudge her side, wanting to show her the piles of stuck flies. She shushes me and walks over to talk to an old woman in the kitchen.

"Sit there, and we'll be back in a bit." Mom points to an orange couch wrapped in plastic.

"Mom, please don't leave me by myself," I whisper, nodding to the woman at the stove who still hasn't said hi to me.

"Cut the crap and sit." She disappears down the hall with Al.

Wearing only shorts and a T-shirt, my bare skin sticks to the plastic. Watching fly parts floating in the air, I make a game

out of sticking and unsticking my arms and thighs, wincing from the burn each time my skin peels off the plastic. Mom still hasn't come out of the bedroom, and my eyes want to close because I'm sleepy and hungry, but there's no way I can fall asleep with the woman watching from the kitchen. I count dead flies on the strips to stay awake.

Mom shakes my shoulder, waking me up. "Come on, baby. Let's get you to bed."

I peel off my cheek glued to the plastic with drool. "Where are we, Mommy?" Of course, I know where we are but figure if I act like a little kid, she'll act like a mom. I'm too tall to carry, so I pretend to be sleepier than I am and lean against her, forcing her to hold me up the way I do when she's too drunk to get herself to bed.

She steers me into a dark bedroom. "Here you go," she whispers, covering me with a blanket on the floor.

"Mommy, the blanket is scratchy."

"You'll be asleep soon, and it won't matter." She tucks it under my chin.

"I'm hungry."

She kisses me on the lips. "We'll eat a big breakfast in the morning. Sweet dreams."

The door closes, and my eyes open. I sit up and see shelves lined with wide-eyed porcelain dolls wearing lacy hats and fancy dresses that look yellow from the glow of the streetlight outside. Throwing off the itchy blanket, I hit the table next to me, knocking over a tiny glass figurine shaped like an open book. Holding it up to the light, I see gold writing on it:

Now I lay me down to sleep,
I pray thy Lord my soul to keep.
If I should die before I wake,
I pray thy Lord my soul to take.
 ~Amen.

I read the prayer a few times trying to figure out what it means. *Am I asking to die in my sleep? Am I saying I know I'll die in my sleep?* Covering myself back up with the scratchy blanket, I hold the glass book against my chest. Admiring one of the doll's long eyelashes and curled hair, I think about how I'd like a doll like that.

Reading the prayer again, I suddenly think about dying— wondering where I'll go and how it's possible for me to just be gone. I close my eyes and see outer space—stars and planets—and I'm flying around them, but I'm scared because it's dark and cold in space. And I'm all alone.

My heart is beating too fast. I open my eyes and sit up, breathing in and out as slowly as I can to calm myself down. I want my mom.

Nothing about moving to Tahoe with Al feels right. I don't know why we're taking him to our yellow house where we dance and sing at the top of our lungs because I doubt he's gonna let us do that. I read the last line on the glass book again—*If I should die before I wake, I pray thy Lord my soul to take*—and decide I better memorize the whole thing and say it every night before bed to make sure God knows to take me if something bad happens.

I also convince myself that if I don't say it, I'll die in my sleep.

CHAPTER 10

Learning to Fly

Lake Tahoe 1981

The next evening—after another day of Al not speaking to me—we round the corner of Echo Summit and see the same postcard view of Lake Tahoe we did when we moved here with Jeff.

Mom bursts into tears. "Look! It's our lake!"

Annoyed she's pretending we've been gone forever, I remind her it's only been a few months then look over at Al, staring at the road like he's afraid to look at the pretty view because it might crack a smile in his ugly face.

My chest suddenly feels like someone is hugging me too tight. I roll down the window to get some air.

"What the hell are you doing?" Al hollers, swatting his long black curls out of his eyes. "You tryin' to make me run us off the road? Shut the goddamn window!"

Al speaking directly to me squeezes my chest even tighter, making it hard to breathe. Like a fish out of water, I open my mouth wide and suck in all the air I can.

"Jesus! What's wrong with you?" Mom shoves my arm, and I point to the window. "Oh, for God's sake, you're so dramatic!" She reaches across me and rolls it down, saying to Al, "Hold your hair back for a second because Bridey thinks she's dying."

I stick my head out the window, like Gracie used to on car rides, and let the air rush down my throat. Mom tugs on my arm, and I swing my head back inside the cab.

"What's going on?" She rolls up the window.

"Trying—to—breathe." I pant—again, like Gracie.

She rolls her eyes and shakes her head.

We pull up to our sweet yellow house on Osborne Street. The Thompsons, grandparents who own the rock shop next door, wave hello from their yard, and Candy, a divorced mom with two little girls, waves from her kitchen window across the street.

Mom waves to them as I run to give hugs. Al only cares about unpacking his Harley and tosses garbage bags full of our clothes onto the dirt before rolling his stupid bike down a wooden ramp. He revs the engine, which forces everyone to cover our ears—except Mom—as the motorcycle spits out a cloud of stinky gas and hums POTATO, POTATO, POTATO. Al gets on his Harley—that's way too big for his short, skinny body to hold up—and rides it down the brick path Mom and I laid last summer before we left for Juneau, up another wood plank, and right into our living room.

Embarrassed, I grab a couple garbage bags and ask, "Why can't he park it outside like a normal person?"

Mom snickers. "He's a biker, and that motorcycle is his baby—just like you're mine!" She blows me a kiss and practically skips up the path and into our yellow house that I know will never smell or sound like us again.

Because we left for Juneau in a hurry, the house is dusty but already unpacked: peacock feathers in their vase, scarves draped over the lamps, and the macramé Honey made us is hanging in the widow—although the plants in it are dead.

We've been home for a couple weeks, and even though Mom said things would get better once Al and I got to know each other, he still only talks to me through her. "Bridey watches too much fuckin' TV. Tell her to go outside."

Mom tips her head and motions with her eyes to the front yard. Al thinks he's bossing me around, but the joke is on him because I'd rather be outside where I can't smell the motorcycle parked behind the couch. From the yard, I see Al standing in the living room window, holding a can of Dr Pepper that he drinks like an alcoholic. I figure he's waiting for me to do something wrong so he can have Mom yell at me but then realize he's looking past me, like he's watching for someone to come down Osborne Street.

When Al finally lets me come back in the house, his voice stops me before I get too far. "Go do the dishes."

Al talking directly to me scares the crap out of me, and I'm not sure what to do or say. I give him a half smile and back away slowly into the kitchen. Clanging pots and pans to sound busy, I wash dishes and stare out the window over the sink at the dead yellow Datsun in our backyard where Heather and I used to sleep on its roof and pretend we were at the drive-in. I miss my friends coming over, but I'd never let them now that Al lives here.

"You's a good little nigra doin' all them chores, aren't ya?" Al says behind me, and I jump—dropping the bowl I'm washing but, luckily, not breaking it. Feeling like all the air is gone around me, I suck in a long, deep breath. Al laughs—happy he scared me—as I hold my breath until his boots stomp out of the kitchen. Exhale.

In bed that night, I think about how my mom would smack my mouth if I talked like Al. I don't understand why she's with him in the first place. I decide to say the prayer two times tonight. *Now I lay me down to sleep, I pray thy Lord my soul to keep. If I should die before I wake, I pray thy Lord my soul to take. Now I lay me down to sleep, I pray thy Lord my soul to keep. If I should die before I wake, I pray thy Lord my soul to take.*

"WATCH YOUR FUCKIN' MOUTH!" Al shouts outside my bedroom, waking me up.

I hop out of bed and press my ear against the door to hear, but it's quiet. I crack it a tiny bit and see Al smack my mom across the face. She whimpers like Gracie did once when I accidentally stepped on her tail.

"Mom!" I throw open my door.

"No, Bridey! Close it! Now!" she shouts.

Al grabs her arm, and I scream, "Stop, you're hurting her!"

He pulls her toward their bedroom—only a couple feet from mine—and she cries to me, "Please, baby, stay in your room."

Their door slams, and I climb on my bed to listen through the wall in case she needs me. I nearly fall asleep waiting—then hear them doing *it*.

Burying myself under my covers and piling all my pillows on my head to block out the hurting noises she's making, I pound the mattress with my fists and cry loud so she hears—"Stupid! Stupid! Stupid! Stupid!" Tossing and turning, I again pray myself all the way to sleep. *Now I lay me down to sleep, I pray thy Lord my soul to keep. If I should die before I wake, I pray thy Lord my soul to take. Now I lay me down to sleep, I pray thy Lord my soul to keep. If I should die before I wake, I pray thy Lord my soul to take . . .*

I don't know what to say in the morning, so I keep quiet—except for my weird breathing that's starting to sound like I have asthma—and get myself ready for school. Al is at his truck when I leave for the bus stop, but we ignore each other.

Deciding when we're allowed to sit, sleep, and breathe, it's crystal clear that Al owns our house now. Proving he owns us, too, he starts calling me by a slave name he heard on TV: "Kunta Kinte, get me a Dr Pepper!" or shortened, "Kunta, go get some firewood!"

We get a couple days off from school for Thanksgiving, but Al decides I've had enough of a vacation and kicks open my bedroom door. "You know you're not supposed to have this shut," he says like

it's a rule I'm supposed to know, but he just made it up. He spins the thick, silver rings around each of his fingers. "There's brushes and paint on the porch. Go cover the yellow."

"But it's freezing outside," I say, quickly wishing I hadn't because even though Al has never laid a finger on me, it doesn't mean he won't.

"Guess you better put on a coat." He laughs.

In the side yard, I cry and open the paint can with a screwdriver. Although the label reads BRICK RED, it should be called DRIED BLOOD. Gross.

Nikki, a sixth grader who's a year older than me, is the only friend I let come over because her dad—also named Al—is friends with the monster in my house and almost as mean.

Because Nikki understands what it's like to live with a monster, I'm not embarrassed when she sees the motorcycle in my living room or the holes in our doors. She and I do our chores together, secretly playing while getting them done. After cleaning my house, we run down the street to clean hers—which includes five hundred sit-ups because her dad thinks she's chubby and building a fire in their woodstove to fry a steak he'll eat after work.

"Maybe they'll crash on their motorcycles!" I laugh, while folding her dad's shirts.

"Yeah!" she cheers. "Right into each other!"

We clap, celebrating their horrific deaths, then make up a dance to "Abracadabra" by the Steve Miller Band—but change the lyrics to "reach out and stab ya" as a dedication to our monsters.

By Christmas, Al doesn't bother taking Mom into their bedroom to hit her. He smacks her whenever he feels like it, and although he still has never hit me, he might as well because I feel everything my mom does.

I've started dreaming about flying, and it's always the same: I'm sitting in a rowing machine—something I've only seen on TV—and pushing back with my legs while pulling two metal bars against

my chest. This pumping motion fills my body with air until I float up to the ceiling like Violet Beauregarde when she gets turned into a giant blueberry in *Willy Wonka*. I drift through our roof and outside where I can see our entire neighborhood. My arms outstretched, I fly up and over the houses, dipping down into yards then zipping up, high into the sky. With every dream, my flying gets better—dodging cars and telephone poles—until I fall toward the ground, jolting myself awake. My prayer puts me back to sleep. *Now I lay me down to sleep, I pray thy Lord my soul to keep.*

Mom whacking my arm every time I do the deep asthma-breathing finally works because one day it stops, and I can breathe just fine. Unfortunately, my body comes up with a new way to irritate my mom and decides to stop speaking—at least at home.

Please.
No.
Do I have to?

"What are you doing?" Mom asks, seeing my right hand twirling in the air in front of us.

My hand answers her—*Writing.*

She squints, trying to see what it is. "I don't get it."

My hand answers, again—*Sorry.*

She swats my arm down. "Go do the dishes. You're being weird."

I want to tell her she's right—I am weird, and that it's all her fault.

THE WHIRRING OF MOM'S SEWING machine wakes me up for school.

"More Barbie clothes?" I joke, walking into the living room.

"No, smart-ass." She cuts off a piece of thread. "It's a new bedspread and matching pillows for you!" She flips over the blue material. "See the forget-me-nots? That's the Alaska state flower."

"It's pretty, Mom. It took you all night, though? Aren't you tired?"

"Not really. You want breakfast?"

"No, but thank you for the bedding. I love it." I kiss her cheek and notice a couple of tiny white pills next to her sewing machine that I figure are baby aspirin.

MOM AND AL ARE GONE WHEN I GET home from school. Even though he made up *another rule* that their bedroom is off-limits, this is *our* house, not his, and I'm sick of him telling me what to do. Not wanting to sit on their bed where they do gross stuff, I stay standing and open the drawers of Mom's jewelry box. Pushing aside little red pills and tiny white ones, like I saw this morning, I wrap my favorite snake bracelet up my arm. From another drawer, I pick up a small piece of white plastic shaped like a squiggly line that kind of looks like a toy from a cereal box.

"Hey! You know you're not supposed to be in here!" Mom shouts, scaring the crap out of me. I drop the toy as she waves me out of their room. "Come on, before Al catches you."

I pick up the plastic toy. "Mom, what's this?"

She snatches it out of my hand. "Put that back! That's my IUD!"

"What's an IUD?"

"It's for birth control." She sets it in the drawer next to another plastic toy shaped like an arrow.

"Is that one, too?"

"What are you, a detective?" She shoos me out of her room.

"How does an IUD work if it's in your jewelry box?"

"Go!" she yells and shuts the door on me.

"Why do you let Al be the boss?" I holler.

In my bedroom, I crouch down next to the Barbie Dreamhouse Santa bought me for Christmas. I pick up Barbie and Ken, sitting Barbie on her pink couch and standing Ken under the pink elevator—then dropping it on his head over and over, while singing my favorite song. *"You piss me off—you fuckin' jerk—get on my nerves!"*

"BRIDEY! BABY, HELP ME!"

Scrambling out of bed, I see my mom curled in a ball on the living room carpet, holding her stomach. Before I can get to her, Al stomps out of the kitchen and kicks her.

"Stop!" I run to her as he storms outside, leaving the front door open.

"Mom?" Pushing her blonde curls away from her face, I'm trying not to cry, but tears slip down my cheeks. "I'm here. It's okay."

Al's truck engine rumbles outside, and Mom moans something I can't understand and grabs my arm to help her off the floor.

"Mom? What are you doing?" I cry harder. "Just let him go. Please!"

Al walks back in the house and slams their bedroom door. My mom wrestles out of my grip and pushes me away. "Mom, no! Don't go in there!" I shout. But instead of going to her bedroom, she stumbles out the front door and into the yard. Following, I whisper-shout in the dark, "Where are you going? What are you doing?"

I watch her pick up a long metal bar and get in the back of Al's truck, climbing on top of the cab. Sitting up on her knees, she raises the bar over her head and slams it down on the windshield so hard she almost falls over. Screaming into the night sky, "I hate you!" she bashes the glass again. "I fucking hate *youuu*!"

Al slips past me toward his truck, and I realize I need help. I run inside and dial "O"—pleading and crying to the operator. "Please send the police! My mom's boyfriend is hurting her! Hurry!"

The operator's gentle voice tries to settle me, but she's asking too many questions, and my mom is screaming in the yard. "You have the address! Please hurry!"

I drop the phone without hanging up and feel my whole body lift, like in my flying dream—except I'm not rowing, I'm riding on a strange machine—like a crane a movie director might sit on to be above the actors. Below me, Al has my mom pinned against his truck, smacking her in the face. Watching them from up here, I don't hear anything—except my breath—and I don't feel afraid

anymore. The camera crane sets me down, and I scream behind Al. "Get away! Leave her alone!"

Suddenly, we're surrounded by red, white, and blue flashing lights—also silent.

An officer handcuffs Al and puts him in the back seat of the cop car. *Take him away forever*, I think to myself, pulling my mom's hand toward the house.

She lets go of me.

A second officer asks, "Ma'am, do you want to press charges?"

I watch to see what she says. Although I don't know what pressing charges means, it sounds like she should say yes.

"No." She shakes her head.

The cop stops writing on his notepad and looks at her. "Are you sure? Your daughter called us for help."

"Everything is fine now. Thank you."

Fine? I look her up and down—her ripped shirt and bloody face. *We're not fine!*

The officer opens the back door of his cop car, and Al steps out. I drop my head and stare at my bare feet as his big black boots pass by, crunching the cold ground.

The police turn off their flashing lights and drive away, leaving Mom and I alone in the dark—except for the neighbors' porch lights that are now on. Knowing they probably watched what happened makes me want to cry because we're the scary house now—like the dry cleaners where the mean sisters live.

"Can we just sleep in the truck?" I ask, terrified to go back in the house because Al is probably even madder now that the police came.

Mom's puffy lips make her smile crooked. "Next time, don't call the cops unless I tell you to, okay?"

In bed, I say my prayer under my pillow—although I'm too tired to say the whole thing.

If I should die before I wake, I pray thy Lord my soul to take. Amen.

Girl Stands Still

*N*o one is awake when I get up for school the next morning. Mom's door is closed, and the house is trashed—broken glass on the floor, ripped papers everywhere, and furniture knocked over. I brush my teeth and eat a bowl of Puffed Rice that tastes like nothing, wishing I had actual Rice Krispies like I get at Grandmother's house.

After school, though, I walk into a clean, quiet living room and do a double take because I'm sure I've walked into the wrong house.

Mom comes out of the kitchen. "Did you have a good day at school?" she asks, sounding like a normal mom who checks on her kids.

"Huh?" I look around, confused. Al—who didn't get thrown away with the broken glass and other garbage that was here this morning—is on the couch with his Dr Pepper. "I guess," I answer, not sure what to say because we're obviously not talking about last night.

"Well, I'm cooking ribs for dinner, so get your chores done." Mom prances on her toes to the kitchen, where she hardly ever goes anymore. The last time she cooked, she passed out, leaving the hamburger soaking in its own grease on the stove all night. It took me forever to clean it up because I kept gagging as I scooped the thick layer of orange fat into the trash.

"I'M GOING TO CHURCH," I ANNOUNCE one Sunday, wearing the only dress I own—a lavender and lace one that goes down to my ankles.

"You're going where?" Mom asks, looking disgusted as she pours her coffee.

"Candy invited me to church with her and the girls. Is that okay?" I answer casually, like going to church is something I do all the time and not an idea I just came up with to annoy her.

She looks me up and down. "You want to go to the crazy church with the Bible-beater?"

"Mom, I don't know what that means, but it doesn't sound nice. Why is it a 'crazy church'?"

She raises her eyebrows. "Oh, you'll see. Have fun, but you better not come home talkin' in tongues and shit."

I also don't know what that means, but if Mom doesn't want me to do it, I definitely will.

"DON'T WORRY IF YOU DON'T KNOW the words. They're all in here." Candy hands me a Bible and smiles, looking very happy I'm here.

The small A-frame church is cozy and feels like we're sitting in someone's house, except for the rows of wooden benches facing the front. I've seen church on TV lots of times, but I'm still not sure what to expect, except for maybe some singing, and a man—like the one standing in front of us—talking for a long time.

I don't really get much of what he's saying, but everyone is smiling as they talk back to him and clap a lot. When the singing starts, we all stand, and people wave their hands in the air and dance. A woman moves into the center aisle, flapping her hands and singing at the top of her lungs, although the words she's singing don't sound like any language I've ever heard—like she's babbling stuff she's making up as she goes.

Candy nudges me and says, "That's the Holy Spirit moving through her. Can you feel it?" She smiles, waiting for me to say yes.

Thinking the prayer I say every night is what she means, I start reciting it to her. "Now I lay me down to sleep—"

She giggles sweetly. "You don't have to pray! It's what's coming out of your heart!"

Because I want Candy to be proud of me, I copy what I see everyone doing and roll my tongue around my mouth like it's chasing marbles, then add a little moaning. Candy hugs me. "You got the Holy Spirit in you!"

Although I don't really think I do, at least I get an "A" in pretending to talk in tongues. As soon as I get home, I start babbling and clapping around the house.

"Goddamnit, knock that shit off!" Mom swats my hands. "It's fuckin' creepy!"

"Mom, it's God. I can't just tell him to stop." I purse my lips and shake my head to show her how sad it is that she's such a non-believer then babble my Jesus-gibberish all the way to my bedroom where I dance with Barbie and don't smash Ken with the elevator because I'm in such a good mood.

BANG! WHATEVER JUST SLAMMED INTO the other side of my bedroom wall rattles my metal bed frame, jolting me awake. I don't move—even though I hear Mom's muffled screams through two pillows over my head—because it's hard to tell whether they're "doing it" or fighting.

BANG! Another slam against my wall rocks my bed back and forth, like a boat on a wave. Mom screams a bloodcurdling shriek I've only heard in horror movies. "Help *meee! Hurryyy! Brideee!*"

In the few steps between our bedrooms, the camera crane that lifted me once now swoops me up again—this time to my mom's bedroom ceiling. Below me, I see myself standing in her doorway but don't feel the fear I did just moments ago. The bedroom light is on, and Al has on jeans and his black boots. He's pushing the tip of his gun into the side of her head. Except for her T-shirt, my mom is naked and shivering. "Help *m-m-me*, baby. He's *g-g-going* to *k-k-kill* me!"

Still hovering above the scene, a script lands in my hands with words to say and actions to do to save my mom. Like an actor

whose job it is to read the lines they're given, I speak—unafraid. "Mom, I'm here. It's okay."

Al turns his gun at me. Staring down the barrel, I see two black holes next to Al's two black eyes. He points toward my bedroom with his gun. "Get. Out. Now."

But my script reads, *Girl stands still.* I don't move. "No."

With Al distracted for that split second, Mom slips out of his grip and shoves me out of the doorway, yelling, "Don't you do that to my baby!"

"Mom! Watch out!" I scream, seeing Al behind her.

He slams her against the wall heater outside my bedroom, then holds her by the shoulders and drags her nearly-naked body up and down the heater grates—her bones hit the metal, ringing around us a nightmarish sound like a kid running a little wooden stick over a toy xylophone.

"Leave her alone!" I scream, grabbing at his leather vest. Holding her against the heater with one fist, he slams her in the gut with his other—then lets her go. She drops to the carpet, and I drop with her—pulling her into my lap to cradle her the way I always do. "*Shhh.* It's okay. I'm here," I cry over and over, as we rock together on the floor.

Al's truck revs in the yard then rumbles away until it's quiet, except for my mom moaning, "Don't let him come back, baby. Please. He'll kill us."

TWO MONTHS LATER, SHE CALLS ME to Debbie's house to tell me she's pregnant with Al's baby and asks if I'm ready to be a dad.

I answer, "Yes."

CHAPTER 12

Playing House

"Alright, let's blow this pop stand." Mom whispers because the sun is barely up, and all our neighbors are still asleep. After all the screaming and fighting they had to deal with this past year, I doubt they'll be sad when they figure out we left.

She gently closes the door on our little yellow house that's hidden under the blood-red paint Al forced me to cover it with. Mom and I had spent the summer making it ours again—patching holes we filled with friends' laughter, scrubbing engine oil off the carpet by dancing across it, and bleaching everything to kill the smell of Al.

"Hurry now." Mom waves me off the porch toward the head-lights waiting to take us to the airport. Carrying a suitcase I rushed to pack because she just told me last night we were going to Juneau this morning, I'm still happier than I've ever been to move because even though Al left, he isn't really gone. He drives by our house constantly—staring in our windows until he sees us see him. Even though Mom hides her baby belly under baggy sweatshirts and behind big bags, we're both terrified Al will figure out our secret and force his way back into our lives. That's why we're leaving in secret, and why I couldn't tell anyone—not even my best friend.

Driving away from Osborne Street, we pass Nikki's house. Tears slip down my cheeks, knowing she'll be confused and scared in a couple

hours when she knocks on my door to walk to the bus stop together, and I'm not there. I wanted to call her last night, but Mom said no.

"She won't tell her dad, I promise."

"Baby, I'm sorry, but what if she does? Do you know what Al would do to us?"

"I know, Mom."

"No, you don't. He'd kill us, Bridey. All three of us."

I knew she was right—and I knew how exhausted she was from hiding her belly.

Juneau, Alaska January 16, 1983

"IT'S A GIRL!" AUNTIE LYNNE ANNOUNCES in the hospital waiting room. "You can go meet your sister now," she says, motioning me inside the double doors.

"Congratulations, you're a dad," Mom says softly, pulling the blanket away for me to see the baby. "We're naming her Bephens like we talked about."

"Hi, sister," I whisper because she's sleeping. "I'm so happy to finally meet you."

AFTER LIVING WITH MY AUNTIE LYNNE since we moved back to Juneau in September, the three of us finally get to move into our own place.

Mom tells me, "Grandmother pulled a few strings to move us up the list."

What she means is that Grandmother's new boyfriend—who also happens to be the governor of Alaska—made some phone calls to get us into the new low-income housing project the city just built.

We pull into Coho Park in our rusted-red Volkswagen Bug and see brand new buildings with grassy yards. Mom gushes, "It's beautiful!"

Sitting with Bephens in the back of the Bug because it's missing a passenger seat, I look out the window at all the kids—some running and playing and some dragging black trash bags I'm betting

are full of their clothes and toys. "And it's brand-new? Like nobody has ever lived here before?" I ask.

"Nope, nobody!" She parks in front of the building. "Our townhouse is at the end, next to the forest. Isn't that cool?"

"Townhouse?"

"It's a fancy word for an apartment." Mom winks. "We're fancy now, like Grandmother."

Being careful not to drop Bephens through the hole in the Bug's floor where I can see wet pavement, I hand her car seat to Mom and grab a couple garbage bags. Carrying them down the sidewalk, I notice lots of moms but not one dad. We definitely fit in here.

Mom waves at me from the porch. "Let's walk in together!"

She opens the door, and we both *ooh* and *aah* seeing the spotless tan carpet and bright white walls.

"We should take off our shoes," I say, slipping off my rubber boot and tapping the spongy softness with my sock. "It feels so good!"

Mom takes in a big breath. "And it doesn't smell like a motorcycle, which I know you love." She hugs me then gives me a weird look, like she's trying to remember something. "Shit! Bephens is on top of the car!"

Without stopping to put our shoes back on, we sprint down the puddled sidewalk. Mom grabs the car seat off the roof. "Oh, good. She's asleep."

"Guess we better start remembering there's three of us now."

We shake our heads and huddle with the car seat between us, laughing. It feels like the end of a TV episode when everything that had gone wrong works out perfectly, and the theme song plays while the credits roll.

"Mom, we have stairs!"

"What you've always dreamed of!" she yells from the kitchen.

"Yeah, because everybody on TV has 'em!" I shout back, hopping up each step and announcing the families I dream about being like. "The Brady Bunch . . . the Cunninghams . . . Alex Keaton!"

Standing at the top, I dance and sing the theme song from *The Jeffersons* down to her.

After some unpacking, Mom lets me check out the playground. Spinning themselves dizzy on a shiny merry-go-round that hasn't rusted in the rain yet is a crew of kids in high-water pants who have crooked-tooth, bucked-tooth smiles like mine.

Some of the big kids are giving the little ones underdogs on the swings—whooping and hollering, "Hold on!"

I hop on a plastic dinosaur and rock back and forth—not caring that I'm too tall and probably look silly with my knees sticking out—because it feels too good being a normal eleven-year-old for a few minutes. Looking at the kids around me who are my age, I'm betting they feel the same way. They probably know we all had to be broke to move into Coho Park, but being the first on all these new toys feels like we're the rich kids—the ones who get to play with the Barbies before we buy them from the Salvation Army when they're all chewed up and missing legs.

"Let's go to the grocery store." Mom grabs her purse.

"Do I have to go?"

"It'll be fine. Let's go. I'll even let you pick out the cereal." She laughs because we never get *fun* cereal. It's always the boring kind that tastes like paper because that's what we can afford.

Busy making faces to Bephens, I'm not paying attention as Mom gets to the front of the line—until I hear the grocery clerk practically yelling at her.

"You see? It's right here!" the lady says, much louder and slower than she needs to, then points at the coupon. "You *can* have KIX because it's on the list, but you *can't* have Rice Krispies because it's not."

"Thank you. I can read." Mom hands me the box of Rice Krispies. "Go get the shitty cereal the lady says you're allowed to eat."

I sprint away, pretending not to see the people in line glaring at us because we're making them wait. Going to the grocery store has always sucked because we used food stamps, which means buying

the cheapest food, but the WIC coupons Mom gets now that we have a baby are even worse because we can only get certain brands—and they're all gross. "Here, Mom." I hand her the box of KIX.

The clerk hands her the receipt. "Maybe try knowing the list before you go grocery shopping next time?"

"Maybe try not being a bitch next time." Mom smiles and waves at everyone in line.

COHO PARK FEELS LIKE THE FIRST FEW months Mom and I lived in our yellow house—chatting in the kitchen while we make dinner, dancing around the living room, and falling asleep on our fold-out couch with the TV on and Bephens between us.

But the same way she did in the yellow house when she started dating again, Mom breaks the magic spell of happiness and decides eight weeks is enough time to spend at home with her newborn. She teaches me how to mix Similac. "Don't get the water too hot and spray a little to check it." Squirting baby formula on the back of my hand, she asks, "Feel that? That's the temperature you want." She points to the closet under the stairs and laughs. "And I know you know where the diapers are!"

"How long are you staying out?" I ask, jostling Bephens in my arms as she sleeps.

Lying on the floor and pulling up the zipper on her pre-pregnancy jeans the way Jeff used to get on his tight pants, she asks, "Why does it matter? You should be sleeping anyway, so you're not tired when Bephens wakes up and needs to be changed." Back on her feet, Mom douses herself in Emeraude—her new perfume because Tabu reminds us both of Al—and fluffs her blonde perm upside down a couple times. "How do I look?" She poses, popping her hip out.

Annoyed she's not really answering my question, I ignore hers. "Maybe you should tell me where you're going in case of emergency?"

"The Landing Strip with the girls—"

I cut her off. "The Landing Strip? Where you met Al?"

"He doesn't live here and won't ever come back, so you don't have to worry." She picks up her purse. "Didn't I tell you what Grandmother did?"

"No."

"Oh, you're not gonna believe this." Her eyes get big. "She put a bounty on Al."

"What's that?"

"Grandmother put out a hundred-thousand-dollar reward to anyone who kills Al if he shows up in Juneau."

"No way! Really? Does he know?"

Mom pulls the car keys out of her purse. "Well, I didn't tell him, but news like that travels fast. Anyway, I'm only telling you because I want you to stop worrying. You're gonna give yourself an ulcer before you start seventh grade."

I roll my eyes. "Not funny." Bephens wiggles in my arms, waking up. "Are you sure I'm ready to be alone with her? She's only two months old."

Halfway out the door, Mom says over her shoulder, "Duh. Of course I'm sure. You're her dad, remember?"

The *click, click, click* of Mom's heeled boots on the sidewalk sounds like she's running away from home. I smile at my baby sister. "Guess it's just me and you, kid."

CHAPTER 13

A Great Mother

A few minutes after five, Mom comes out through the concrete building's glass doors, carrying her purse and a plastic bag. As she walks down the sidewalk toward us, images of what I think she's gone through the past three days flash in my mind: wrinkled-faced women in orange jumpsuits fighting over trays of mashed potatoes and trading cigarettes for phone time, while rats run between cells and prisoners clang metal cups across the metal bars of their cells. I recently watched *Escape from Alcatraz* and assume the Juneau jail must be like the one in the movie.

Mom sees us waiting in Uncle Killian's van and gives us a small smile, and I wonder if she's embarrassed about ending up in jail. I wave, deciding I'm not mad anymore that she left me home alone with Bephens. When she gets in the van, I'll tell her it's okay because people make mistakes. Then we'll hug, and everything will okay.

She opens the door. "Hey, girls. Did you girls miss your mama?"

Hugging her, I smell unfamiliar soap in her damp hair. "Yes, Mom. A lot."

Bephens, old enough to stand but not yet walking, stops pretending to steer the van and climbs over me to get to Mom.

"Hi, baby." Mom nuzzles her then says to her brother, "Thanks for picking me up, Killian."

"Yeah, no problem," he answers, backing out of the parking spot. "So, how was it? It's a new building, right? I heard it's not that bad."

"Not bad?" she scoffs and reaches in her purse to get a cigarette. "I didn't wanna leave!"

"You *liked* jail?" I ask, balancing on one butt cheek to keep from falling off the seat I'm sharing with her and Bephens.

She lights her Marlboro. "Three days with no kids, cable, and someone cooking for me? What's not to like?"

"Maybe they'll invite you to come back, Fran?" Uncle Killian chuckles.

"You first, Kill." She laughs and rolls down her window.

"So, you'd rather be in jail than be with us?" I ask, instantly regretting it and waiting for the smack I know is coming.

"No, smart-ass. I'm not saying that." Mom takes a drag of her cigarette. "We're just too broke to get cable, so it was nice to have it."

Broke? Then how'd you buy cigarettes? I hear my question— grateful I didn't actually say it out loud—and let my butt cheek slide off, sitting on my knees between the seats to get farther away in case I do blurt out something she wants to whack me for.

"It was a fuckin' vacation, honestly," Mom says, and she and Uncle Killian laugh, but I don't think it's funny, at all.

My stomach shakes, and my hands ball up into fists, as I think all the things I shouldn't say right now. *A vacation from what? I cook. I clean. I never get to go to slumber parties because I'm always babysitting Bephens—*

"What was that?" Mom asks.

"Uh? Nothin.'"

BECAUSE THE FAIRY TALE I THOUGHT was our new life ended the night Mom left me alone with Bephens for the first time, I secretly hoped jail would change her—like it did the juvenile delinquents I saw on a TV documentary who stopped breaking the law after a few days in prison. But the Jane Fonda workout videos and Cornish game

hens they served that Mom keeps bragging about didn't seem to scare her straight. In fact, she's acting pretty crooked.

"Is it okay if I take Bridey fishing this afternoon?" Honey—who still smells sweet like her name—calls up to my mom's room from the bottom stair. She's one of the only friends who still comes over, and the only person I've never heard Mom fight with. I think it's because Honey is easy-breezy like a cloud, so nothing hard can land on her—mean words blow right through and fly up, up, and away.

"As long as she picks up the house first!" Mom shouts back.

Honey gives me a thumbs-up, then notices my baby sister eating dry puffs of KIX cereal in her high chair. "What about Bephens?" she yells to my mom, then says to me, "Why don't you wait on the porch?"

I nod and grab my coat. As I step outside, Mom yells from inside, "Don't let the door hit you in the ass!"

Honey slips out the door, butt first, still negotiating my release with Mom. "Yes, only an hour or so." She grabs my hand, and we run to her car before Mom changes her mind.

Although I've never liked fishing—which is very *un-Alaskan* of me—getting to go with Honey is less about what I catch and more about what I release—anything on my line and everything on my mind. For a few hours, I get to be a silly twelve-year-old who isn't a dad.

"Gross! What is that?" I wince, disgusted at the fish wriggling on the end of my line. "Oh, my god! Get it off! I think it puked on itself! And its eyes are about to pop out of its head!"

Honey laughs. "You caught an Irish lord." She brings the muddy-brown fish that looks like it's turned inside out closer to the boat. "Your line went too low, but nobody wants to catch them because I don't think you can eat them." Honey cuts the hook from its mouth, and the Irish lord slips into the black water and back down to the bottom of Auke Bay.

Honey helps me cast my line, and as it bobs in the water, I think about the fish people *want* to catch here—king salmon the

Native Alaskans carve into totem poles and Alaskan halibut fish-
ermen win piles of money for because they grow to the size of
Honey's skiff.

Crap, I think to myself. *If I were a fish, I'd be an Irish lord—ugly
and unwanted.* It's not just my mom who can't stand me. At school,
I get picked last in PE because my legs have grown five inches this
year, making me trip over myself. At dances, I stand on the side
of the gym with my back against the wall to keep the bright lights
from glaring off my big, bucked teeth because kids call me "Bucky
Beaver" when they see them.

After only one fishing trip with Honey, my mom says I can't
go anymore—giving me a reason she stole from Al. "There's shit to
do around here."

BECAUSE NONE OF HER OLD FRIENDS seem to like her anymore, Mom
starts hanging out with some of the moms at Coho Park, inviting
them over to drink wine from jelly jars and talk shit about their
kids' deadbeat dads.

One night, I pull Mom away from bitching with her friends
because it's an emergency. "I need more pads! I only have one left
that I got from the school nurse."

My mom swipes the pad from my hand and waves it over her
head. "Girls, look at this goddamn towel Bridey got at school! Can
you imagine having to wear it between your legs?"

"You're a woman now!" one of them cheers and raises her
jelly jar.

Humiliated, I run upstairs to my room and slam the door.
Hearing them laugh, I bury my head under a pile of stuffed panda
bears and scream, "*I hate you!*"

The next time the moms come over to drink, I hide in my
bedroom—until my mom needs me for something she can't do
herself. "Hey, Bridey! Get your ass down here!"

"Yeah?" I stop halfway down the stairs, hoping she'll tell me
quickly and let me go. Then I see it—my new training bra tacked to

the wall above them. "Mom?" I ask, panicked and pointing at the bra. "Why is that up there? Can you *please* take it down?"

She nearly spits out her wine, cracking up. "Ah, Christ on a crutch! What's the big deal? I'm stretching it because you told Missy it didn't fit your itty-bitty titties!"

"You listened to my phone call to her?" I shake my head in disbelief. "And I never said that. I can't believe you did this to me!" Again, I run upstairs and throw myself on my bed—punching the mattress and flinging my panda bears all over the room.

IT'S THE WEEKEND, AND I WANT TO STAY away from my mom because she finished her morning pot of coffee and has moved into her jug of generic RED WINE. I decide to take Bephens to the playground.

Mom is standing on our porch talking to a couple friends on the porch next door as I try to slip by her. "Where are you going?" she asks me.

"The playground. Why?"

"What did you say?" She cocks her head to the side, and I know I'm in trouble.

"Sorry, I just meant what else should I be doing because the house is clean?"

Because we're facing the other moms, who are obviously watching, Mom pinches the skin on the back of my arm to keep them from seeing.

"Mom, you're hurting me," I whisper.

"Don't you fuckin' move," she says, without moving her lips except to smile at her friends, "and don't you dare ever ask me why. If I say, 'Jump,' the only thing you ask is, 'How high?'" She waves at the other moms. "Be right there!"

Tears fill my eyes, but I'm trying not to cry.

"Do you understand me?" She pinches harder.

It's my turn to answer without moving my lips. "Yes."

She lets go of my skin and gives me a fake smile. "Now, take all the kids to the playground."

I swallow my tears and walk Bephens to the other porch. "I'll take the kids with me," I say to the moms, offering my other hand to another toddler and heading down the sidewalk with a trail of little ones following behind me.

Mom calls out, "Hey, Bridey!"

I turn. "Yeah?"

"Jump!" She nods to the other moms to be sure they're watching the show she's putting on for them.

Again humiliated by what she's doing to me, I take a deep breath—to keep from crying or screaming—and swallow. Looking around to make sure no kids my age are watching, I start jumping and call out to her, "How high?"

She and the moms laugh a little, but when their kids start jumping next to me, the moms lose it—slapping each other's backs and spilling wine on themselves.

BECAUSE I'M NOT ALLOWED TO GET anything less than an "A" at school, I take any extra credit my teachers offer, including playing the part of the nucleus in our seventh-grade science skit, "The Mighty Mitochondria." Because our teacher told us we get *even more* credit if we wear a costume, I make a headband and a cape out of a bedsheet—although it's pretty stained, so I decide I'll have to fly fast around the classroom to keep the kids from seeing.

We don't have money for me to get my hair cut anywhere but our kitchen, and the Joan Jett–rocker mullet I have right now is one of the two haircuts my mom can do—the other is Dorothy Hamill's ice-skating bob. "Mom! My bangs are too long. They look stupid under my headband!" I yell, walking in the door from school and hoping she's sober enough to trim them.

"*Heeeyyy, Briiight Eyesss!*"

Oh, God. The French accent. Although the new way she's slurring her words sounds more like the fancy lady from *Green Acres*

who says, "Dah-ling," and isn't actually French, the "French accent" is the best way I can describe how my mom talks when she's really drunk. Hearing her now, I wish I kept my mouth shut about my bangs, but it's too late.

Mom flashes the wire cutters she brought home from Grandmother's flower shop where she works. "Getcher *asss* over *heeere!*"

As she wields them over her head like a sword, I duck and dodge. "Mom, not those. They'll make my bangs crooked."

She pushes me down into the kitchen chair. "Sitch your *asss* down. *Nowww.* I use *theeese everyyy goddammmn daaay!*"

I cover my face with my hands and hold my breath, sitting as still as I can. Sure enough, her first snip grazes my forehead. "Ouch! Mom! Stop!"

I flinch, and the thick metal nicks me again, pissing her off. "*Shiiit! Jussst staaay* still!" Straddling my legs to keep me from moving, she realizes how much I've grown in seventh grade. "Jesus, yer big, *Brideee.* You bedder wash out you don' become a big *girrrl!*"

I close my eyes, but it only makes the wire cutters chewing through my bangs louder—like using plastic elementary school scissors to cut a thick stack of construction paper.

"*Voilà!*" Mom tosses the wire cutters on the kitchen table. "*Gooo seee 'em, braaat!*"

I run my fingers through my bangs, and they're way too short. Crying will only make her mad, so I quickly brush the hair off my legs and sweep up the floor. Upstairs in the bathroom, I check the damage—ragged, jagged bangs barely covering the tiny droplets of dried blood. I scrub my skin with wet toilet paper, muttering to the mirror, *Why didn't I keep my stupid mouth shut?*

At school the next day, my bangs gathered to the side in a plastic butterfly barrette, I walk by the glass trophy case and notice Jennifer and Stacy—the two most popular girls at Floyd Dryden Middle School—looking at something behind the glass. Keeping my back against the opposite wall to give them more room for their

awesomeness, Jennifer's voice stops me. "Brady? Bri-day? Birdie? What kinda name is that?"

As I'm deciding there's no way Jennifer is saying *my* name, she reads words that I know I wrote. "We sit on my blue forget-me-not bedspread my mom sewed just for me, surrounded by my panda bear collection."

That's my essay. Why is she reading my essay? Why is it in the trophy case? While I'm dying to push the popular girls' perfectly feathered hair out of the way to see why my essay is behind the glass, nobody messes with Jennifer and Stacy. Instead, I pretend to read the posters on the wall next to them and keep eavesdropping.

Stacy starts reading where Jennifer left off, stabbing one of my sentences in the middle with her snotty tone. "My mom is my *best* friend."

The two girls bust up laughing, and I look down at my feet, wishing there was a giant hole I could fall down. When they finally catch their breath, Jennifer and Stacy prance away in their matching red Reeboks and Guess jeans.

I rush to the glass.

My essay?

First Place.

My stupid bangs reflected in the glass?

Last Place.

Two months earlier, my seventh-grade Language Arts teacher had assigned the essay during the last twenty minutes of class. "How I Get High on Life Without Drugs" was the prompt we answered for First Lady Nancy Reagan's "Just Say No" anti-drug campaign.

"One student from each state will win!" our teacher told us.

I thought the topic was stupid because it sounded like I used to do drugs but don't anymore, but I had to write it because it was for a grade. Because I was at my fourteenth school, I wrote what I'd learned teachers wanted to hear.

"How I Get High on Life Without Drugs" by Bridey Thelen described the forget-me-not bedspread and matching pillows Mom

sewed for me but left out the white pills she probably took to finish the set in one night. I wrote about how we talked about our day while surrounded by my collections of stuffed panda bears and Smurfs but left out the hoarding I'd started because we moved so much that I never got to keep anything for very long. I ended the essay with a syrupy-sweet, ooey-gooey answer to the essay prompt: *My mom is my best friend, and being with her is how I get high on life without drugs.*

As I walk into class after lunch, my teacher sees me and starts clapping.

"Bridey's essay took first place in the whole state of Alaska *and* made the senator who read it cry!" She smiles. "You and your mom each get a ten-speed bike *and* a membership to the racquet-ball club!"

I smile at my classmates, embarrassed but also proud. One girl rolls her eyes, and another puts her finger down her throat like she's barfing because even they know I'm full of crap. Even if my mom is my best friend, no seventh-grade girl is gonna admit it.

Even though it's only three o'clock when I start walking home, it's almost dark as I slip across the icy path in the woods between my school and Coho Park. Grabbing a branch to keep from falling on my butt, I think how I'll never use the membership because I don't even know what racquetball is, and my mom probably won't ride the other ten speed because she's never at home—and never sober when she is. Maybe I'll give it to my best friend, Missy. I try to imagine the senator my teacher said cried about my essay and picture a grown man sobbing over his desk about a comforter and some panda bears. It makes me laugh because he'd really bawl his eyes out if he knew the truth.

My chest suddenly feels tight, and I start wheezing and gulp-ing the air around me like I used to when we lived with Al. I'm breathing too quickly and feel dizzy, the way you do when you blow up balloons too fast. I stop at the edge of the dirt road and try slowing down my breath. Across the street, Missy's bedroom light

is on. I could go there, but I also have to get home to Bephens who is probably in her Johnny-Jump-Up with a dirty diaper because Mom passed out.

Seeing a truck's headlights coming down the gravel, I have the sudden urge to throw myself in front it. *Because if I die, my mom will know it's her fault and will be sad for the rest of her life.* A whoosh of wind pushes me back as the truck passes, taking with it my chance to make my mom pay for how disgusting she's become.

Later that week, Mom walks in the door, beaming a bigger smile than I've ever seen and waving a copy of the *Juneau Empire*. "Look who made the paper?" Opening it, she practically sings as she reads, "My high is being best friends with my mom." She throws the newspaper at me and snickers. "See? I'm a great fuckin' mother. You even said so yourself!"

CHAPTER 14

The Deadbeat Dating Game

"*I*t's heavy." I weigh the paperback the size of a phone book in my hands. "What is it?"

Mac, Mom's old friend who recently moved back to Juneau, points at the cover. "It's a study guide. You'll need it to practice for the PSAT."

"The what?" I flip through the pages filled with words but no pictures.

Mac chuckles, jiggling his watermelon belly. "It's the test you take *before the test* to get into college—the practice SAT before the real SAT."

I shake my head, trying to rattle all the words he just said into place. "That's a lot of stuff I've never heard before—except college. I know what that is. You went, right?"

"Yep." He nods. "Best thing I ever did. How do you think I afford to travel all over the world? Hard to do that without a college degree."

"Well, it was nice of you to get this for me—and nice that you think I can go to college, too." I give him a hug then look through the book again, confused about why the math section has so many letters in it.

"Bridey," he says, tipping his head down to talk over his glasses, "your essay was better than any other seventh grader in the *entire*

state of Alaska." He smiles. "Sounds to me like we have an English major on our hands!"

More words I don't understand, but I feel stupid asking another question. "Thanks, Mac. I promise I'll read the whole thing."

"When do you graduate from high school?" he asks.

Realizing I've never really thought about it, I shrug. "Like five years, right?"

"Yep, the class of 1989. That means you'll take the PSAT in 1987, so you have three years to study." He smiles. "And I hope you do because college is going to help you live the life of your dreams."

After Mac leaves, I stand the study guide on my dresser next to my village of Smurf figurines, feeling a little embarrassed it's the only book I've ever owned that I didn't steal from one of the schools I've gone to. Tracing the black PSAT letters, I think about the life Mac said I could have if I go to college—*the life of my dreams.* I'm not really sure what life that is, but I know it's definitely not the one I have now.

MOM DANCES DOWN THE STAIRS, wafting her Emeraude perfume across the living room. Wearing a black blouse and tight jeans—thankfully, not mine—she goes into the kitchen.

I hop off the couch and follow her. "You're going out? But you said I could spend the night with Missy because I watched Bephens last weekend—and the weekend before."

She gulps down the red wine in her jelly jar then narrows her eyes, like she's studying me. "You on the rag or somethin'?"

"Gross, Mom. We've just been planning the slumber party all week."

She refills her jar. "Don't be such a fuckin' martyr, Bridey. Missy can stay here."

"But that wasn't the plan." I cross my arms and cock my head to the side, showing her I'm annoyed.

She blows me a fart noise. "Welp, Virgo, it's the plan now."

Watching Mom chug the rest of her wine, fluff her hair upside down, then slip on her leather boots without caring for a second that

I'm upset—or offering to change her plans and stay home—I decide to see how long I can keep her here. "Mom, I have to tell you something."

"Now?" She grabs her purse. "Can't it wait until tomorrow?"

I take a big breath, puff up my mouth like a blowfish, then let it all out as slowly and dramatically as I can. "It's bad, Mom." I sniffle, holding back fake tears. "Really bad."

"What are you talking about? What's *really bad* mean? What's going on?" She's rushing her questions to leave, but knows she's trapped until I answer. I stay quiet—except the sniffling—and sit on the couch with my head down. Taking the bait, she sits next to me and brushes my hair away from my face. "Can't help but see your dipshit dad when I look at those bright blue eyes of yours. He doesn't give you jack shit, but at least he gave you those." Mom laughs and nudges my arm like I should, too.

Some little whoosh of wind raises goosebumps on my arms, and I play it up—shivering like I'm scared of what I'm about to say. "I dunno how to tell you, but Uncle Kill—"

"Uncle Killian?" She stands up. "Goddamnit, Bridey! What did he do to you?"

"No! No, Mom!" I take her hand and make her sit back down with me. "Not Killian, but his friend Stevie—"

"It's okay, baby," she says, her voice softer. "Tell Mama what that boy did to you."

I wipe my nose with my sleeve and tell her everything all at once. "He laid on me when I was sleeping on Grandmother's couch and rubbed himself on my butt, then jumped up and ran into the kitchen and told me he thought I was Uncle Killian's girlfriend."

"That little fucker." She bites her bottom lip and shakes her head. "Did he hurt you?"

"No. Just scared me. A lot."

"Did you tell Grandmother? Uncle Killian?"

"No."

"Wait, when did this happen? You haven't been to Grand-mother's lately."

"When I was nine—the night before you brought Al to the condo."

"Nine? Jesus, baby. That was *three* years ago! Why didn't you tell me?"

I shrug my shoulders, taking a second to think about it. "I was going to, but then Al was there, and you and Grandmother were fighting. I just figured I'd tell you later."

"Well, Stevie was a kid then, but he's a fuckin' man now, and he's about to get handled like one!"

"Whatdaya gonna do?" I ask, opening my eyes big like it'll help me hear her plan better.

"Kick his ass!" Mom snarls and squints like the bad guys on TV when they have an evil plan. She dots kisses across my forehead. "Your mama's got this."

"Don't get hurt!" I yell as she shuts the door.

"Don't wait up." She blows me a kiss. "Sweet dreams."

THE SMELL OF BREAKFAST OPENS MY eyes, and I realize I fell asleep on the couch. Bephens is in her high chair, eating scrambled eggs, and Mom is cooking. She waves her spatula. "Good morning, Bright Eyes! I did it!"

I hustle into the kitchen and give her a hug—standing a couple inches taller than her because I've grown so much this year and have the ugly stretch marks on my hips to prove how painful it's been. "You saw him?"

"Yep." She faces me. "Walked right up to him and grabbed his crotch!" Mom cups the air with her hand to show me how she did it. "I said, 'I'm wise to the rise in your Levi's, so keep your tool cool, Fool.' Then I knocked his ass on the floor!" She raises her eyebrows and scrapes scrambled eggs onto a plate. "The son of a bitch actually cried. Your uncle Killian is lucky I didn't knock him out, too."

"Why? What'd he do?"

"Spoiled little shit said you made it up."

I shake my head. "Why would I do that?"

"You wouldn't. That's the point. But Stevie isn't touching another kid, I *guaran-damn-tee* that!" She laughs. "Eat your eggs before they get cold."

Letting my breakfast freeze because I can't stop picturing my mom grabbing Stevie then punching him out, I wonder why nobody called the cops, but I'm glad because she shouldn't get in trouble sticking up for her kid. Pushing eggs around my plate, I think about the others who messed me with me when I was little—Rocky, the babysitter, and Jeff—and I could tell my mom right now, but it was a long time ago and maybe doesn't matter anymore. Part of me knows she wouldn't believe me about Jeff anyway, because she stills calls him the love of her life. Watching her wash dishes, I think about what I'd have to do for her to call me that?

WHEN MOM FINALLY DECIDES TO buy cable, I know it's to shut me up about her going out all the time. What she doesn't know is that I'm way happier having MTV at home than her.

Missy, my best friend who doesn't have cable yet, loves helping me babysit Bephens because we plop her down in her Johnny-Jump-Up and let her bounce while we bop to "Girls Just Wanna Have Fun," then scream with Twisted Sister, "We're Not Gonna Take it!"

"Go! Go!" Missy yells for me to change the channel when the "Footloose" music video ends on *Night Flight* because another video we love is probably playing on *Night Tracks* or MTV at this very second.

Sweaty and exhausted from dancing and running to change the channel all night, we finally get to leave it on MTV because the other two music shows are over.

"What's wrong with the TV?" Missy asks when the screen flickers.

My hand ready to smack the side of the box the way the Fonz taught us all to fix a TV, the picture flashes to a few women singing, "*Da na na na—Da na na na—*" then a bunch of other images flash

on the screen so fast it's hard to know what we're seeing. Then a man sings—"*Da reflex . . . flex flex flex flex flex!*" and three guys jump together onto the stage.

Without a word, Missy and I scoot as close as we can to the screen. Inches from the gorgeous singer with spiked hair and a cool black-and-white suit, I put my hand out like little Carol Anne right before the ghosts took her into the TV in *Poltergeist*. Drool drips onto my bare legs, but I don't bother wiping it off. A giant, animated wave pours over the audience, and all the girls are crying.

The singer says, "—*and watch-ing*—" and the camera stops for a split second on a hot guy with bleached bangs who looks at the screen, staring right at us! Missy and I scream, "OHMYGODOHMYGOD!"

As the video ends, MTV shows us the name of the band we've fallen in love at first sight with—

Duran Duran

"The Reflex"

Seven and the Ragged Tiger

THE NEXT DAY, MISSY AND I FIND every bit of money we've ever saved and ride our bikes to the record store to buy Duran Duran's new record, *Seven and the Ragged Tiger*, and matching T-shirts with the band's faces on them. We get copies of *BOP*, *Tiger Beat*, and *16* magazine at the grocery story, then race home and replace our Scholastic Book Fair puppy and kitten posters on our walls with Duran Duran posters we tear out of the magazines. In the articles about the band, we learn that we're now "Duranies" and decide we're gonna learn everything we can about Duran Duran.

"When is Simon's birthday?" Missy stops dancing and stares me down with the serious look she gives when we test each other for our Friday vocab quizzes.

Even though my crush on Simon is only one day old, I roll my eyes and sigh dramatically because I'm positive every good Duranie knows his birthday. "October twenty-seventh! Duh!" We fall on the

floor, wrapping our arms around ourselves and pretending to kiss our favorites. "I love Simon!" I shout to the ceiling.

"John Taylor is the hottest fucking guy on the planet!" Missy screams—throwing us both into hysterics because she cussed.

While I swap my stuffed panda bears and Smurf toys for Duran Duran records, pins, and posters, my mom begins hoarding her own collection of temporary boyfriends I meet each morning when I open her bedroom door to see if she's come home yet.

I imagine I'm the host of the show I call *The Deadbeat Dating Game*. "Let's meet Deadbeat Number One! The blond bowl cut and big glasses trying to hide under the covers looks like John Denver! Oh, your name isn't John? Guess what? I don't care because I know I'll never see you again. Say hello—and goodbye—to One-Night-Stand Man!"

"Now, let's say hello to Deadbeat Number Two! The black-eyed bad guy who looks just like Al must also like a woman who can handle a good kick because he wore his black boots to bed. He looks like—*Wait? What?* Oh, you can't stay because you're headed back to jail? That's good news for our doors and walls that you won't have time to kick holes in! Later, loser!"

"Finally, let's meet Deadbeat Number Three! This red-eyed devil with a slicked-back ponytail is stoned to the bone after his breakfast in bed of Budweiser and a handful of pills. His big biceps look like he can pack a punch, so put your hands together before he holds them down and welcome Danny!"

CHAPTER 15

Same Shit. Different Day

*D*anny Doyle can wait on the porch all night as far as I'm concerned. He revved his Harley way too loud when he knows everyone is sleeping, and his eyes are all twinkly and red from whatever he drank or smoked before he got here. Besides, I already dealt with him this morning when I got up for school and accidentally walked in on him peeing.

"You gonna get your mom or what?" he asks when I open the door a second time to see if he's still there.

Although I wanna be a smart-ass and answer, "Or what?" I don't. But I do shut the door on him, again.

"He's been waiting outside this whole time?" Mom pushes past me and skips down the stairs, yelling over her shoulder, "You're such a fuckin' cop, Bridey!"

"Because somebody needs to protect us!" I holler, knowing she's too busy flirting to get mad at me. I run into the kitchen where Bephens is finishing her mac and cheese and pick her up, singing a song for the loser on the porch, "U-G-L-Y, you ain't got no alibi! You ugly, yeah, yeah, you ugly. M-A-M-A, we know how you got that way! Your mama, yeah, yeah, your mama!"

Bephens giggles and points to me. "Mom-ma."

"No! No!" I shake my head and laugh. "I'm your sister, silly! Say, 'Sis-ter.'"

"Sees-ter!" She tickles me, making us both laugh and say together, "Sees-ter!"

"And you're not ugly." I kiss her nose then point up at Mom's bedroom above us where she just took Danny. "But that guy is." I stick my finger down my throat. "Gag me with a spoon!"

We giggle and dance around the kitchen, chanting, "Gag me! Gag me!"

MOM STAYS AT DANNY'S PLACE MOST nights—like she did with Al—but I'm not sure if she's hiding Danny from us or us from Danny.

"Hey, Bird," he says one night as he walks in the door without knocking.

"My name is Bridey," I correct him, then go back to studying Duran Duran's pet peeves in *Tiger Beat*.

Helping himself to a beer in our fridge—which is annoying—Danny sits down at the kitchen table with me. "How tall are you, anyway?"

"Five-seven," I answer, without looking up from my magazine.

"That's pretty tall for a—what grade you in?"

"Eighth." I sigh loudly to let him know how irritating he is.

"Anyone ever call you *Big Birrrd*?" He laughs and chugs his beer.

Feeling like I'm talking to a dumb boy at school who won't stop until he gets you to punch him or run away crying, I look Danny in the eyes the same way I would that kid. "No. No one has *ever* called me that."

"Until now—" He grins, clearly a promise to call me the name again.

WHEN MOM TELLS ME WE'RE MOVING back to Tahoe, she at least gives me enough time to pack and enough time to have my first-ever going-away party—one I'm not baking my own cupcakes for.

Missy's mom serves us white cake with blue frosting that spells out *Goodbye Bridey, DD Loves You* while the Duranie girls and I dance to a VHS tape of Duran Duran videos we've never seen before because they don't show them on MTV. It's a perfect night that I don't ever want to end.

When we leave for the ferry in the middle of the next night, Missy sobs as she chases Danny's truck, while I cry to her out the window, "You're my best friend forever! I'll write to you! I promise!"

We board the Alaska state ferry with another biker in black boots and dirty jeans who wears a big knife and has a Harley-Davidson in the back of his rusted truck. Avoiding Mom and Danny who are sleeping on the same outside deck Mom did with Al, I make my bed in the corner of the movie theater same as before—only now, I have Bephens to play with and letters to write.

> *Dear Missy,*
> *Tell your mom thanks for the awesome party. I can't wait to find Duranies at my new school! Mom said I can start wearing makeup because a waitress asked if I was a boy. I hope the rest of eighth grade is rad, and you better tell me when you get a boyfriend and he better be as cute as John Taylor!*
> Bridey + Simon = TLA
> *PS BFF's 4-ever!*
> *PPS I want to write to DD but stamps to London cost a lot of money, but I'm gonna get a diary WITH A LOCK and write to them in there!*

Three days later, the ferry docks near Seattle. Thankfully, Bephens and I get to ride in the truck's camper because I can't handle listening to Mom talk about the mountains and cry, "Look! It's our lake," when they turn the corner and see Tahoe because she wants to pretend Danny is the first—not the third—guy she's moved here.

We drive down Osborne Steet, and I wonder if the Thompsons or Candy will come out to say hi, or if they're still recovering from our last trip and want to wait until they see who we've brought home with us this time. I can't go to Nikki's house because she moved—plus she's in high school now—so I'm not sure when I'll ever get to see her again.

Danny opens the camper door and starts tossing black bags out on the dirt to get to his precious Panhead parked in the middle of the camper. "Jesus Christ! What is all this shit?"

"Our life," I answer, watching to see if he's gonna throw my essay-winning ten speed on the dirt, too. "Be careful with my bike, please."

Mom's bike rusted in the rain on the side of our building, so we only brought mine.

Danny rolls his Harley down a ramp and starts it up, belching the same stinky smoke that sent our neighbors running inside their houses two years ago.

Bephens and I run down the broken brick path as Mom—with all the excitement she always has when we get to make a fresh start—pushes open our front door like she's showing off the grand foyer of a fabulous mansion and not our beat-up one-story with patched-up holes and oil stains on the carpet. "We're home! We're finally home!"

Seeing her huge smile, I really hope she's right this time.

Danny comes through the door and stops a few feet in, sniffing the air around him. He looks down, brushes the carpet with his boot, then goes back outside and starts up his Harley—revving the familiar *POTATO, POTATO, POTATO*. Riding up the wood ramp and into the house, he stops right on top of Al's oil stain and drops his kickstand—reminding me of a dog peeing on the rock every other dog in the neighborhood already has, but since he's the last one, it's his now. Danny looks around the living room, smiling "a shit-eatin' grin"—as Mom puts it when you know you've done something wrong and gotten away with it.

"This is our bedroom!" I roll Bephens in the blue comforter Mom sewed for me. "No crib for you anymore, big girl! You're sleeping with me!"

Bephens unpacks her toys from her trash bag while I set my *PSAT Study Guide* on my dresser and pull out the Duran Duran records I tucked between two pillows stuffed into one case. "Hello, boys! Welcome to California!"

Heading to the truck for more garbage bags, I nearly trip over an oval piece of stained glass propped against the front door. "What's this, Mom?"

"*Ooohhh*, isn't it beautiful?" She picks it up. "I bought it before we left last time and left it in the attic. It's a rose in a Derringer. I'm putting it in the front door."

"You're cutting a hole in the door?"

"Yeah."

"So, when people come to our house, the first thing they'll see is a rose sticking out of a gun?"

"What's the big deal?"

"Why would we have a gun welcoming people to our house?"

"Why not?" She shrugs and throws her hands up. "And any fuckin' stiffs who'd be bothered by it shouldn't be coming over anyway. Maybe it'll keep the Bible-beaters from knocking on our door!" She laughs. "Better get it in there quick!"

I head outside, shaking my head at how easily she forgets anything she doesn't want to remember—like a gun aimed between her kid's eyes. Being back here, it's hard not to feel like Al's truck is gonna come around the corner any second. I wonder if maybe that's why Mom made sure she had a boyfriend before we came back. Danny comes out the door and strolls around the yard— maybe looking for another place to pee and mark his territory. "Hi, Bridey!" Candy calls out from her porch. "Welcome home!"

"Thanks! I'll come say hi in a minute!"

"Who's that nosy fuckin' neighbor?" Danny asks, suddenly next to me.

I whip my head around. "She's a really nice lady, so please don't say that."

"She'd be nicer if her tits were bigger." He snickers and walks toward the house.

"That's gross," I say, sassier than I know I should, realizing I must not be as scared of him as I was of Al.

DANNY AND I MEET AGAIN IN THE KITCHEN when I'm putting away cans of soup and other food Mom brought with us from Juneau because she didn't want to waste it.

"That's my side," Danny says, pointing to an empty shelf.

"Whatdaya mean 'your side'?"

"It means, my food goes here," he says, setting down a box of Kraft macaroni and cheese and a bag of Doritos on the shelf. "And nobody touches it, or else."

I'm reminded again that my mom is dating a seventh-grade boy who's now threatening to beat me up if I touch his noodles like they're his prized baseball cards. "You get your own food—and it's the expensive stuff?"

"I have a job, so I get to eat what I want. You and Bephens just eat the shit your mom buys you."

Shit is exactly how I'd describe the cheap bread, runny jelly, and logs of hamburger meat we eat. Bephens toddles into the kitchen with her silky, pink bunny blanket she rubs on her cheek the way I used to rub my rabbit fur above my nose. I pick her up. "Hey, you hungry?"

"Get her goddamn fingers out of her mouth!" Danny hollers.

Instinctively, I turn her away from him and ask over my shoulder, "Why can't she suck her fingers?"

"It's fuckin' disgusting, that's why."

I laugh nervously, not sure if he's serious. "It's not like she has her whole hand in her mouth. It's only two fingers."

"Two fingers she touches shit with then sticks back in her mouth." He swats her hand.

"Hey, why'd you do that? She's not even two." Even though it wasn't more than a tap, Bephens is crying. "It's okay." I rub her hand as she leans against my shoulder.

"I'm smackin' 'em out of her mouth every fuckin' time," Danny promises, then leaves with his Doritos. He isn't kidding.

"Get your fuckin' fingers out of your mouth!" Danny shouts in the living room, and I hear Bephens crying, again.

I run and scoop her up into my arms, glaring at him on the couch. "What's wrong with you? She's a baby!"

He looks at me then at her, disgusted. "She's a snivelin' little brat who's about to get somethin' to cry about if she doesn't shut up."

There's something about taking care of Bephens that keeps me from being as scared of Danny as I probably should be—or maybe because nobody will ever be as terrifying as Al. "Just leave her alone, okay?" I take Bephens to our bedroom and tuck her and her silky bunny in for a nap, not realizing Danny followed us.

"You don't want her to get bucked teeth like you, right, *Big Birrrd*!" Danny drags the *R*, making duck lips. "Or should I say, Bucky Beaver?" He laughs and slams my door.

Bephens looks up at me, wide-eyed, and sticks her fingers back in her mouth. We giggle. "Eye," I say, pointing to my eye, "La," overpronouncing the *L*, "View!" then tickle her.

Mom gets home from wherever she's been, and I find her in the kitchen. "Why is Danny so mean to Bephens? Why does he care that she sucks her fingers? I sucked my thumb forever, and you never flicked me in the mouth."

She looks at my teeth. "Maybe I should've." She snickers.

I cover my mouth. "No, seriously, Mom."

"Don't make it a big deal, Bridey. It's fine."

"It's not fine."

"Do the dishes or something."

LIKE A SCHOOLYARD BULLY, DANNY stalks Bephens, waiting for any reason to pick on her.

"Pick this shit up before I step on it!" he hollers if her toys are out, then chases her to our room, laughing his ass off as she slides under our bed to hide from him. If she leaves even a pea on her plate at dinner, he loses his mind. "You're not getting down from that table until everything is gone!"

And this is when I'm home. I start to wonder what it's like when I'm at school. I wait until Danny is at work one day and—in the nicest voice I have because I don't want to start a fight—I approach my mom in her bedroom. "Hey? What do you think about how Danny is with Bephens? I mean, why does he hate her? He's never that mean to me."

She stops putting away laundry and whispers, "I told him about Al."

"What does that matter? Do they even know each other?"

She raises her eyebrows. "They used to be best friends."

"Really?"

"Until Danny found Al in bed with his wife."

"*Ewww*. Gross."

"And Danny nearly killed Al for it."

Suddenly, everything makes perfect sense. "And Bephens is Al's kid."

"Yep." Mom nods. "Poor girl isn't ever gonna live that down."

"Mom, you have to make him stop. He's a bully."

"I know. I'll talk to him. You just keep her out of his way for a while."

LUCKILY FOR ME AND BEPHENS, DANNY isn't into playing house much and rarely comes home.

Mom's part-time job has become tracking him down.

I'm coming out of the kitchen when Mom charges through the front door and shoves Danny from behind as he's sitting on the couch. "Whose fucking footprints are on the windshield?"

"Goddamnit!" He stands up, wiping beer he spilled on his lap. "What the fuck is wrong with you?"

"Whose footprints are those, Dan?"

I glance around the room for Bephens and see our bedroom door shut. Keeping one eye on the door and one on my mom, I stay where I am and play referee.

Danny shoves my mom against the wall, pinning down her shoulders. "Fuck you! I don't know what you're talking about!" He smacks her in the face a couple times—hard and fast—then stomps outside.

She follows, screaming, "I'm not crazy! Those aren't my feet!" She flings a pink bra across the yard. "And this isn't mine, either, you son-of-a-bitch!"

"Just let him go!" I yell from the porch as she runs toward the black Smokey and the Bandit Trans Am Danny bought with money we don't have. Seeing the pink bra on the dirt, I know it's not mine, and it's definitely not Mom's because she only has her "school bra"—the one she wears when she absolutely has to go to my school.

"Don't you leave me!" Mom screams and climbs through the passenger side window because Danny locked the door. He's laughing and revving the engine, like he's about to peel out and race down Osborne Street.

Standing on the porch—deciding whether to pull my mom out of the car and probably get run over in the process or make sure Bephens is okay—I run inside the house and let Mom deal with her seventh-grade boyfriend.

Huddled in the corner under our bed, Bephens is shaking and sucking her fingers.

"Oh, it's okay." I scoot under the bed until we're face to face. She rubs my cheek with her silky bunny. "Everything is gonna be okay. You stay here, and I'll be right back."

She stares with big eyes and takes her fingers out of her mouth. "I okay."

"I know it's scary, but don't move, okay?"

She nods, her fingers already back in her mouth.

I run to the yard in time to see Mom dangling from the door as Danny pulls away from the house. With one last heave, she throws her body into the car, and the tires squeal as the two idiots take off down the street, like Smokey and his girlfriend running from Sheriff Rosco P. Coltrane. Mom and Danny get back late, and I hear them making up all night—through three pillows on my head.

After making a bunch of phone calls that involve Mom saying stuff like "big tits" and "skinny bitch," she tells me Danny has been picking up a girl from the high school every day at lunch.

"High school?"

"Fuckin' creeper, right? She's some redheaded senior who's missing her bra." Mom laughs, but I'm not sure it's that funny. While I'm waiting for her to get mad or start breaking Danny's stuff, she just keeps laughing.

"What are you gonna do, Mom? Kick him out?" I ask, hoping and praying my hardest.

Mom shrugs her shoulders. "And let him get his way?" She blows a raspberry. "Fuck that. I'm gonna make him miserable." She cackles, sounding like the Wicked Witch from *The Wizard of Oz*.

IN A TOTALLY BIZARRE MOVE, MOM really doesn't fight with Danny about the girl. Instead, she becomes the girl—acting like a stupid teenager who will do whatever it takes to keep the bad boy she's dating interested in her.

"*Dannyyyy*" becomes the longest word she's ever said in her life, as she gets him a beer, brings him *his* food from *his* shelf, and follows him everywhere. When he's at work, she chews her fingernails and bites the inside of her cheek while yelling at me because she can't yell at him. "Do the dishes!"

"I did."

"Don't you talk back to me. Go do something productive."

"But everything is clean, Mom."

"Clean it again, goddamnit!"

I know better than to push my luck, but I'm exhausted from doing everything she can't do—or won't—because she's too busy standing at the window, watching for Danny. "You really want me to clean the house again because you're mad he's not home?"

"What did you say?" she asks. Her eyes burn mine, and her nostrils flare.

Shit. I knew better. "I'm sorry, Mom. I don't know why I said that." I back away. "I'll go do the dishes."

It's too late. She's in the kitchen, opening drawers and rattling silverware, looking for something to smack me with.

"No, Mom. Please, no," I plead, seeing her grab the wooden spoon. I run to my bedroom and slam the door, holding my back against it. "I'm too big to spank, Mom! You can't do this!" I look down and see Bephens, already hiding under our bed.

"The hell you are!" She shoves the door open and smacks the door frame with the spoon. "Get over here, or it's gonna be way worse!"

"No, Mom. Please, don't." I'm crying, which I haven't done in a long time. "I'm almost in high school! Please don't do this."

She grabs my T-shirt and whacks my arm. I flail and twist out of her grip. "You better fuckin' stop!" She hollers and smacks any bare skin she can reach—legs, shoulders, back.

Fending her off, my forearm blocks a hit, and she smacks herself with the wooden spoon. "Shit! Look what you did!"

"Mom! I'm sorry," I sob hysterically. "But please stop!"

"Don't you ever block me again!" She whacks me across my arm so hard I fall down on my blue shag carpet, holding my arm and sobbing. She throws the spoon down next to me and walks out. "Next time, don't talk back to me."

After a minute, I hear my sister's little voice. "Brah-dee? You k?"

I look up at her and force a smile. "I'm okay."

She sits down next to me, rubbing her silky bunny over my wet cheeks. "No cry. I here."

When Danny shows up—way after dark and way after he was done with work—Mom hops in the Trans Am, and they take off.

TO FIND MORE TIME TO KEEP TRACK of Danny, Mom stops letting me take the city bus to school early, even though it's the only time I get to finish the homework I'm not actually allowed to do at home because that requires sitting—also not allowed after Al taught Mom that only lazy people sit.

"By the way, you're grounded," she says, after cutting off my early-morning bus ride.

"Grounded?" I set down my brand-new copy of "Do They Know It's Christmas?" that I've already played a million times because the lead singer of Duran Duran sings on it. "For what? I didn't do anything wrong."

"Yes, you did."

"What did I do? And how long am I grounded for?"

"I don't remember, but it was last week."

"When you were drunk?"

"Watch it." She narrows her eyes on me.

"Mom, I didn't do anything but help you to bed."

She shuts my door and yells on the other side, "You're grounded! Get over it!"

I open the door and find her in the living room. "For how long?"

"Until school's out—"

"In June? Mom, it's barely after Christmas! You're grounding me for the rest of the year?" I can barely breathe.

"But you can go to school a few days a week to get your home-work."

I completely lose it. "What? I'm grounded from school, too? Don't normal parents force their kids to go to school?" Not caring if she smacks me, I follow her through the house, crying and shouting outside her bedroom door after she shuts it in my face. "Why are you doing this to *me*?"

In my room, I put *Rio* on my record player and drop the needle on "Save a Prayer." While Simon sings, I snuggle with Bephens and sob, promising to tell my teachers because I'm pretty sure it's a law that I get to go to school. To fall asleep, I say the prayer I haven't in

a long time. *Now I lay me down to sleep . . .* but this time I add to the end: *Please send someone to rescue me—for once.*

"SO, YOU'RE ONLY GOING TO CARSON City, right?" I know my hand is on my hip and I'm using the "Mom voice," but I don't care because it's who I am now—Mom to Bephens and to two rebellious teens who smirk and whisper while I wait for an answer.

"Yeah," Mom barely answers, eyeing her purse like I'm about to search it. She sees me looking at her sweatshirt that she cut off at the neck like the girl in *Flashdance* and pushes it off her shoulder even more, proudly showing off the bra she's not wearing.

Danny is leaning all the way back in his seat, acting cool with the Trans Am's T-tops off, heavy metal music blaring, and a lit cigarette dangling from his mouth. Without another word—not even goodbye—he revs the engine and peels out like always. The two of them laugh their asses off at me—the nagging mother they've tricked into letting them leave the house on their own.

I wave through the dust cloud in our front yard to Candy, who hasn't come across the street once since we moved back. She calls out, "You girls okay? Need anything?"

"We're okay. Thank you!" I'd never ask her for help, but it's sweet she asks.

Bephens and I watch TV and eat ramen for dinner. Mom isn't home in the morning, but it doesn't matter because I'm grounded from school anyway. We spend the day cleaning, then I do homework from last week when I got to go to school a couple times, and Bephens colors. For dinner, we eat the last can of beef barley soup. Mom still isn't home the next morning, so we eat peanut butter and jelly sandwiches for breakfast with the two heels left in the bread bag and repeat what we did yesterday—cleaning, homework, coloring, watching for the Trans Am, and waiting for the phone to ring.

Searching the cupboards for something else to cook, I dump what's left of a bag of white rice into a pan. As I'm about to pour water on it, the rice moves. "*Ewww!*" I scream and pour the rice

in the sink. "The rice is moving!" I pick Bephens up to see the wiggling worms.

"Yucky!"

The phone rings, and I run to answer it. "Mom?"

"Hey, baby, I—"

"When are you coming home?" I cut her off, not caring what she has to say. "We're hungry, and there's no food in the house."

"Bullshit. Don't be so dramatic. Have some soup."

"We ate the last can. Where are you?"

"San Francisco—"

"*San Francisco!?* Are you kidding me? You said you'd be back in a couple hours! Mom, it's been two days!"

"Danny had something he had to do."

"He always has *something* he has to do."

"Same shit. Different day." She snickers. "Go to bed. We'll be home in the morning."

"Bed? We haven't eaten dinner because *there's no food in the house!*"

She already hung up.

Because I don't want to tell Candy we're hungry and have her worry more than she probably does, I call my mom's friend who owes me babysitting money and ask her to bring us some Burger King. She offers for us to come over, but I lie and tell her my mom will be home any minute. Bephens and I lay a blanket on the living room floor and have a picnic with our Whoppers and fries.

Poor Bephens eats too fast and throws everything up in her lap.

CHAPTER 16

Didn't Pack Duran Duran

*M*om's standing in the front yard when Bephens and I pull up on my ten speed. Taking my sister with me is a loophole I've figured out in Mom's plan to ground me for the rest of my life: If I have Bephens, I can stay gone as long as I want.

"You're moving to Long Beach to live with your dad." Mom's hands are on her hips, ready for me to argue.

I drop my kickstand. "My dad? Like my *real* dad?"

"What other dad do you have?" she asks, forgetting I still think of Jim Cargill as my first dad. "I told him it was his turn."

"To do what?"

"To be a parent, for Christ's sake." Mom walks toward the house, yelling back over her shoulder, "He hasn't paid shit for you your whole life. Now he can see what it costs to feed those long arms and legs he gave you."

"He sends child support!" I yell, for some reason defending the dad I hardly know.

Mom stops and looks around the yard. "Where's the money?" She points at me. "He sends it to you? Because it's not to me. Not a goddamn dime. What about your birthday? What's he ever sent?" She walks toward me. "I'm sick and tired of hearing how your dad is some goddamn knight in shining armor who can do no wrong, while you pick me apart for every fuckin' thing I do."

"No, I don't, Mom," I say softly, hoping to avoid a bigger fight.

"You're cramping everybody's style around here, Bridey—just too fuckin' uptight for thirteen. You can nag your dad for a while."

"But I barely know him."

Her eyes narrow on me. "Then why do you have him so high on a pedestal that he's un-fucking-touchable?" She throws her hands up. "You know he was a junkie who stole my jewelry to buy drugs? Never told you that, did I?"

"No," I whisper.

"That's why I left him."

"Did he stop, though? I mean, he must've because you let me meet him."

Mom softens a bit and brushes my hair away from my face. "Yes, he did. That's why you got to see him." She gazes at me and laughs. "He was a good-lookin' dude. Sometimes you look so much like him, I just wanna smack it right off you." She slaps my butt. "At least you got his ass! First time I saw your dad, he was walking away, and I knew I was gonna marry that ass." Suddenly, my mom remembers she's pissed at him. "Anyway, your dad can show you what a spectacular fucking father he is."

"But what about Bephens?" I ask, unbuckling her from the seat on my bike.

Mom grabs her and walks to the house. "She'll be fine. I'm her mom, remember?"

Walking my ten speed to the backyard, I think about the million reasons why Bephens won't be fine without me, but there's no way to change my mom's mind once it's made up. I just hope she didn't force my dad, and that he really wants me to come.

"HEY, KIDDO!" MY DAD OPENS HIS arms, and I run straight to him the way I did the first time we met at Rennie's house.

He holds my hand while we walk through the Long Beach Airport, and I notice a couple pointing at him and whispering to each other. I ask, "Why are those people staring at you?"

"Oh, yeah." He chuckles. "That *Magnum P.I.* guy is real popular right now, and some people think I'm him. Yesterday at work, some guy yelled, 'Hey, Magnum!'"

"Maybe you should give autographs!"

He laughs again. "Welcome to LA, baby doll!"

Dad puts my suitcase in the back of his El Camino. "That's all you brought? You plan on leaving soon?"

"Mom didn't give me much time to pack." I shrug my shoulders.

"Yeah, I figured because she called and said I had to buy your ticket *right fuckin' now*." He opens my door. "Well, I'm real glad you're here. Let's go meet the family!"

WE DRIVE INTO A NEIGHBORHOOD that's straight out of a TV show—green lawns, nice cars, kids riding bikes, and people walking their dogs. "Here it is. Home sweet home."

We pull into the driveway of a cute blue-and-white house with a swing on the porch.

Welcome to Normal, I say to myself. "Wow! This is nice."

My dad realizes I'm looking at the wrong place. "Oh, no, that's my buddy's house. Ours is in the back."

He parks next to a smaller house shaped like a perfect box, and I'm barely out of the car when a cute blond kid who looks about seven or eight runs over and hugs me around the waist. "Hi, sis!"

Sis? Guess I should talk to my dad more.

"Now, give her some space, Clint," Dad says, as he introduces us. "Bridey, this is your little brother, Clint."

"I'm five!" He holds up his hand and spreads out his fingers to show me, smiling with a mouth of missing teeth.

"You're tall for five." I shake his hand. "And I'm tall for fourteen." I laugh. "Guess we are brother and sister!"

A gorgeous blonde woman comes out the front door, looking like she's stepped off the set of the show *Dynasty* with feathered blonde hair, perfectly layered eye shadow, and bright pink lipstick. "Hi, honey." Her beautiful smile squints her sparkly green

eyes. She hugs me against her big boobs. "I'm Susie, your new stepmom—"

Dad interrupts, "No stepmoms around here. This is your mom." They smile at each other and hold hands, and it feels like I'm dreaming because this isn't real life.

"Oh, yeah, you got married." I smile, trying not to feel weird that I wasn't invited but figure my mom had something to do with it.

"On my birthday a few months ago. July fourth, so I'll never forget it." They both laugh. "Well, let's go see your room, and we'll have dinner in a bit."

"Dinner?"

"Yes . . ." my dad says, waiting to see why I don't understand what dinner is, "you know, the meal you eat at night?" He puts his arm around me. "Come on, kid."

My face feels hot, and I try explaining. "I just forgot what time it was." Of course, what I really forgot is that parents make dinner for their kids.

The house only has two bedrooms. "Where does Clint sleep?" I ask, looking around my new room. "He can sleep in here with me."

Clint sets down my suitcase. "It's okay, sis. I like sleeping on the couch."

THAT WEEKEND, DAD TAKES ME TO his friend's house to meet her daughter and niece because I'll be starting school with them on Monday, and my dad wants me to have friends.

Valerie and Christine walk into the living room, and I realize immediately that fourteen in Long Beach is not the same as fourteen in Tahoe. "Hi!" they squeal together, looking like models from *Seventeen* magazine in their shoulder-padded blazers, bangs sprayed sky-high, and pastel pumps.

"Hi." Not knowing what to say because I feel like a dork compared to them, I start listing the reasons why I'm too ugly for them to be friends with me. "Uh, my mom gave me this permed mullet, and I hate it." I point to my dirty Kmart high-tops. "And we don't

really wear heels in Tahoe." Then I stretch the elastic band on my yellow pants. "And I made these myself by cutting a jumpsuit in half."

Valerie pulls her long blonde hair back with both hands like she's about to get down to work and smacks her frosted pink lips together. "Cute. Did you make them in Home Ec?"

"No, at home."

Christine is circling me, sizing me up for some plan she's making with each lap around my body. Her spicy perfume smells older than the Jean Nate After Bath Splash and bubblegum lip gloss my friends and I wear. Christine lifts the bottom of my T-shirt to tie it, and I get a whiff, reminding me that I forgot to put on deodorant. She fluffs her shiny black mullet that's cut like mine but spikier and way cooler, like she should have a guitar slung over her shoulder. She licks her fingers and slicks her perfect eyebrows that look drawn in with a black Sharpie. "This is going to be fun!" she says, flipping the ends of my kitchen-and-dull-scissors mullet.

I think I know what's about to happen, but I ask to be sure. "What are we doing?"

As if they rehearsed it, they clap and squeal in unison, "We're giving you a makeover!"

Then, in a scene right out of a John Hughes movie, my fashion montage begins—high-tops traded for two-inch pumps, home-made pants swapped out for a crop top and jean miniskirt, eye shadow layered on top of eye shadow, thick coats of black mascara, and a giant pink can of Aqua Net they spray on my hair until I choke on the fumes.

"Pucker up!" Valerie coats my lips. "This is Wet n Wild number 528, and the only color you should wear because it's totally rad on you!" She spins me around to see myself in her mirror, adding, "The boys at school will totally have crushes on you!"

And, just like that, I feel totally pretty—like Valley Girl-*totally-tubular* pretty. "Thanks for helping me. I really like it." I hug Valerie and Christine, promising I'll use my stepmom's makeup to recreate this look for school on Monday.

CLINT COMES ALONG FOR THE RIDE as Susie—who I want to call Mom but haven't yet—drives me to Stanford Junior High, even though we pass schools on the way that I could walk to. "We wanted you to go somewhere good where you'd have friends," she explains.

"I've never been driven to school before. Makes me feel like one of the *Richies*."

She looks at me, confused.

"You know, like Richie Rich, the boy from the cartoon. It's just that the rich kids don't have to take the bus to school."

"Oh, I get it." She laughs and parks our old, not rich-looking car in front of the school.

FOR THE NEXT FEW WEEKS, I WAIT FOR boys to have crushes on me like Valerie promised, convinced they will if I put on more eyeshadow and spray on more Aqua Net. When I get my school photos, I look like a clown because my makeup isn't nearly as pretty as when the girls did it.

Because Susie has giant trays of eyeshadows and lipsticks, I ask her to help me not look so stupid. "Of course, sweet girl. That's what mamas are for." She smiles and brings out her makeup kit, explaining how to put the colors together as she applies them to my eyes and cheeks. "Perfect," she says, gazing at me. "Go see how beautiful you are."

In the bathroom mirror, I look a bit less like Bozo the Clown but still not like myself.

Trying my best not to feel like a visitor, I help with dishes and fold laundry—although Susie always takes the plate or the shirt from my hand, saying sweetly, "I'll do this. You go get your school-work done."

Life with her and my dad feels like an episode of the *Twilight Zone*—like this *normal* isn't normal, at all. I've hoped and prayed a million times for this, but it almost makes me more nervous—like they're faking it, and one night I'll wake up to them fighting and

screaming for me to call the police. But every day is the same, easy day—breakfast, school, homework, dinner, TV, and bed. The only thing that's hard is sleeping because if I put pillows on my head, like I'm used to, it's too quiet—if there's such a thing.

One night, while I'm pacing around the house trying to figure out what to do with myself, Dad looks up from the *TV Guide* he studies to know what he and Susie are gonna watch all week. "You're making me nervous. Everything okay?"

"Yeah, I just don't know what to do here sometimes."

"You don't have to *do* anything." He chuckles.

"Yeah, I guess." I sit down at the kitchen counter and flip through one of Susie's magazines that has pictures of exercises to firm my neck.

Dad sits next to me. "You know you've got the itch?"

"What itch?"

"To call your mom."

I don't say anything because he's right.

"You count the days between phone calls to her, don't you?"

I nod that I do. "It's expensive to call, but it's hard because Bephens misses me."

"And you miss your mom." Dad squeezes my shoulder. "I get it. I mean, I don't miss her, but she is *your* mom." He laughs.

"I'm happy here. I promise." I smile.

He takes my hand. "I'm glad because we're happy you're here, too. And I know your mom probably told you about my drug days— and I'll answer anything you want to ask—but I know an addict when I see one."

"Me?" I ask, feeling like I might cry.

"But you can't help it. You grew up worrying about her and probably all kinds of stuff you didn't need to at your age. You're only fourteen. You know what I mean?"

"I think so."

"So be fourteen. That means no more worrying when me and Sue argue—which people do—and no more checking to see if we

have enough gas in the car to get you to school. We're the parents, and you're the kid. Okay?"

"Okay, I'll try." I hug him, crying on his shoulder.

"I want to talk to you about something else. I'll be right back." He goes into his bedroom.

I wait, wondering if I'm in trouble for something.

He sets a pile of checks in front of me. "Your mom has yelled at me enough times on the phone about not sending money that I figure she doesn't want you to know that I have." As he flips through the checks, he points at the dates. "I've been sending these for a long time." He turns one over and points at the stamp. "This shows it's been cashed."

"So, she's been lying all this time?"

"Well, I don't want to say that, but I've got receipts for all the dolls and toys I've sent for your birthdays, too. You get any of it?"

I shake my head. "No."

He sighs. "Damn that woman. What is wrong with her?"

"You sent me a doll?"

"Yep. Quite a few."

"Wonder what she did with all of them?"

"Hell if I know, but I wanted you to see this because I doubt she ever says anything nice about me. I guess I can't blame her, but I'm still your dad and tried to do my best for you."

"Thanks for this. I'm sorry she let me think you didn't remember my birthday."

"How could I ever forget the best day of my life, baby doll?" He pulls me in for another hug. "And you can call your mom whenever you want—but call collect. She can pay to talk to you the way I always have." He laughs.

"I HAVE A COLLECT CALL FROM A Bridey. Do you accept the charges?"

"Yes."

"Sorry, Mom. Dad told me to call collect."

"Cheap son of a bitch. Anyway, you miss your mama, baby?"

"Yes," I cry.

"Oh, it's okay. I'm right here. We miss you, too, Bright Eyes—especially Bephens."

"Is she okay? I mean, without me?"

"She's okay. And she's almost three. Can you believe that?"

"I'll send her a present in the mail."

"She'd like that. So, you still like it there? Your stepmom nice?"

"Yes, it's—"

A loud noise on her end stops me.

"Oh, shit! I gotta go! Call again soon, okay?"

Trying to fall asleep that night, I start wondering about how long I'm staying here because it's already Christmas. If I knew that I was staying forever, I would've brought the stuff I can't live without. But I didn't pack Duran Duran—or Bephens.

"CAN YOU WATCH CLINT TONIGHT WHILE we go next door for Tim's New Year's Eve party?" Dad asks, opening a beer.

"Of course. We'll party like it's 1999!" I tickle Clint, and he laughs himself off the couch and onto the carpet.

"Party time!" he shouts, jumping up and down.

Susie calls from the bathroom, "You don't have plans?"

"Plans?" I laugh. "Uh, no."

Dad pours tequila in a glass. "We'll pay you in the morning for babysitting."

I whip my head around. "You're gonna pay me to watch my brother?"

This time, Susie shouts from the bathroom. "Hell yes, we're gonna pay you! You're doing us a huge favor watching him and not hanging out with your friends!"

"Well, that's really nice of you." I wrap Clint in a bear hug, pretending to squeeze the breath out of him. "Ready to stay up until midnight and bang pots and pans!"

He runs around the living room then dashes outside, hollering, "Happy New Year! Happy New Year!"

I watch Susie fix my dad's collar then smooth out her silky jump-suit. It's kind of funny they haven't noticed that I don't have friends here. Valerie and Christine stopped hanging out with me after we got drunk on Robitussin and I barfed. Another friend only came over because I told her my dad smokes pot, and she wanted me to steal her some. My friend Krista visited from Tahoe when she was in Long Beach with her family, and stupid me spent the whole time making her believe I loved it here—telling her a boy in my typing class liked me and the red sports car in the driveway that we took pictures with was ours. I hoped she'd tell our friends back home how happy I was.

Dad and Susie come home a few minutes after midnight, and Clint is asleep next to me on the couch. My dad is still in the door-way when I run headfirst into his stomach, bawling my eyes out.

He leans down and asks with liquored-up breath, "Who died, baby doll? What's wrong?"

In between sobs, I tell him. "He . . . got . . . married! Simon got . . . married! *Daaad . . . nooo!*"

Dad lifts my chin and his eyes are red, but it doesn't bug me the way it does when it's Danny or Mom. "Simon got married? Who's Simon?"

"The singer in Duran Duran, Dad! He got married tonight!" I start crying again.

"Oh, that's the band you like, right?"

"Like?" I stop crying to correct him. "*Love*, Dad! I *love* them!"

"Well, I'm sure he didn't mean to make his little fans upset, but he's allowed to get married."

"I know!" I roll my eyes. "It's not like I was gonna marry Simon. I just love him!"

Dad chuckles.

"Don't laugh at me! This is really hard!"

"I know it is, and I'm sure Simon appreciates it. Hell, maybe one day you can tell him yourself." He hugs me then then digs a five out of his pocket. "This oughta cheer you up. Thanks for babysitting, kid."

WHEN SUMMER STARTS, DAD AGREES to let me see my mom, who's now living in Elko, a small town somewhere in Nevada.

"See you in a month, baby doll." Dad gives me a long hug and hands me my suitcase. His eyes are teary, and it makes me want to cry, too. "You take care of yourself and don't let her get to you the way she does, okay?"

"Okay. I love you, Dad." I turn and wipe my tears off my cheek.

"I love you, too—more than you know. Give Bephens a hug from your old dad."

"I will." I wave goodbye and walk down the ramp toward the plane, stopping like they do in movies to see if my dad is still watching.

He is.

He waves then takes off his sunglasses and wipes his tears away.

CHAPTER 17

Welcome to Austin, Nevada

Pop. 504

"You're taking it all! Gimme some!" I pull the bedsheet a little my way, and Bephens wiggles herself closer to stay under it.

"Peek-a-boo!" she teases, as Danny takes a corner too fast and sends us first pinballing into each other, and then off our mattress and into the black trash bags full of whatever Mom needed to bring on this trip.

"Oh no! Are you okay?" I unwind her from the sheet Mom gave us to keep the scorching sun from frying us like bacon in the bed of Danny's truck. Through the back windshield, I can see him laughing. "Here." I sit Bephens up. "Let's make a teepee that we can look out." We tuck the sheet under our butts and lean into each other as we take the final turns into Austin.

With one week left of my summer visit, Mom said we had to come to this little town because Danny might have a job at the gold mine here. For the past three hours from Elko to Austin, Bephens and I baked under our sheet—sleeping, giggling, and playing I Spy.

Mom yells out her window. "Hey, girls! Check it out!"

Coming out from under our sheet teepee, it feels like we've driven onto the set of an old western—wrinkled cowboys in dirty jeans tip their hats to each other outside a bar that has what looks like a hitching post for horses. We pass a pizza place with a group of kids outside and a row of little shops with dusty windows, making it hard to tell whether they're open or have been closed for years. Against the hillside, a maze of dirt roads winds up around dozens of little houses and trailers. We pass a church that looks too big for a town this small, a few gas stations, and a café that reminds me how hungry I am. Before I can bang on the window and tell my mom we're starving and need to pee, Danny has driven us out of town. Unfortunately for the good people who live in Austin, he makes a U-turn.

Although in Elko Mom said she was "only packing a few things in case we like the place," the mattress she put in the back for us to lie on is surrounded by black trash bags and boxes, and the truck's cab is crammed with crap. Pots and pans rattle on the dashboard, like we're the grittier and less cheerful version of *The Beverly Hillbillies, as* we pull into the Chevron in the middle of town.

Hiding back under the sheets because I'm almost fifteen and can't imagine how gross I look after roasting for hours in the back of our truck, I peek out just enough to see Danny walking toward the gas station and slicking back stray hairs into his low ponytail. With his black Harley-Davidson T-shirt, steel-toed boots, and knife strapped to his belt, the guys inside the lobby might be worried they're about to get robbed, and I know Danny couldn't be happier about that.

Mom hops out of the truck to follow him—her butt cheeks barely covered in cut-offs and her braless boobs bouncing in her tiny tank top. More reasons why I'm hiding. "Pretend you're asleep when she comes back out," I whisper to Bephens and teach her how to make fake snoring noises.

"Bridey, quit hiding in the truck!" Mom shouts back across the parking lot. "Get your asses out and check out the town!"

"Is she kidding right now?" I ask Bephens, wishing I could scream, *Shut up!* across the parking lot.

Determined to totally humiliate me or prove her kids are as obedient as trained dogs, Mom hollers again. "Bridey! Bephens! Come now!"

I roll my eyes at my little sister. "We better get out before she has a cow. I'll get out first, okay?"

Bephens waits and rubs her pink silky bunny—that's now more of a grayish brown—against her cheek.

I slip over the side of the truck and land on all fours, a move I've been doing since I was five and thought I was Wonder Woman. Keeping myself hidden, I creep up slowly toward the side mirror to check out the damage. *Oh, God.* I lick my fingers to smooth my frizzed hair, dig the dust boogers out of the corners of my eyes, and yank my shorts out of my butt crack.

Okay, here we go. Welcome to Austin.

"HEY, BRIDEY!" A BOY'S VOICE—SAYING *my* name—freezes me. "How are ya?" he calls out.

My eyes dart around for a place to hide. For a second, I think about diving under the truck—until I imagine the boy sliding under there to find me. Knowing Mom is watching and laughing her ass off because I'm dying right now, I force a smile and turn to the voice.

Holy Crapitola, he's hot.

A gorgeous boy with short black hair and teeth so white he should do a toothpaste commercial is leaning against the other side of our truck and smiling—at me. Without thinking about how gross it is, I wipe the dried spit caked on my lips and swallow the dust coating my tongue before giving a ridiculously weak, "Hi."

"Hey, I'm Joey! I hear you're moving here? That's great!"

Moving here?

Before I can tell him I'm not, he asks, "Where ya from?"

Trying to wrap my head around his questions—and the fact that a super-hot guy is talking to me—I've forgotten how to speak. "Yeah."

He's confused because I didn't actually answer his question. I swallow and try again. "I mean, my parents are moving here—well,

he's not my dad, and I live in Long Beach." None of that made sense, and this kid probably thinks I'm an idiot.

He steps back from the truck. "What grade ya in?"

Staring at his tan muscles and white tank top, I'm trying to remember. "Ten. I mean, tenth. I'll be a sophomore."

"Cool! Too bad you're not moving here. Lotsa new kids are because of the mine. You should think about it because it's really better than it looks!" He laughs like he knows the middle of nowhere might be a hard sell to a teenage girl.

Not sure what else to say or do, I reach over the side and pull the sheet. "Hey, Bephens. Wanna come see?" She slips out and climbs over the side of the truck and into my arms.

Joey smiles at her. "Hey, sweetie! How old are you?"

She holds up three fingers. "Free."

Before he can ask me anything else that I'll sound stupid answering, I say, "My mom wants us to go look around."

"Great! It was nice to meet ya, and maybe I'll see ya later!" He walks back to the gas station, waving and smiling with the enthusiasm of a young mayor who wants my vote.

Walking down the sidewalk, my belly flips and flops, and I can't stop giggling about what just happened. Across the street, the kids are still hanging out in front of the pizza parlor. They look over at me, and I wave and smile—trying not to look weird.

Tumbleweeds—like I've only seen in cowboy movies—roll and bounce down the road, and it makes me wonder what kids do out here for fun. Then I think about being in Long Beach—with all its malls and movie theaters—and that wasn't as much fun as it's supposed to be, so maybe living here isn't too bad.

Mom drives up and stops the truck in the middle of the street because there aren't any other cars on the road. "Hop in! We're gonna drive around while Danny talks to some guys about a job."

The old truck chugs its way up skinny dirt roads while Mom points out broken cars and crumbling houses that look like they used to be fancy. "Wow. That woodwork is beautiful. Can you

imagine what it looked like when it was new? I wonder how many people used to live here?"

Like the stained glass Mom put in our front door with the rose in the Derringer, Austin feels both beautiful and a little dangerous—like the people who live here are far enough away from anywhere else that they can do whatever they want. Mom told me the closest real grocery store is over an hour away, and I haven't seen a cop since we got to town—which I admit I've been looking for.

"Here's the school." Mom parks in front of a two-story brick building that would be a mansion if it were a house. "I bet there's only one."

"For all the kids?"

"Probably. Might be nice to go to a little school like this instead of the huge one you said you're going to this year, huh? How many kids go there?"

"To Wilson? Like five thousand, I think? My friend told me the school has its own police department."

"Jesus Christ." Mom shakes her head in disbelief. "I heard there's five hundred people living here because of the mine. It's the most people they've had here in years."

"That kid at Chevron was pretty excited about everybody moving here."

"Oh, so you liked him, huh? Is he like a totally rad dude, or what?"

"Mom, stop. You sound silly talking like that."

"Well, gag me with a spoon!" She cracks herself up then says, in a more serious voice, "Hey, I don't know how it went this year, but your dad and Susie are newlyweds. It's probably been hard having you around because they're just getting to know each other, and so are you and your dad. Susie might be a little jealous sharing him with you. Maybe you should give them their space?"

"Like leave?"

"I think it's time to come home to your mama, baby."

I look at my mom, wondering if she remembers that it was her idea for me to move, not mine?

"Your sister misses you. Don't you want Bright Eyes to come home now?" She tickles Bephens.

"Yeah! Bite ice!" she giggles, trying to say my nickname.

Mom and Danny have both been on their best behavior for the past three weeks—which means they've been mostly sober and not fighting as much—and Danny hasn't made fun of me once, which I'm sure is killing him. Sitting in our truck and listening to my mom, I realize she's been buttering me up for this moment.

"So will you come home now?" she asks, making a show of fluttering her eyelashes.

"By home, you mean here?"

"Yeah. Danny got the job. He's filling out paperwork now."

Parked high on the hillside, we have a view of the whole town that Mom thinks should become my whole world. Then Bephens climbs in my lap, reminding me that my whole world is actually right here in this truck.

STANDING OUTSIDE THE PAY PHONE, my mom looks nervous—chewing the inside of her cheek and tapping quickly on the glass. "Dial the number. Tell him you're staying."

"I will. Gimme a second." I look down, doodling in the dirt with my big toe.

She taps again. "Call collect!"

I nod, *I know.* "I don't have any change anyway!"

Even though it's hot inside the booth and the sweat dripping down my arms is making the receiver slippery, I'm not about to open the folding door and let Mom listen to me break my dad's heart.

"Operator."

"Collect call from Bridey."

My dad picks up on the first ring. "Yes, I'll accept. Hel-low?"

I clear my throat. "Hi, Dad! How are you? How is everyone?" *Shoot. I'm talking too fast.*

"We're all doing good, kid." He's calm, like always.

But I'm not, and everything comes out at once—a messy verbal diarrhea of shit he doesn't want to hear, and shit I don't need to say. "That's great. Everything's good here, too. She's better. I mean, Mom is better. And we're in this little town right out of a cowboy movie. And Bephens loved the hug from you."

He's quiet for long enough that I almost wonder if he hung up. "You comin' home, baby doll?"

Staring at the rocks and sagebrush hanging onto the steep hillside next to the pay phone, I bite my bottom lip, hanging onto my answer. "No, I'm not. I'm so sorry, Dad."

He lets out a long, deep breath that I'm afraid he's been holding in since my plane took off three weeks ago.

I wipe my tears with my tank top, making sure not to cry because we both need to believe I'll be okay staying with her.

"Well . . . if that's what you want . . . I can't say I'm surprised . . . I knew she'd find a way . . ."

"I'm really sorry, Dad. It's just been hard being without Bephens, and she's so happy I'm here. I love you all very much and loved living with you."

He clears his throat, and I'm pretty sure he's crying. "We love you, too, and we're gonna miss ya. You take care of yourself, kid."

Mom taps on the glass. *What?* I mouth to her.

She opens the door and holds her hand out. "Let me talk to him."

Mad because I can't warn him, I drop the receiver in her hand harder than I need to.

We watch from the truck as she yells inside the booth with the door shut to keep us from hearing. She slams the phone on the hook and whips the door open. "It's done! You're staying! Now, let's blow this pop stand and find a place to live!"

CHAPTER 18

Baptism by Fire

*D*anny stays in town to find a place for us to rent—which I know means getting drunk and looking tomorrow—while we head to a campground on the outskirts of Austin where Mom says we're staying until we find a house.

"Camp?" I look out the window at the empty valley of sagebrush that might as well be the moon for how familiar it is to us. "Are you serious? We're not campers. Do we have a tent? Sleeping bags?"

Mom is too busy dodging potholes on the dirt road to discuss. "It's a night or two. You'll survive."

She slams a deep rut, sending me into the dashboard. "Ow! Can you slow down?"

"We have to get there before dark." She snickers, letting me know she's not sorry.

We pass a brown forest service sign with yellow lettering—*BIG CREEK CAMPGROUND HIGH FIRE DANGER $250,000 FINE.*

"Two hundred and fifty thousand dollars? For what?" I ask, with as much appreciation for the desert as any girl my age who's been searching for a mall since leaving Long Beach.

We drive through a tunnel of leafy trees into a dirt clearing, and Mom pulls into one of three spots, each with a picnic table and a fire pit. "How bitchin' is this? We're right next to the river!"

"Mom, that's not a river. It's barely a creek," I correct her—something I can do when she's sober. I think I'm also pushing my

luck because it was only a couple hours ago that I chose her instead of my dad, and I'm curious how much that's worth.

"But it's a *Big* Creek!" She cracks herself up. "Why do you always have to be right, Bridey? It's fuckin' irritating!" Mom hops out of the truck and grabs her green kitchen broom from the back next to the other stuff she packed "just in case."

Whisking away loose pebbles and small sticks, Mom sweeps the dirt clean. It probably looks weird to somebody else, but I know she's setting up house. It's her second favorite thing to do—packing to leave is her first.

She arranges rocks in a circle around the fire pit then glances over at the truck, probably wishing she'd packed her peacock feathers and silk scarves to make it look homey—even if we're only here for a day or two.

Seeing me standing still, she points to the woods on the other side of the truck. "Take Bephens and look for kindling!"

"You're building a fire?" I pull my tank top away from my body to show her that I'm sweating. "It's a million degrees out."

"Yes, smart-ass, I know. But it gets cold in the desert at night."

I roll my eyes for Bephens to see, and when she tries to roll hers, we both crack up. "Let's go get the crazy lady wood."

"I heard that!" Mom yells.

A few minutes later, we return with an armful of the skinniest twigs I could find because I don't want Mom building a bonfire. "Here." I drop the sticks, and something red flashes in the corner of my eye. She's holding a red gas can and a jar.

"Mom? What are you doing?"

She ignores me and fills the glass jar full of gasoline.

"You sure we need that?"

"It's fine. This is the way we do it in Juneau."

"But that's a rainforest—"

Before I can finish pointing out why it might be different building a fire in a place that never stops raining versus a dry desert, everything happens in a flash. Mom pours gas on the fire, flames

ricochet back into the jar, and she flings it into Big Creek as she screams, "Holy shit! Shit! Shit!"

In the knee-deep water, we see the glass land on the rocky bottom. I'm about to say, *That was a close call!* when an orange-and-blue flame flickers on the surface.

Then another.

And another.

In moments, the flames connect into a fiery blue-and-orange tail, whipping across the water and under the overhanging trees. I've never seen fire float on water and am stunned, watching the flames race away from us and toward the valley of dry desert sagebrush.

"Bridey! Put it out!" Mom hucks the broom at me. "Hurry!"

Barefoot and bare-legged, I jump into the water and sharp rocks stab my feet. "Ouch! I need my shoes!"

"There's no time! You have to catch it!" She shoos me down the creek. "Slap the water with the broom!"

All the quarters I've ever plugged into arcade games suddenly pay off as my eyes track the flickering tail darting left then right like Pac-Man swallowing flashing dots. Juking back and forth, I feel like the frog trying to get through traffic in *Frogger* as I raise the broom over my head and smack the flames under the surface—over and over and over—like clubbing stuffed rodents into their holes playing *Whac-A-Mole.*

Within seconds, the flames are gone.

Clutching the green broom against my chest, I hear myself panting and chanting, *Thank you, thank you, thank you, thank you* as I slosh back upstream. Checking over my shoulder to make sure the fire is really out, I trip over a rock and stumble to catch myself. I look down and see my shins are scratched and bleeding into the cool water that's numbing them. "Mom? Can you help me?" I reach for her hand, but it's not there. I look around and see her standing by the truck, holding Bephens and watching from a distance.

Limping toward her to get a rag for my bleeding legs, my mind flashes back to Coho Park—her laughing with the other moms as

she yelled for me to *jump!* And, because I was twelve and afraid of her, I did jump—embarrassed but obedient—and asked, *How high?* instead of *Why?*

"Are you okay?" Mom asks when I get to the other side of the truck.

Ignoring her stupid question, I look for a towel.

Bephens comes around the side and carefully touches my shin. "Owie. You k, Bah-dee?"

"I'm fine." I kiss her and wipe my skin harder than I need to because I'm actually not fine at all. A year away from my mom, and nothing has changed—still jumping in to save her, still putting out fires she not only makes but pours fucking gasoline on. The scratches and gashes burn now that they're out of the cold water, and I blow on them—pissed that these aren't her legs. Pissed because she should've jumped in the water. A good mom would've thrown herself into the fire instead of pushing in her kid, but even after everything I've done, this shallow creek was too deep for her.

Behind me, she lifts Bephens up and twirls her around, like a shield between us. "She did it! Bridey saved us!"

Watching them celebrate, I can't believe she convinced me to stay—can't believe I called my dad. He'd given me a chance to have a normal life, and I blew it because I don't know how to be normal. A few hours ago, I was still flying back to Long Beach in a week, but now I'm at a campground in the middle of nowhere—too embarrassed to call and tell my dad I lied about my mom being better or to ask if I can still come back.

Danny never makes it to the campground.

In the morning, we head into town to find him. Passing by the *High Fire Danger* sign again, I want to steal it and hang it on the house we rent because our new neighbors deserve to know what the real danger in the valley is.

CHAPTER 19

The White House

"Mom, is that our landlord?" I point at the man riding his horse down the dirt driveway. "Look, Bephens! It's a cowboy!"

Slowing his shiny brown horse up next to the porch where we're standing, the man tips his dusty cowboy hat to us. "Hello. I'm Lavar Young, and this here's my place. Met Dan last night in town, and I'm happy to have y'all stay here."

"I'm Frankie, and these are my daughters, Bridey and Bephens. Dan is already at work on the mine and loves it!" Mom says, in a perky-cheerleader voice she probably hasn't used since she was on the squad in high school.

"Glad to meet y'all."

Mom's tone switches to syrupy-sweet. "We just *love* it out here, Mr. Young. I've *always* wanted to live in the country, and we promise to take *really good* care of your house."

Apparently, while Mom and I almost committed arson at the campground last night, Danny and Lavar signed a lease with a handshake. Poor, trusting cowboy doesn't realize who he's handing his housekeys over to. As my mom continues lying to the man's face about a vegetable garden that she's gonna plant and other stuff I doubt she'll do, I want to pantomime like I'm slitting my throat to warn him: *Don't do it. Don't let us live here. We're gonna destroy your house.*

He points at the mountains across the Reese River valley where we are. "I live on the other side of that range with my wife and ten children. They go to the school in town." He smiles at me. "My daughter Sharolyn is about your age. I bet you'll get along real well."

"Bridey already met the cute boy at Chevron, and they got along *real well*, too." Mom snickers and nudges me with her elbow, like I'm supposed to think her hinting about me being a slut is funny.

Lavar doesn't hear her or ignores the comment and pats his horse's neck a couple times. "Well, I'll leave you to it and check with Dan next week to see if y'all need anything."

The three of us watch as he gallops back down the driveway and crosses the highway to the meadow on the other side. With the cowboy out of range, Mom's real voice returns. "Holy shit! What a polite man. But how many kids did he say he has? Christ. Must be Mormon."

Not familiar with any Mormons other than the smiley Osmond family who sing and dance on their TV show, being Mormon looks way more fun than whatever our family is. "Let's check out the horse corral," I say to Bephens, lifting her to sit on my shoulders like my first dad, Jim Cargill, used to with me. "Hang onto my hair like you're a cowgirl." She grabs her reins, and we gallop away.

"We're gonna get some horses!" Mom yells after us.

Across the corral, the wide open valley looks like an amazing place to ride, but the one time I got on a horse, I was scared to death. Behind us, I see a tiny shack I wouldn't be able to stand up in. "Mom, what's that?"

"It's a pumphouse." She walks over, saying it with the confidence of someone who's lived on a farm—which she hasn't. "Our water comes from a well in there."

"Wow. Kinda feels like *Little House on the Prairie*."

"Yep!" Mom smacks my butt. "You'll have a lot of chores to do."

"What else is new?" I shake my head and gallop Bephens around the rest of the yard. My eyes follow the highway as far as

they can, but I still don't see town. "Hey, Mom?" I ask, seeing her with the green broom that saved the day last night. "How far away in Austin?"

"About twelve miles."

In the other direction are little boxes that must be where our neighbors live. "And how many miles away are those houses?"

She stops sweeping the front porch—which is a losing battle because the whole yard is dirt—and squints, gauging the distance. "Maybe five miles? You could probably get there in an hour if you jogged—like you would ever jog!" She cracks herself up because I'm not much of an athlete, even though that would've meant she had money to register me for sports, time to organize snacks for the team, and the willpower to stay sober enough to pick me up from practice. Proud of herself for getting in a dig, Mom turns on her heels to go sweep dirt somewhere else, adding, "I love that they're far away, though, because we don't need nosy neighbors!"

Yes, I do.

I holler, "Do we have a phone?"

"Nope!" she snaps back, cackling like it's her evil plan to keep me from calling my friends—or my dad.

But what about calling for help? I blow out all my breath and squint, gauging the distance to the houses for myself and wondering how fast the sound of a scream travels.

I CARRY BOXES AND TRASH BAGS inside the house, opening a door I assume is the garage. A wave of cold air passes over me from the dark room that isn't a garage or a bedroom. The light from the living room window shows two pillow-size stains on the concrete. "Oh, my god! What's on the floor?"

Mom scoots by me and steps down into the room. She pulls on the long cord of a bare lightbulb hanging from the ceiling. Next to her, a metal pole hangs like a clothesline over the splotches. "It's blood," she says, pushing the pole as it swings back and forth.

"What?" I step back from the doorway.

"Probably deer blood because this looks like a room where they bled out animals."

"Come on, get out there!" I wave her out of the room, not caring how she knows this. "It's disgusting."

Her silhouette on the wall behind her, she throws her hands up and looks around the nearly pitch-black room. "It's not like people were killed here. I'll just put rugs over it."

"You're gonna sleep in here? Are you serious?"

"I grew up in Alaska, remember? All my uncles hunted, so we had dead shit hanging around all the time." She steps up out of the room. "It's dark in there. I'll sleep better."

Grossed out that my mom's new bedroom used to be a slaughterhouse, I head out to the front yard to get some fresh air. Standing on the dry, cracked dirt Mom promised Lavar she'd turn into a garden, I breathe in a burnt, earthy smell that I learned yesterday is sagebrush. A warm breeze blowing over the house spins and lifts tufts of tumbleweed, bouncing them high in the air. The sky is too big to take in all at once, so I scan it in parts—forever to the left, forever to the right, and the little house in the middle of the big valley.

The emptiness doesn't feel as peaceful as I think it's supposed to, and we're not the people Mom wants Lavar to believe we are—friendly folks who live quietly, growing their own food and hanging out on the porch listening to crickets. We disturb the peace most nights, our vegetables come in cans, and Mom screams too loud to hear crickets—or whatever bugs make noise out here that she'll smash with her shoe anyway.

Mom also told Lavar she's *always wanted to live in the country.* Even though I've never heard her say that before, I think what she really meant is that she's always wanted to live somewhere that she and Danny could do whatever they want—and get away with it.

This house *is* perfect.

For them.

CLOUDS DRIFT SLOWLY OVERHEAD—CHANGING the warm and cozy cream-colored house Lavar gave us keys to into a colder and paler white. A gust of wind slaps sticks and small rocks against the mud stained in patterns on the stucco—some darker and some light— reminding me of the patterns of bruises we've tried to heal—some deep and some old. All stained.

A stronger rush of wind claps a door open and shut in another part of the yard. I walk around the house and find the pumphouse door flapping. Quickly locking it with the metal hook on the frame, I creep myself out imagining getting trapped inside the way they do in scary movies.

The wind slams the corral's wooden gate so hard I'm sure it's cracked, and a swirling stirring of pebbles whips itself into a funnel toward the sky, like a smaller version of the tornado that carried Dorothy's house to Oz. The wind continues whipping itself around the yard, and the little house with battered sides and cracked stucco looks fragile—like it's hunkering down and holding onto its foundation for dear life—hoping not to be carried up, up, and away.

Bephens opens the kitchen door and runs to me.

"Hi, big girl!" I sweep her up in my arms. "Let's go see our bedroom!"

Walking across the yard, I think about the warning I wanted to give Lavar—*Don't do it. Don't let us live here. We're gonna destroy your house*—but wonder if maybe this house is gonna destroy us, too?

CHAPTER 20

The New Girl (Again)

"Okay, you're officially an Austin Bronco!" the kind lady at the front desk says with a sweet smile. "School starts Monday, and Cecil Rose will be your bus driver. She lives out past your house."

With my new Molly Ringwald bob Mom gave me by cutting off my mullet, a little foundation, light mascara, and lipstick—Wet n Wild #528, of course—it takes me a lot less time to get ready for school than it did in Long Beach with all the layers of eye shadow and gallons of Aqua Net. Eating my toast and watching out the front window for the school bus, I reread the note Mom left for me on the kitchen table and put it in my pocket as good luck for the day.

Hope you have a great first day at school!
Eye la view
Mom

THE SCHOOL BUS, A YELLOW VAN PAINTED with black stripes, comes down our dirt driveway and honks.

A woman with twinkly eyes, a huge smile, and pink cheeks motions for me to open the back door. "Good morning! I'm Cecil, your bus driver."

"Good morning," I say, taking my seat and giving the kids in the van a tighter smile than I mean to because, for some reason, I'm more nervous than usual about starting a new school.

As Cecil pulls onto the highway, she talks to me through the rearview mirror. "That's my daughter, Ellie, and our neighbor, Chris—they're a couple grades younger than you—and my sons, Charlie and Alex, who are seniors this year—and twins, just not identical."

I turn around and make sure to give them a much friendlier smile. "Hi, I'm Bridey."

"Our house is about five miles from yours," Cecil says, confirming Mom's guess. "I pulled up today because it's your first day, but from now on, you'll meet us at the road."

"Okay, thank you."

"And, just so you know, if you aren't at the road when I stop, I'll wait a minute then assume you're not going to school and leave."

"Okay."

"You don't have a phone, do you?"

"No."

"You can always come use ours."

"Thank you."

For the rest of the drive to town, Cecil asks me a million questions. "Do you like the house? What does your dad do? What does your mom do? Where did you live before? Do you have any brothers or sisters? Do you play sports?"

Thrilled to have a nosy neighbor, I answer all her questions. When I tell her I probably won't try out for any teams, she whips her neck around—driving without looking—but the road is totally straight, so it's not like she's gonna kill us. "You have to play sports because it's the only way for kids to get outta town. The schools we play are far away, so every trip is overnight. You'll love it! I think basketball and cheerleading tryouts are soon, right, boys?"

Alex says, "Yeah, later this week, I think."

Cecil parks outside the school, and there are kids of all ages huddled together with new backpacks. Some younger ones chase

each other on the playground, and others who look about my age are hanging around the steps by the school's front door. "You'll do great." Cecil smiles. "Charlie and Alex will introduce you to everyone."

When the boys get out of the bus, they're taller than I thought. "You play basketball?"

Alex chuckles. "Everybody here plays basketball."

I figure he's referring to his mom's comment about getting out of town.

Charlie, who's as tall as Alex but a little skinnier and with curlier hair, points to the group on the steps. "Come on, we'll go meet everybody. It won't take long because there's not a lot of us." He laughs. "But I heard this is the most kids we've had in a long time." He looks at Alex. "What'd Mom say, like thirty or thirty-five?"

"In the whole twelfth grade?" I ask.

The boys laugh. Charlie says, "In the whole high school. But if you count the elementary and middle school—which are here, too—it's probably like sixty."

"Wow. The school I was supposed to go to has like five thousand."

The boys' eyes get big. "Well, we'll see how you like it here," Alex chuckles again. "Hope you don't die of boredom."

A gorgeous girl with a big smile and way bigger boobs than me walks up. Her brown curls bounce as she talks. "Hi! I'm Sharolyn! My dad owns the house you're in!"

Lavar was right. I love his daughter.

Over her shoulder, the young mayor from the gas station is standing next to a blue truck. He sees me and waves. "Hey! You stayed!"

Keeping my arms at my side in case I'm sweating through my pink T-shirt, I give him a half wave and keep my mouth shut to keep the butterflies in my stomach from coming up my throat and making me barf. Saved by the bell. It rings before he can walk over.

Sharolyn and I head to first period. It's packed. "Is the whole school in this class?" I joke.

"Yep. We take almost every class together, except English—that'll just be sophomores. I think there's like six of us."

"Six?" I hear myself and decide to stop acting so surprised at how small this town is because it might sound rude. Truth is, I'd rather be here than Wilson High in Long Beach that I heard takes up a whole city block.

By the end of the first day, I've been invited to try out for the cheerleading squad and girls' basketball. I've also been invited on my first date.

"What's a tire fire?" I ask Joey when he tells me that's where we're going.

"Where you burn tires?" He laughs, probably because the answer was pretty obvious. "A bunch of us are going. You'll like it."

Burning tires doesn't sound that great, but I couldn't care less because it's a date with the cutest boy who's ever given me the time of day.

"MOM, DON'T TALK ABOUT IT. OKAY? Everybody's gonna be there."

"But you're going with *Jo-eeey*," she sings and raises her eyebrows a couple times. "Hubba-hubba."

"It's a bonfire, not a fancy dinner or anything."

"Well, you make sure he gets you home by the morning—"

"Morning?" I stop her before she makes another slut joke. "I'm not gonna be out all night."

"Jesus Christ, I'm kidding. I'll talk to Danny about your curfew."

"Curfew?" I shake my head because I've never heard her use a parenting word in my life. And we both know I'm a way better parent than she is. "Will you teach me your cheer now?"

"Yes!" Mom jogs in place for a couple seconds, excited to show off the cheer she still knows from high school. She claps and chants, "Victory! Victory! is our cry! V-I-C-T-O-R-Y!"

I follow her moves a few times while Bephens jumps around doing her own cheer.

"Thanks, Mom. I'll practice a bunch before Friday."

At the end of the week, Sharolyn and I try out for the girls' varsity basketball team and varsity cheer. We make JV for both—in a school of thirty-five kids. After that, we're officially best friends.

AFTER JOEY THROWS A COUPLE TIRES on the fire, we hang out for a while with the kids standing around it—some drinking beer, some smoking cigarettes, and everyone dodging the giant plume of black smoke. Wearing my white sweater was a bad idea.

"Wanna listen to some music in my truck?" Joey asks.

"Okay," I say, nervous but also excited for my first *real* make-out session, because every teenage girl knows what a boy's invitation to *listen to music* really means. He pushes play on his cassette deck, blasting AC/DC's "You Shook Me All Night Long" and singing for a second before leaning over and kissing me—which rings all the bells and blows all the whistles as fireworks explode around us—or maybe only in my head.

"Let's go up there," he says after a couple minutes and points to the small bed in the back of the truck's cab. "It's where I sleep when we go hunting."

While AC/DC belts out their next song, he moves on top of me, and we kiss. When his hand slips under my shirt, my instinct pushes him away. When he tugs at my zipper, my fear whispers, "I don't want to."

He stops for a moment, and his hot breath in my ear shivers my whole body. "The doors are locked. Nobody's gonna bug us."

I wiggle under him. "I'm sorry, but I've never done *it* before—"

He lifts himself up just enough to look in my eyes in the almost-dark cab. "What? You've never—"

"No."

"You mean you're a . . . virgin?" he asks, laughing a little.

"Uh, yeah," I say, not sure why it's funny.

He doesn't say anything else—just climbs into the passenger seat and yells out the door to make sure all the other kids hear. "You're a virgin? I didn't know there were any virgins left in high

school!" Joey laughs himself out of the truck. "A virgin! She's still a virgin!"

Shit. There's no way to get out of this without totally embarrassing myself. Getting back in the passenger seat, I watch out the window as Joey walks around the fire, probably telling everybody what happened. He's been so nice, but this feels like something right out of a movie—the popular boy making fun of the dorky girl who won't put out. I thought moving here would be different from Long Beach—that I wouldn't be the loser who needed a makeover and had no friends. But the first chance I get to fit in, I blow it.

Joey walks toward the truck, and I wipe away tears he's definitely not gonna see me cry, straighten my white sweater that's now gray, and smooth out my messy hair.

He gets in and starts the truck. "It's late. I'll get you home." He turns up AC/DC pretty loud, so neither of us feels like we have to talk. "See ya at school," he says when he drops me off, smiling like everything is okay, and I really hope it is.

In bed with Bephens, I replay the whole night—wondering if his smile meant he still likes me, or just that he's not mad about what happened? And the kids laughing have really all done *it*? I mean, I've only been fifteen for a few days. That doesn't seem too old to still be a virgin. Bephens snuggles closer to me, and I kiss her forehead. Joey doesn't realize I've been a dad since I was eleven and know what it's like to have a kid so pissing off the popular boy is way better than getting pregnant.

At school on Monday, Joey isn't falling all over himself to ask me out again, but he's nice enough—even pretending not to notice when I cheat over his shoulder in geometry class—and, luckily, the other kids aren't acting like the new girl has weird-virgin cooties.

IT'S BEEN A FEW WEEKS SINCE WE MOVED into the white house, and life is uncomfortably fine—like we're all faking whatever role we're supposed to be playing.

Danny is man of the house who makes more money than he ever has, and Mom is the stay-at-home kind who cooks, cleans, and putzes around the yard—even planting perennials like we'll still be here next year to see them bloom. Bephens is a silly three-year-old who chases chickens around the property, and I almost feel like a normal teenager because I get to go to basketball and cheer practice and still have time to do my homework and draft letters that I'll never send to Duran Duran because postage to England is too much money. But I still write, promising to turn some of the kids here into Duranies, and even though my records are still in Tahoe, I sing their songs every day because I know all their lyrics by heart.

Because I don't trust the *grass-is-really-greener* spell this house seems to have cast over us, I feel like I'm walking on eggshells—knowing I'm gonna do something that will piss Mom off, or that Danny will remember how much he hates Bephens, and then things will be back to the normal *abnormal* we're all used to. Like the quiet at my dad's house, the silence in this valley is so loud I can't sleep—sometimes I even slip out of bed and crawl to my door to listen, just in case my mom needs me.

"MOM, THEY'RE ALMOST HERE!" I HOLLER from the porch when the Rose boys' headlights turn off their dirt road onto the highway toward our house. I run to the bathroom for a last-minute look at my homecoming outfit. Charlie invited me to the dance and said no one dresses up, but I still have on my nicest outfit—a polka-dot top, white miniskirt, and white pumps I used to wear to school in Long Beach but not here.

I watch as Charlie and Alex get out of their minivan and smooth their hair and shirts. Alex seems to slow his steps to let Charlie get to my door first.

A boy has never picked me up from the house, and none of us really know what to do. Bephens nearly trips Alex and Charlie when they come in the door because she wants them to see her toy, then Danny spills his Budweiser trying to get off the couch when he realizes Charlie wants to shake his hand.

"Thanks for letting me take your daughter to the dance," Charlies says.

"Daughter?" Danny laughs. "Oh, yeah, sure. She's not much fun, so good luck." He grins at me. "Or maybe you are when you're not here, huh, *Birrrd*?"

And just like that, Danny teases me, breaking the spell.

Mom calls from the kitchen, "Hey, boys, come and get it!" She holds up tequila.

"Mom, no!"

"Don't be such a stiff, Bridey. I'm sure the boys could use a drink."

Alex looks at Charlie and chuckles. "I mean, why not?"

"Mom, they're driving."

"It's one shot, Bridey." She hands the glasses to the boys. "You'll be fine, right?"

The boys grin at each other and take their shots. "Thanks," they say together.

My mom sticks her tongue out at me and points with her index finger. "Jesus Christ, how'd you get to be so straight, Bridey!"

"It's because you're so crooked," I say, hooking my index finger.

"Maybe Charlie should take me to the dance instead of you!" She laughs and slaps his butt. "Have fun, kids! Don't do anything I wouldn't do."

CHAPTER 21

Stranger Danger

"*I* don't want to hold it." I put my hands up between me and the gun, confused about why Danny is suddenly acting like a super-concerned dad who wants to protect his kids.

He continues loading his handgun without looking at me. "You need to know how to shoot in case someone shows up and we're not here."

"You think I can actually shoot someone? Are you serious?"

"You never know what kind of crazy motherfucker might pull into the driveway." He aims the gun at the sky. "You can at least fire it off and scare the shit out of 'em."

"This is stupid. No one is gonna come out here," I say through gritted teeth but know he isn't gonna stop until I shoot something because he's having way too much fun. "Fine. Let's just do this."

Putting the gun in my hand and placing my fingers around it, he doesn't ask if I'm scared or nervous—even though he knows the last gun I saw was Al's when he aimed it between my eyes. "Hold it like this," Danny says and points across the corral. "See your targets over there?"

"The cans?"

"Yeah. You gotta close one eye and line up your shot."

He's too close and stinks like old beer and cigarettes. "Got it." I hold my breath.

He nudges the back of my knee with his. "Spread your legs some. You need a strong stance, or it's gonna knock you on your ass. You ready?"

I nod because I can't speak and just want this over with.

"Aim."

He positions the gun.

"Fire!"

I pull the trigger with my eyes closed.

It knocks me back, but Danny catches me. I quickly shake loose from him and fight the urge to wipe off all his cooties, distracting myself by trying to find where my shot landed. "Did I hit anything?"

"Nope. But you did good."

"Good? I missed."

"You pulled the fuckin' trigger. That's all you have to do if someone shows up. Who cares where you hit 'em." Danny laughs. "I'll show you where I keep the gun in case you ever need it."

"Okay, whatever." Walking back to the house, shaking my head and laughing a little, I can't believe how stupid that was. Danny really thinks I'm more afraid of strangers than the people we know—the ones who've actually hurt me? *Such an idiot.*

FROM OUR PORCH, I'VE BEEN WATCHING for our car's headlights for hours because Mom and Danny have been gone longer than she said they'd be. Once a car makes the turn onto our highway from town, it's about ten minutes to our house.

Suddenly, a car's lights shine in our direction, starting the ten-minute timer.

The crap-brown Ford Galaxie Danny bought drives like a boat and has bouncy springs I can hear before the car pulls up. Whoever is driving tonight takes the turn into our driveway too fast then hauls ass down the dirt road, kicking up dust. *Shit. My spidey-senses are warning me to get ready. I knew it was too good to last.*

"Bephens? Where are you?" I run inside the house and see her

playing in our bedroom. "Stay there, okay?" She nods and picks up her silky bunny.

Our Galaxie rumbles across the gravel behind the kitchen. Two doors creak open, and slam shut. Mom shouts something I can't quite make out, but I know it's not good. Closing our bedroom door, I smile at Bephens. "I'm gonna shut this, okay?"

"Why, Bah-dee?"

"Just don't come out, but I'll be right back."

Her eyes get big, and she climbs into our bed.

Danny stumbles through the kitchen door first. Mom is on his heels, grabbing for his beer. "You think you're so great, Dan? You think you can do anything you want?"

Danny fends her off with one arm. "Get your fuckin' hands off me!" She makes another grab for the can, and he backhands her across the face. She yelps and grabs her cheek.

"Leave her alone!" I yell at him.

Mom hucks a plate at the back of Danny's head. "Stupid son of a bitch!" It misses and smashes into pieces on the wall in front of him.

"Mom, no! Stop!"

Danny grabs her sweatshirt and forces her down into a kitchen chair, pinning her arms back and shouting inches from her face. "Don't you fuckin' move!" He walks to the living room, brushing past me. "You cunts deserve each other."

I drop to my knees next to my mom's chair. "Are you okay?"

She sobs and slobbers. "I hate him! I fucking hate him!"

"It's okay, Mom. It's over." I look in the living room and see Danny on the couch, nearly passed out. "He's asleep. Let's get you to bed."

As I'm helping her get undressed, she begins to heave—my signal to hurry up and get a pot by her bed. I hustle through the living room, and Danny cracks his eyes open and slurs, "Get me a beer . . . *Birrrd!*"

"Why don't you just leave?" I shout and head into the kitchen. On my way back with the pot, he's out cold.

After dumping Mom's puke in the toilet and making sure both of them are asleep, I open my bedroom door and see Bephens asleep under our bed. She didn't forget where to hide when things get scary.

THE SMELL OF BACON AND coffee wakes us up.

In the kitchen, Mom waves her spatula. "Good morning, girls! Who wants eggies?" She's already done the dishes and is halfway through a pot of coffee.

Bephens climbs into a chair. "Me, peas."

I look around for the broken plate, but it's been picked up. We're back to normal—doing that *morning-after* thing—the great pretending that all hell didn't break loose last night. Whoever got up first threw away the smashed plate and washed out the puke pot. For a couple hours this morning, we'll act like a family, eating breakfast and talking about the day ahead. Nobody will say anything about what happened—no cheap digs, no shitty comments, and no apologies asked for or given.

Danny is nursing his hangover on the couch with a plate of bacon and eggs, and even though I'm dying to say something crappy about what he did, I keep my mouth shut because the fake forgetting feels way too good.

The sun came up, which means we made it through the night.

Again.

CHAPTER 22

Happy Holidays

"*I* just called Grandpa Dwight, and he's coming for Thanksgiving!" Mom squeals as she gets out of the Galaxie.

"He's coming all the way from Alaska?"

"No, he lives a couple hours away. Moved to Nevada years ago."

"I've never met him, right?"

"I don't think so, but you'll love him. When Grandmother married him, I thought he looked like a movie star."

"So, he's my uncles' dad, right?"

"Yeah, he married Mom a few years after my daddy left." She strides past me into the house. "Move your ass! We gotta get this house clean!"

FOR THE NEXT TWO DAYS, WE BLEACH countertops, wipe down walls, and rearrange the furniture.

"She really chased him down in a plane?" I stop washing the plate in my hand, not sure if I believe my mom.

"Yep!" She flicks me lightly with the towel she's folding. "She got her brother to fly his plane down the highway until they saw our station wagon, then landed on the road right in front of him. Can you imagine? Dwight was probably shittin' bricks watching Mad Martha get out the plane and walk toward him."

"What'd she do?"

"Told him it was time to come home."

On Thanksgiving, Grandpa Dwight's dark sedan barrels down our driveway, spitting rocks and dirt behind it. Mom runs out to meet him, blushing and giggling like a teenager whose prom date finally arrived. As she opens his door, she has to catch Grandpa Dwight before he falls out onto the dirt. A couple beer cans beat him to it. I can't hear what she's saying, but they're both laughing.

The movie star Mom is helping to his feet has on a brown polyester suit he's probably owned since she was little, and his saggy eyes and slicked black hair he obviously dyes remind me of bloated, Vegas Elvis. I hide Bephens behind my legs as Mom struggles to get her stepdad into the kitchen.

"Thanks for helping your old man, Frankie," he says, smiling with a mouthful of missing teeth and putting Mom in a loose chokehold like wasted people do when they're happy to see you.

Danny shakes Dwight's hand by putting a Budweiser in it and asks, "How's Martha?"

"She never shuts up!" Dwight laughs and takes a swig.

"Mom, why are they talking about Grandmother?"

She grabs a beer. "They're not. Dwight named his pet crow Martha because he said the bird squawks all the time like she used to when they were married."

Dodging the chokehold my grandpa tries giving me after Mom introduces me and Bephens, we follow them around the yard as she shows Grandpa Dwight the chickens and the corral. He saunters behind with Danny, drinking beer and pretending he's interested. Watching how excited she is and how rude they're being, I'm not too impressed with my grandpa.

Back inside, Danny turns on the one channel we get to watch the football game that's on, while Mom spreads out fancy doilies on the kitchen table. "Go ahead and set it," she says.

"The table?"

"Yes, the table. Smart-ass."

I fold a few smaller towels for napkins and put out our mismatched plates and bowls. "Done!" I announce, waving my hands over the setup.

Mom doesn't hear because she's trying to squeeze into the conversation Danny and Dwight are having in the living room.

"Life gave us a raw deal, Dan."

"The short end of the stick, Dwight. But whatdaya gonna do, because life's a bitch and then you marry one!" The two drunkards chuckle into their beers.

"No wonder why you haven't married her!" Dwight smacks Danny on the back.

"Like I'd marry him?" Mom laughs with them, even though it doesn't look like they heard her.

Watching from the kitchen, I can imagine my mom as a little girl, spinning around in her Sunday best and tight pigtails, hoping someone will pay attention to her. But her mom is at work, and her first dad—who she calls "Daddy" and said was a gentle, sweet drunk—left and never came back.

I open the cans she set out for Thanksgiving dinner: yams, green beans, creamed corn, fruit cocktail, and cranberry gelatin with the can grooves on the side. The turkey went in late this morning, and I'm hoping it's done before everybody passes out.

"Don't you touch me!" Mom shouts.

I put my finger to my lips for Bephens to be quiet and scoot her and her toys to the other side of the kitchen floor to keep her out of sight. *Stay there*, I mouth to her.

In the living room, Mom has Danny against the wall. Shocked to see her doing this to him, instead of their usual style, I keep quiet and don't move.

He shoves her hard, and she lands in the big chair next to the couch where her stepdad's brown suit matches the ranch scene on the velour material. I still don't move because I know Dwight is gonna get up any second and help his daughter.

Danny straddles my mom and slaps her in the face. "You done?"

She writhes under him, pushing out a word with every exhale. "Don't . . . you . . . do . . . this!"

Danny shoves his forearm under her chin, his weight holding her deep in the cushion, as she twists from side to side. "You done now?" A final slap, and she whimpers under him and stops moving.

"Do something!" I scream at Dwight—who I decide this very second that I'll never call *Grandpa*.

Danny pushes himself up off my mom and grabs his pack of Marlboros to take outside.

Grabbing a washcloth from the table, I run to my mom and wipe her face as she sobs into my rag—maybe more embarrassed than hurt. I shake my head at Dwight, disgusted. "I can't believe you didn't help her! What kind of dad are you?"

He stares through me at the white wall on the other side of the living room, then takes a swig of his beer and struggles to get off the couch—nearly falling. Without a word to my mom, he staggers out the kitchen door and drives away.

"I'm glad he left," I say, picking up Bephens and moving her toys out of the way with my foot. "Now we can have our own dinner—just us."

With Dwight probably passed out on the side of the road somewhere and Danny passed out in the bedroom, the three of us sit at our fancy table and eat cold Thanksgiving straight out of the cans.

It's almost Christmas when Cecil drops me off after the basketball game. I hoped Mom would come to watch, but she hasn't seen a game yet—maybe because the only two points I've ever scored were when I rebounded the other team's ball and put it back in for them. We turn onto our driveway, and Cecil's tires make fresh tracks over the snow that's been coming down hard since we left town.

"There's no lights on. Think anyone's home?" she asks.

"Maybe not, but I'll be fine. They have Bephens, so they probably went to Fallon to get groceries and do some Christmas shopping."

Cecil parks under the light of the streetlamp in our yard that you can see from everywhere in the Reese River valley. "She didn't tell you? It's not like running into town to get milk." Cecil laughs, but I know she doesn't really think it's funny. "You want to come home with me until they get back? We can see your lights come on from our porch."

"No, I'm fine. Thank you. I'll make dinner and do my homework." I open the minivan door, and the wind whips snow inside.

"Pick you up in the morning!" Cecil waves and heads back down our driveway.

The kitchen door is locked. I run around to the front door, and it's locked, too. All the windows are locked. The house is sealed tight, like we have anything worth stealing. Standing on our porch, I search for headlights in both directions. Wearing only my basketball shorts and a sweatshirt, I'm freezing, but it's too far and too embarrassing to walk to Cecil's house. I walk around the back to check the windows one more time, and I notice a sliver of light in the pumphouse door.

I unlock its hook; the bare bulb hanging over the five-gallon bucket is keeping the tiny space warmer than outside. I take a seat on the bucket and close the door. After a few minutes of wondering if I'll have to sleep in here or break into the house, headlights flash through the crack in the door.

Expecting our Ford Galaxie, I duck out and wave to let them know I'm here, but it's Cecil's van. She pokes her head out the window. "Come on before you freeze to death!"

Warming my hands on the dashboard heater, I say, "Thank you for coming back."

"I kept watching for your lights to go on, and when they didn't, I turned around in my driveway and came back."

"Guess they forgot to leave a door unlocked."

"You lock your doors?" She looks around the pitch-black valley and laughs.

Everybody is asleep, except me and Cecil, when our Ford Galaxie pulls up to her house. "Finally," Cecil says, standing at the window with her arms crossed.

Knowing Mom won't come to the door, I grab my backpack and hug Cecil. "Thank you, again."

She hands me the rest of my dinner wrapped in aluminum foil. "You're always welcome here, you know that."

On the way home, Mom tells me the snow made the drive back take twice as long. "I figured you'd be at Cecil's."

"Yep." I snuggle Bephens in my lap. "Almost froze to death in the pumphouse waiting for you. Good thing we have nosy neighbors."

"Jesus, you're so dramatic, Bridey."

IT'S CHRISTMAS EVE, AND I'VE ALREADY given Bephens her bath and tucked her in.

"Good night, Mom." I kiss her on the cheek. "Merry Christmas."

"What? Where are you going?"

"What do you mean? I always go to bed early on Christmas Eve."

She shakes her head and looks at me like I'm nuts. "Not this year, you're not." Pointing with her Budweiser to a long box by the door, she says, "It's your turn to play Santa. I'm going to bed early while you stay up and put that wagon together."

"Mom, are you kidding? I don't know how to do that."

She guzzles the last of her beer. "Well, you better figure it out, or you'll have to explain to Bephens why Santa left her wagon in the box." She laughs and heads to her room where Danny has been asleep for hours because he couldn't care less about Christmas. It'd probably be the greatest day of his life if Bephens woke up crying because Santa didn't come. Mom closes her door, whispering, "Hope you don't ruin Christmas."

Breathing through my nose and clenching my fists, I want to scream because she knows I'd never let Bephens wake up to nothing. I stomp to the kitchen to get a screwdriver and spend an hour wrestling the red wagon together—crying quietly the whole time. Tightening the last screw, I put all my weight into it, taking out my anger on the poor little wagon as tears drip onto the red metal. *Why is she taking Christmas when she's already taken the rest of my childhood?*

Because we're always broke, Christmas presents are never that great, but there's still a little magic that I don't have anything to do with—tinsel slopped all over the tree because Santa doesn't have time to drape it nicely, and stockings filled with oranges, nuts, chocolate bells, and small presents wrapped in paper with Santa's face on it to prove they're from him.

Finished with the wagon, I stuff our stockings, giving Danny one orange and Mom a handful of nuts. I want to leave them completely empty, so I can tell Bephens they're on Santa's naughty list, but I don't want to make her cry—even though I would laugh my ass off. She gets their chocolates, and I put only enough in mine to have a few treats to show her—although I'm already gonna feel stupid pretending to be surprised.

I throw handfuls of tinsel over the tree and across the red wagon and leave all the Christmas lights on the tree plugged in because Bephens will probably wake up in the dark, and I want it to look magical. Picking up the screwdriver to take to the kitchen, I look at the twinkling lights and wonder why Mom is doing this now. Does she really think I'm not grown up enough? I feel old and tired—like I'm fifteen going on fifty.

I don't need to grow up, I need to grow down.

"Bah-deee! Santa came!" Bephens tugs my arm to get me out of bed. It's still dark as she climbs in her red wagon that's covered in the sparkling rainbow of tree lights. She squeals, "Pull me! Pull me!"

I glance around to see if my mom snuck out in the middle of the night to add any tinsel or other presents under the tree. Nope.

Bah humbug.

CHAPTER 23

Rip Van Percodan

"You know how I'm gonna kill Danny?" I whisper to Mom as she puts away the dishes.

"How?" She leans in to hear my plan.

"He'll be an old man in his wheelchair, and I'll go visit him to show him how successful I've become." I look to my left then to my right, like we're in a crowded place and not alone in the kitchen. "And you know that really steep hill by Honey's apartment—"

"*Nooo*, Bridey! Not that hill! That's too mean!" Mom slaps me lightly, pretending to protest.

"Yep! I'm gonna roll Old Dan's wheelchair to the top then push it, and he's gonna fly right into all those cars at the bottom!"

We laugh ourselves out the kitchen door and into the backyard to keep from waking Danny up.

IT'S BEEN THREE MONTHS SINCE DANNY let himself get hurt on the job after figuring out disability checks pay almost as much as working. He pops Percodan like Skittles and sleeps on the couch, waking up a few times a day to chase his pain pills with a Budweiser, eat a bowl of Frosted Flakes, and remind us why we hate him. "You're all worthless bitches."

"Well, good morning to you, too, sunshine," Mom says.

"Fuck you."

While Danny sleeps, the three of us eat meals together, work in the yard, and dance in the living room—right in front of him because he's too stoned to wake up.

"He's gonna die by himself, you know," Mom says one afternoon while we're in her bedroom. "He'll be drunk and crippled with no one around to help because he's run everyone off." She stuffs a wad of cash under their dresser lid. "This is my stash for when I finally leave his sorry ass."

I want to ask her when that is, but there's no point because I remember how long she waited before leaving Al—almost too long.

WINTER MELTS, FLOWERS BLOOM, AND Rip Van Percodan wakes up. "You bitches don't even care that I'm in pain!" he shouts and pitches an empty Budweiser can at me when I walk through the living room. "Yeehaw! Got one!"

"You're so dumb!" I yell from the kitchen, knowing he's too hurt to get up. From the window, I see Mom in the corral and wonder if I should tell her he's awake.

"Nah, you be a *goood* lil' pickaninny and get me a bee-ah," Danny calls from the couch, reminding me that he's a disgusting racist like his best friend, Al, who also got a kick out of calling me horrible names.

"Are you kidding?" I come out of the kitchen with my arms crossed.

He grins and picks up his empty beer can, fixing his eyes on Bephens. He cocks his arm back for the pitch.

"Don't throw that at her! I'll get your stupid beer!"

Bephens runs into the kitchen, and I set the beer on the table next to Danny but keep my distance. "That's mighty white a ya, *Birrrd.*" He laughs and kicks the empty can at his feet.

As I lean down to grab it so he can't huck it at Bephens, Danny palms the top of my head like a basketball. "While you're down there, wanna make some money?"

Flinging his hand off, I yell, "I hate you!"

He laughs. "Why don't you call your dad and see if he'll take your snivelin' ass back?"

"And why don't you pop some more pills and go back to sleep—forever!"

I scoop Bephens up, and we run outside to find Mom and tell on Danny—even though she won't do anything about it.

CHAPTER 24

Told You So

Our Ford Galaxie is parked in front of our living room window, and Danny has been watching us from it for hours—a constant trail of cigarette smoke wafts out of the car, while John Prine sings because his cassette is stuck in the car's tape deck. I can't hear the song, but I know it's "Illegal Smile"—a song about a man who does drugs to numb the pain of his shitty life—because Danny is punctuating the chorus with his beer'd hand high in the air. He loves songs about depressed drug addicts who are in jail or ready to die.

Mom stands to the side of the window, keeping an eye on Danny and drinking her beer.

"Mom, slow down, please." I cover the top of her can with my hand.

She brushes it off. "He thinks we're plotting against him."

"What? That's nuts," I say, even though we both know how much fun we've had fantasizing about his death. Maybe he heard us during his months' long couch coma?

"It's the crank. Makes him paranoid. He thinks I'm leaving him, and that you're in on it."

"I wish." I laugh. "Is crank like coke?" I ask, familiar with that drug but not the other.

"No. And it's not funny. It's dangerous." She guzzles her beer. "Did you tell him he's crazy?"

"Like that would help?" She grabs my arm. "Don't stare. You'll piss him off."

Mom paces between the living room and the refrigerator, getting a new beer each time she throws out an empty one. Danny's empty cans are piling up outside the driver's side window.

Tired of watching her watch him, and him watch us—and tricked by the peaceful glow of the beautiful pink sunset—I go help Bephens clean up her toys and get ready for bed.

I've just about read us both to sleep when Mom's scream scares the crap out of me, shattering the quiet in my room like a rock smashed through the window. "Bridey! Hurry!"

I whisper to Bephens who's now wide-awake, "Stay here. I'll be right back."

She grabs my hand. "Peas, no leave."

"It's okay." I tuck the blankets under her chin and kiss her forehead. "You stay."

I shut my bedroom door behind me. "Get off her! She can't breathe!" I scream at Danny, who is pinning my mom down in the chair the way he did on Thanksgiving. As she writhes and grunts under him, he cocks his arm back and punches her in the face.

She cries as I try pulling him off her. "Stop! Leave her alone!" Danny doesn't budge—doesn't even know I'm behind him.

I look for the phone to call the police. *Shit.* Out the window, I see Cecil's lights, but I can't leave Bephens to run there.

Danny punches Mom again. "Quit. Fucking. Moving!"

The gun. I run to their bedroom but stop before getting it. What if I shoot it to scare him, but he grabs it and shoots us? I hear Bephens crying in our room, and Mom wailing as Danny hits her over and over.

I grab the baseball bat my mom keeps in the closet for intruders—so she says—and my body suddenly lifts up and out of itself the way it did that night with Al and the gun—except there's

no camera crane. In a flash, I'm floating and don't feel afraid, at all. Numb, I drop back into my body and raise the bat over my head— ready to smash Danny's back the way I smashed those flames in the creek. Mom pushes Danny up, rocking him back just enough for me to lose my footing and drop the bat. I grab his T-shirt and pull, screaming. "*Get off her! Now!*"

"Get the fuck off me!" Danny yells, then lets up—almost too easily. He stumbles and reaches for his pack of Marlboros. While I wait to see what he's gonna do, Mom catches us both off guard and punches Danny in the side of the face. He reels around to grab her, but she dodges him and runs into the front yard and straight to the Galaxie.

The keys are always in, but it's not starting for her—just winding over and over.

Danny pulls Mom out through the driver's side window as she screams, "The Civic, Bridey! Start the Civic!"

I run to the crappy Honda Danny said is mine when I turn sixteen, but it won't start, either. Neither does the truck.

Through the windshield, I see Danny drag my mom up the concrete steps and into the house—her legs flailing behind her, trying to stand.

Across the valley are Cecil's lights, but I don't know what he'll do if I leave. We're trapped, and Danny planned it. Tears stream down my cheeks. I need Danny's gun.

In the living room, the two of them are facing off—Mom against the wall, holding Danny's fist in hers. She punches herself in the cheek. "Hit me again! I know you want to!"

"Mom, stop it! What are you doing?"

She hits herself with his fist again. "Come on, big man! You feel like a tough guy?"

"Shut. Your. Fucking. Mouth," Danny says, inches from her face.

Mom squirms her way out of his grip and swings, missing him but punching me in the side. I drop to the carpet, but she doesn't notice and swings at him again. Danny pops her in the mouth, and she lands on the floor next to me.

Holding my side and trying to breathe, I see Danny head out the front door. The hood slams on one of the cars, and it starts up. Headlights strobe across the living room as Danny drives away, his tires crunching the gravel.

Mom isn't moving, but she's moaning. Pissed and in too much pain to deal with her, I get myself to the bathroom and press a wet towel on the redness where she hit me.

"Bridey," my mom calls, almost too weak for me to hear.

I kick the bathroom door shut.

Bephens is asleep under our bed. Too wound up to fall asleep myself, I walk outside to watch for Danny's headlights in case he decides to come back. Surrounded by a sky of stars, I search for the brightest one because I know it's the North Star. Finding it, I draw a line with my finger straight down to where I imagine Juneau is—and my grandmother.

Of all the times my mom has smacked, swatted, pinched, grabbed, and spanked me with wooden spoons and plastic spatulas, she's never hit me like she did tonight. She didn't mean to, but she also didn't stop to see if I was okay.

She never does.

It's cold, and my stomach is shaking so hard I might throw up. Standing in the dark and looking at the white house, I remember the warnings—the one I wanted to give Lavar, and the one the house gave me.

We were both right.

Told you so.

I WAKE UP IN THE MORNING, EXPECTING the usual breakfast of amnesia and coffee that follows a night of fighting, but the only sound in the house is the tub filling up.

I knock on the bathroom door. "Mom? You okay?"

"Can you bring me a beer?" she shouts over the running water.

While I'd usually lecture her about drinking this early, this is how she's forgetting last night. I keep my mouth shut and go to the fridge.

I crack the bathroom door open. "I have your beer."

"You can come in."

Handing her the beer, I see last night's fight mapped across her body. "Mom. Are you okay?" I ask, wishing she'd ask me the same question for once.

"It's okay. I'm okay. Just go now." She takes the beer out of my hand.

I slump down on the toilet, not sure what to say. She's always said she bruises easily, but I think she means that he easily bruises her. As I gently stroke her arm, tears slip down my cheeks. "Mom, this has to stop. Look at what he did to you." *And look at what you did to me.* I'm tempted to lift my shirt and show her.

"I know, baby. I'm sorry. Just please go now—get your sister breakfast."

I write her a note in the fogged-up mirror above the sink.

eye la view

CHAPTER 25

Frankie's Float

*T*he last day of school before summer vacation, Mr. Dean—our math teacher who somehow always gets one pant leg caught in his cowboy boot and walks around all day like that—catches me looking over Joey's shoulder during our geometry final and gives me an F for the semester.

I'm thrilled because Mom has to drive me to town for two weeks to retake geometry. Even though it means sitting on Mr. Dean's plastic-covered dining room chair and actually having to learn geometry because he stapled the answer pages together in the back of the book, it also means I'm not stuck at home dealing with Danny and my mom.

While waiting in town one day for one of them to remember to pick me up, I find a job cleaning rooms at the Lincoln Motel on Main Street. By the time I earn a B in geometry two weeks later, the owner of the motel—a burgundy-haired Swede named Vicky—has made me the manager so she can leave for the summer.

"You'll have to live here while I'm gone. Is that okay with your mom?" Vicky asks, while I fold motel towels.

"Yeah, it'll be okay."

"But you haven't asked her yet?"

"As long as I bring Bephens, she won't care."

"I'll be in Sweden until school starts. That's not too long?"

"It's not long enough." I laugh because scrubbing toilets and changing questionably stained bedsheets feels like a vacation compared to my house.

The motel's office is the covered porch of Vicky's trailer. She shows me the cash box and how to check in guests to the motel's eighteen rooms. "This is how you turn on the 'Vacancy' and 'No Vacancy' sign." She flips a switch next to the counter. "Oh, and you'll also need this." She pulls out a stamp and ink pad. "A magazine called Highway 50 'The Loneliest Road in America' and now when people drive it, they stop in towns along the way and get fake passports stamped to prove they survived." Vicky laughs.

EXCITED TO BE ON OUR OWN, BEPHENS rocks and rolls in the waves of Vicky's king-size waterbed while I fill our fridge with snacks we buy at the gas station and tiny market next to the motel.

The market only sells about ten things, but we get Fruit Loops and Skippy peanut butter—the "off-limits" food Danny won't ever let us eat. I don't buy too much junk, though, because Mom has been warning me lately about becoming *a big girl.*

"The women in your dad's family are tall. You better be careful, or you're gonna be a linebacker!" She'd cracked up when she said this to me, but I didn't.

Every morning at the motel, Bephens and her silky bunny follow me from room to room, slopping water all over the bathroom as she helps me clean, then jumping on the beds before I change the sheets. At night we eat dinner on the couch, flipping channels on Vicky's satellite TV and watching out the front window for guests pulling into the parking lot.

TONIGHT IS ESPECIALLY WARM, AND I have all the windows open in Vicky's trailer to let in some cooler air. Bephens is asleep on the couch, and I'm watching TV while keeping an eye on the cars cruising Main Street because it's Friday night. A few old guys stumble

out of the International Bar across the street, balancing their bottles of beer and hollering at each other.

I flip to *The Tonight Show* as Ed McMahon announces, "*Heeere's Johnny!*"

Johnny Carson walks through the striped curtains at the same time a dark brown sedan rolls into my view. A woman is sitting on the hood, slamming her fist at the windshield.

Oh, shit. That's my mom.

I jump up and turn down the TV to hear what's happening. She's screaming at Danny on the other side of the glass. "*You . . . sonovabisshhh!*"

The car is rolling likes it's in neutral, and Danny is laughing his ass off behind the wheel. The old guys at the bar are scrambling on the porch to get a good seat for the show Mom and Danny are putting on for them.

Before Mom punched me a few weeks ago, I would've already run outside and pulled her down, but now I don't have it in me to rescue her. Our Galaxie isn't moving fast enough for her to fall off, anyway—unless she dives off the hood. Under the light of the bar's neon signs, she's trying to untangle her arm that's caught in the neck of her sweatshirt she always cuts like the girl in *Flashdance*.

Danny looks over and sees me watching. His brake lights flash as he stops in the middle of the street to give me a center-stage view of his new hood ornament. Slowly waving the red ember of his cigarette, he's acting like the grand marshal of this one-float parade down Main Street.

Mom pounds the windshield with her fist, wailing into the night sky. "*I hate you!!!*"

Realizing Danny could've slammed on his brakes and sent her flying but didn't, I suddenly understand what he's doing. He's parading her crazy for me to judge.

Red, white, and blue lights flash as Austin's only cop comes up behind our Ford Galaxie. I figure he's not bothering to turn on the sirens because it's late and pretty obvious who's getting pulled over.

Danny waves out the window and rolls to the side of the street—with my mom still on the hood.

Knowing he'll talk his way out of this like he always does, I take a deep breath and say *thank you, thank you, thank you* to myself for not running out there and getting in the middle of their mess. I carry Bephens and her silky bunny to Vicky's bedroom and tuck them both in.

As my stomach twists and turns the carton of raspberries I ate earlier, I go into the bathroom and lift up my tank top—sucking in my belly and turning from side to side, noticing the bruise Mom gave me has finally disappeared completely. Stepping on the scale, I watch the arrow bounce back and forth, until it stops on 150.

Big girl.

I lift the toilet seat and sit on my knees. Because I wrote a research paper about anorexia and bulimia this past year, I know one of the tricks to lose weight is barfing.

Throwing up everything in my belly I knew would come out—the raspberries, the milk, the Fruit Loops—my body heaves as it finds more to purge—Mom on the hood, her bruises in the tub, my bruise, Bephens hiding under our bed, and my disgusting addiction to it all.

There are plenty of rooms still left to rent, but it's late, and I've never been so tired. I flip on the No Vacancy sign and head to the bedroom. Cuddling with Bephens, I stare up at the mirrors covering the waterbed's canopy.

Why would anyone want to watch themselves sleep?

CHAPTER 26

My Little Ponies

icky returns from Sweden and scolds me for turning on the No Vacancy every night when there were still rooms to rent. I apologize and remind her she didn't tell me I had to check people in all night long. But I don't remind her that she was desperate to get out of town and left her business in the hands of a fifteen-and-a-half-year-old.

THE FIRST DAY OF ELEVENTH GRADE and my sixteenth birthday are coming up when Mom brings home two Welsh ponies that she says she rescued from the dog food auction for fifty bucks each.

"They're your early birthday presents! Come on, climb up. This is Chester!" Mom is giddy, grabbing my arm to help me onto the light-blond pony and pointing at the darker-blonde female. "That's his mama, named Mama. Isn't that cute?"

"I don't know how to ride a horse," I say, shaking my head and backing away. "And don't I need a saddle?"

"It's a pony, for Christ's sake!" Mom turns to Bephens, hanging on to the fence. "Don't you wanna see your big sister ride Chester?"

"Horsey! Horsey!" Bephens cheers.

"I can't believe you're making me do this." I climb on the fence and lift my leg over, terrified Chester is gonna move. On his back,

I sit as still as I can. "What do I hang onto? Do you have a rope or something?"

"Hold onto his mane! But don't pull too hard!" Mom moves behind me, and I hear her make a *click click* sound with her mouth. As I look over my shoulder to see what she's doing, she slaps Chester's butt. "Off you go! Hang on!"

He bolts—almost out from underneath me—galloping across the corral as I hold on for dear life to his mane. Right before slamming us both into the fence, he hits the brakes and throws me off.

"You happy now?" I ask, as Mom helps me into the kitchen to get ice on my shoulder.

"Oh, you'll get better at it. You just need practice." She laughs.

MY SHOULDER IS STILL BRUISED AND sore when Mom shoves the pan of birthday cake across the carpet to me. "Cut a bigger piece," she says.

"Okay, but the last piece was big enough."

"Cut it from this end, though." She turns the cake pan around.

Cutting a piece that barely fits on my plate, I slide it over to Bephens, who's sitting on the floor next to me. "Here you—"

"No!" Mom pulls the plate away from her and pushes it to me. "It's *your* birthday!"

Confused and feeling a little like Snow White questioning the red apple the witch wants her to eat, I ask, "Mom, what's going on with the cake?"

"Nothing! I'm just excited for you to eat it!"

"Don't we have to save some for Danny—wherever he is?"

She shakes her head. "Snooze you lose."

Tired of me stalling, Mom grabs my plate and stabs the cake with her fork until it's a pile of frosted chunks. "Yes! Found it!" Her fingers dig into the chocolate cake and pull out a clump covered in blue frosting. "You get the keys to the car!"

"What?" I ask as she shakes cake off the ring holding every key she's ever used—to the Ford Galaxie, the Honda Civic, our

pumphouse, the propane tank, the front door, and a bunch of other keys to who-knows-what.

"You can drive the Ford to school when you get your license!"

The Galaxie? She wants me to drive her pathetic parade float—the one that only plays John Prine and stinks like beer and cigarettes? I'm trying to smile because I know this is probably all she can pull off right now, but there's a selfish and shallow sixteen-year-old in me who desperately wishes it was a key to a cute little Volkswagen Bug with a big bow around it like every girl wants for her sweet sixteen. "Thanks, Mom. Now I have a reason to study for the driver's test."

Bephens licks the frosting off the keys while Mom tries wiping it off the carpet, smearing it everywhere. "I can't believe what a mess I made. I forgot which end of the cake I put the keys in when I was baking it." She laughs and gets up, showing off the other surprise she's been baking but forgot to tell me about until a few days ago.

Seven months of baby belly explains why she wasn't lying flat on the Galaxie's hood that night—which would've been safer than sitting up and rolling around—although not nearly as safe as not being on the hood in the first place. I don't know why she'd have Danny's baby, but nothing my mom does makes sense to me. "Wait! You have another gift!" She pulls a rectangular box wrapped in newspaper from behind our velour chair. "Open it!"

I let Bephens unwrap the wicker chest with a gold latch on the front. "What's it for?" I ask.

"It's a hope chest. You put your special things in it, like all your Duran Duran stuff you left in the attic in Tahoe that I know you're worried about."

I smooth my hand over the glossy, weaved wood. "That's a great idea. Thank you." I lift the lid to see inside. "There's nothing in it? Looks pretty hope-*less* to me!" I laugh.

"Smart-ass." Mom flicks me with her frosted fork.

ABOUT A WEEK AFTER MY BIRTHDAY and a few days into the start of eleventh grade, Mom tells me we're moving to Reno, three hours

from Austin. After I beg to stay using the excuse that I was voted secretary-treasurer, Mom lets me ask the Rose family if I can live with them.

"Of course, you can come," Cecil says, giving me a hug. "Ellie would love to have you here now that the boys are in Reno at school."

Steve, her husband who pretends to be cranky but is super sweet, jokes, "Just don't bring those *Bridey-mobiles* or ponies, because we don't need a bunch of cars that don't run, or those ponies because they're worthless for riding and ornery little suckers."

"I won't." I shake my head, laughing with him.

"What's your mom going to do with the ponies?" Cecil asks.

"Dunno. Guess I'll see tomorrow when they leave."

AS MOM LOADS THE LAST OF THEIR bags and boxes in the truck and Galaxie, Bephens hangs on my pantleg, crying. "Peas you come? Peas, Bah-dee?"

"I promise I'll visit soon, okay?" I lift her up to my shoulders to keep her from seeing me cry. "Let's go for a ride!"

We gallop around the yard for the last time, and Bephens pulls the reins of my hair. "Giddy up, horsey!"

I trot us over to Mom, standing at the open corral gate and waving her arms like a crazy woman at Chester and Mama, who don't even notice her. "Run! You're free! Go on, now!"

The ponies don't budge because they haven't seen the movies my mom has. If they had, they'd know she's waiting for them to gallop at full speed out of the corral, then shake their manes in the golden hour light—rearing their silhouettes as a thank-you for saving them from becoming Puppy Chow.

Mom pouts when I remind her of the obvious. "They're not wild mustangs. You know they're probably gonna die out there, right?"

She slaps my arm. "No, they'll be happier! You'll see!" Smacking me must remind her of the day she got Chester to slam me into the fence because she makes the same *click click* sound and slaps his butt. "Go! You're free!"

Other than Chester's back leg nearly kicking Mom, neither pony moves.

"Stubborn shits!" She leaves the gate wide open and walks away. "Guess they'll leave when they're goddamn good and ready."

Won't we all, I think to myself.

THE FIRST FEW DAYS AFTER I MOVE IN with the Rose family, the ponies are still in the corral when we drive past on our way to school. Then one afternoon, they're gone.

PART TWO:

NO

CHAPTER 27

Twelve Steps

Reno 1987

"Guess what? We found a house! You don't have to go back!" Mom squeals like her news is awesome and not a sucker-punch that catches me totally off guard.

"Whatdaya mean I don't *have to go back*?" I stop bouncing Bephens on my lap.

"You were only staying until we found a place. It's time to come home now."

"Home?" I look out the window at a city I've hardly ever been to.

"We'll see if Cecil and Steve can bring your stuff the next time they come to Reno for groceries or whatever."

"I can't believe you're doing this to me." I start crying, thinking about the new boy I have a crush on who just told me he likes me, and all the friends I didn't get to say goodbye to—again.

"For Christ's sake, can you stop acting like living with us is the end of the world?" Mom turns up the radio in the white four-door she's driving that looks like it belonged to a grandma. I don't ask what happened to the Galaxie because I don't care.

Wondering if I should make a run for it at the next light, I beg, "Mom, please don't make me stay here. I'm on the school council, and I get to play on varsity this year."

She ignores me and pulls into a motel parking lot. Throwing my hands up and glaring at her, I point out the obvious. "You said you had a house?"

"That's enough." She snaps her fingers in my face like she did when I was little. "We're moving in a couple days. You're not gonna die before then." She tickles Bephens. "Will she?"

Bephens giggles, then tickles me. "Nope!"

From somewhere beyond the cloud of cigarette smoke filling the motel room, Danny says with a sneer I hear but can't see, "Guess you got tricked into coming back, huh, *Birrrd*?"

Mom points to blankets on the floor. "You can sleep down there with Bephens."

Going right to sleep because there's nothing else to do, I pull the pillow over my head to block out the stink of cigarettes and *The Simpsons* Danny has turned up so loud I can't believe the people in the motel room next door aren't banging on the walls. Closing my eyes, I imagine being back in my little bedroom down the hall from Ellie. We've all just eaten dinner around the table after Steve and Cecil had their evening cocktail hour on the porch where they gossiped about some neighbor they love but who also just did the stupidest thing.

The past month has been like living in a sitcom—the cantankerous but lovable dad in knee-high socks and shorts who complains about nearly everything but laughs while he does it, the preteen with blonde curls and blue eyes that she rolls loudly at her parents but giggles because she adores them like crazy, and the feisty Mom who's too busy to take anyone's crap but has time for the neighbor kid down the road from a troubled home.

Me.

Thinking about how I've been studying pretty much everything the Roses do, the sitcom might also be part nature documentary—like

the Dian Fossey film my science teacher showed us about Fossey and the gorillas she lived with. The normal life I saw at my dad's house was too unfamiliar for me to understand, but I've been paying better attention to the Roses. Observing them the way Fossey studied her gorillas, I've spent weeks watching and listening to how Steve, Cecil, and Ellie speak to each other without screaming, argue but don't fight, and show affection—constantly.

"Did you take one of my Percs?" Through my pillow, I hear Danny holler at my mom.

"No, I didn't take one of your precious fuckin' pills!" she yells back.

And now we return to our regularly scheduled programming.

"SHE'S NOT LETTING YOU COME BACK?" Cecil sounds pissed when I call her from the motel's pay phone. "What about school and the student council? Jesus, the nerve of that woman! She could've told you, so you brought more stuff with you."

"If she did, I would've never gotten on that bus, and she knows it."

"I guess you're right. Maybe she's not as stupid as I thought. But your mom has made one person *very* happy."

"Who? Bephens?"

"No, Sheila. Now she gets to be secretary-treasurer!" Cecil cracks up. "But what a waste of those *Catch the feelin', Vote for Thelen* posters you and Ellie made. Didn't most of the kids vote for you?"

"Yep. I bribed them with suckers." I laugh.

"Well, everybody here is going to miss you, especially us. I'll tell the school you're not coming back, but if you decide to run away, we'll hide you." Cecil snickers, like she's joking, but we both know she also isn't.

THE HOUSE WE MOVE INTO IS IN A nicer neighborhood than I expected and only a couple blocks from Sparks High, where I start eleventh grade all over again.

After dinner one night, Mom opens my bedroom door and says, "You're going to Danny's Narcotics Anonymous meeting with him tonight."

"What?" I look up from the article I'm reading about Duran Duran—one bonus of living in a big city where they sell magazines. "Are you kidding? You want *me* to go to a meeting with a bunch of drug addicts?"

"I need you to make sure he stays the whole time—then comes right home."

"Can't you go?"

Mom points at her huge baby belly and raises her eyebrows like my question is ridiculous. "I could go into labor at any second." Annoyed, she shuts my door.

To prove I'm way more annoyed than her, I open my door just to slam it shut.

"You better cool your jets!" Mom yells from the living room. "And get out here and do the dishes."

Ignoring her as I walk through the living room, I pass the kitchen and go into the bathroom. Turning on the sink faucet to keep her from hearing, I hunch down over the toilet and stick my fingers down my throat. Not much food comes up, but a belly full of my stupid mom does.

ON OUR WAY TO THE MEETING, I don't ask Danny why he's going because I figure someone is forcing him to.

Greeting us with pamphlets and offering coffee, several people smile as we walk into a room much larger than I was imagining it would be. A couple dozen people are sitting in a circle under fluorescent lights that seem too bright for a meeting with the word *Anonymous* in it. Danny and I sit down—unfortunately, next to each other—as everyone avoids eye contact and adjusts their shirt collars, smooths out their hair, and straightens their posture, like they've been called to the principal's office for bad behavior.

Danny's knee touches mine, and I flinch. He laughs into his Styrofoam cup of coffee and grumbles, "Let's get this fuckin' over with."

A large clock on the wall shows fifty-nine minutes to go.

"Welcome everyone," says a dark-haired guy with a friendly smile.

I stop listening after that because this meeting isn't for me. I've had a few wine coolers and gotten wasted on Robitussin once, but I've never even smoked a joint let alone done whatever drugs made these people come to this meeting. I'm here to babysit Danny, so I pretend to read the pamphlet they handed us when we walked in while keeping my eyes on his boots in case they move.

The Twelve Steps of Narcotics Anonymous
Step One: We admitted that we were powerless over our addiction, that our lives had become unmanageable.

I SHAKE MY HEAD READING THE FIRST step because Danny has never admitted to being powerless over anything. He has all the power, and he loves to prove it.

Keeping my head down, I sneak a peek at the circle and all the people who were probably forced to come the way I assume Danny was. The guy across from us looks too old to worry about stopping an addiction at this point in his life, and the kid next to him looks too young to be addicted to anything harder than video games and clove cigarettes. I wonder what Danny and I look like sitting here together—a teenage girl with freckles and blue eye shadow next to a guy wearing sunglasses at night? *God, I hope they don't think we're dating. Gross.*

I hear my mom's instructions—*Make sure he stays the whole time*—and look around for any exit other than the door we came in. If Danny makes a run for it, does she think I can stop him? Am I supposed to scream, "Don't let him out!" and hope the others help me?

As if he reads my mind, Danny stands up and leaves the circle. Like a probation officer guarding her juvenile delinquent, my eyes

track him all the way to the bathroom. Staring at the door and waiting for him to come back out, I picture Danny climbing on the toilet and trying to squeeze out the tiny window above it. I don't actually care if he bails on this meeting, but then I won't have a ride home. Before I can check my bag for a quarter to call my mom if he does, Danny sits down next to me.

The next person introduces himself and starts sharing his story. Feeling like I'm eavesdropping, I look down at the pamphlet, reading the same line as before. " . . . *we were powerless over our addiction, that our lives had become unmanageable.*"

The word *unmanageable* doesn't apply to Danny, either, because he'd tell anybody that he manages his life just fine—as long as we stay out of it.

The clock shows twenty minutes to go when I notice Danny's eyes are shut behind his sunglasses. The guy leading the meeting must know Danny isn't paying attention and calls on him. "Hi, you're new. Would you like to share?"

I shove Sleeping Beauty's shoulder. *Dumbshit, he's talking to you.*

Danny opens his eyes and crosses his arms. "Nah."

I'm grateful not to have to listen to him lie—or tell the truth, which might be worse. Danny looks at the clock and shakes his head, probably pissed he's late for his date with a six-pack and a handful of pills.

As the meeting ends, everyone stands and holds hands— except the two of us—and the group recites a prayer most seem to know by heart. People hug and pat each other on the backs, while Danny heads for the door. Staying close, I stop a few feet behind him when he shakes hands with an older biker dude. Danny waves me over and introduces us. "This is my daughter, Bridey."

I look over both my shoulders to make sure he's talking about me, then force a smile so tight my teeth might break.

The old biker, who looks like Danny might in about thirty years, smiles back. "It's nice you came with your dad. Not many kids would. I want you and your mom to know I'll be there for him

every step of the way. He can do it. I believe in him."

Jesus, get me out of here. I give him another clenched smile and nod to show how appreciative I am. He seems nice but also stupid if he believes the motivational quotes he's memorized from the posters they sell at the mall—the ones with kittens dangling from branches under the words *Hang in there! You can do it!*

Danny is not a struggling kitten who's using all his strength to pull himself up. He's the crocodile we can't see in the poster—the monster waiting, with his mouth open wide, for the kitten to give up and drop. There's no way this nice old man is getting me to feel sorry for Danny for one single, solitary second.

Taking the twelve steps of Narcotics Anonymous literally, Danny counts six steps to the exit and six more steps to our white Dodge Dart. "Let's get the fuck outta here."

OUR NEW LITTLE SISTER, DARA, IS BORN a few weeks later. The house is calm and quiet with a newborn in it—and Danny not. He's taking full advantage of the fact that Mom is breastfeeding and doesn't have the time or energy to chase him down.

Since starting at Sparks High a month ago, I've tried making friends, but the school is huge compared to Austin. The kids have cool cars and cool clothes, and there's even a cheerleader who drives a pink Volkswagen Bug. Because I don't have the trendy clothes or a car, I copied a scene from some movie I saw and bought fake glasses at the mall then sat under a tree during lunch, pretending to read a book. It's now been a few months of fake reading *Macbeth* under the tree and waiting for the scene in the film when the cute boy comes over to the nerdy girl to see if she'll tutor him in English class.

I haven't made friends, but the nerdy girl part is real because Mom somehow found money for me to go the orthodontist, and he put a spacer in my mouth that made big gaps between my teeth that are nowhere near as cute as Madonna's.

Today is the day the spacer comes off and my braces go on. Standing at the receptionist's desk, Mom is smiling, and I can feel

how proud she is at being able to do this for me. "No more Bucky Beaver," she says sweetly and kisses me on the cheek.

"Thanks, Mom. I'm really excited to get my teeth fixed."

She pulls out her checkbook to make the first payment, and her eyebrows pinch together as she skims the entries in the check register with her finger.

"Is everything okay?" I ask.

She takes in a long breath that flares her nostrils then exhales loudly and puts her checkbook in her purse, clearing her throat to get the receptionist's attention. "I'm sorry, but we'll have to reschedule—"

"What?" I interrupt.

She puts her hand up for me to be quiet. "I'll call you later today. Sorry for the confusion."

Following her heels to the car, I blast her with questions. "What's going on? Why can't I get my braces? How do I get this spacer off? When are we coming back?"

As my mom starts the car, she also starts to cry. "I'm so sorry, baby. He spent the money."

"On what?"

"Getting his goddamn gas tanks painted, again."

"Are you kidding?" I slam the dashboard with my fist. "I hate him! Why is he so selfish?"

"I know, Bright Eyes. I'm sorry, but I'll figure it out."

MOM STILL HASN'T RESCHEDULED MY appointment a couple months later when she tells me we're moving back to our house in Tahoe. Without much of a fight, I get to stay in Reno to finish eleventh grade because Sarah Rose, Cecil's daughter who's twenty-one and has her parents' kind heart, agrees to let me stay with her.

As happy to get away from Mom and Danny as he was leaving the one and only NA meeting I ever saw him attend, I follow his twelve-step program: six steps out our front door, and six steps to Sarah's black Trans Am—like the one we used to own but without the girl's footprints on the windshield.

CHAPTER 28

Class of '89

*A*fter I finish eleventh grade, I move back to Lake Tahoe. That summer, Mom and Danny get married in an intimate wedding ceremony—because they don't have many friends left.

Mom hands me a hundred-dollar bill. "It's all we have, so don't spend it all."

"I won't, and I promise I'll pay you back with my first check from work." I kiss her cheek and run to Jennifer's orange Saab. We've stayed friends over the years and still laugh about my mom bribing us with a *Playgirl* to clean my room.

Every store we go to is having back-to-school sales, and I make sure to shop those racks, so that everything I get can be worn together to stretch my money as far as it will go.

Jennifer drops me off at home a little before dark. "Good luck tomorrow!" she says because we go to different high schools.

"You, too! Happy senior year!" I do a little dance with my shopping bags.

Pulling away, she shouts out her window, "Oh yeah, and *happy birthday!!!*"

FLINGING OPEN OUR FRONT DOOR, I nearly take out my mom. "Woah! Sorry, Mom. What are ya doing in the doorway?"

"What the hell, *Brideee*? You almos' knocked me over!" She catches herself on the edge of the couch, and I hear the French accent.

Fuck. She's wasted. My stomach twists into a knot, but I keep my head down and pull out new school clothes to show her.

She shoves my bags off the back of the couch and holds out her hand. "Wherezz my *goddaaamn chaaanggge*?"

"In here, Mom, just a second." Digging in the bottom of one of the bags, I pull out the money I have left. "See? I didn't spend it all." I wave my hand over the two bags full of clothes. "Can you believe I got this much stuff for sixty bucks—"

"You *fuckeeen* spen' it *alll*?" She grabs the bills, and the change lands on the carpet. She hasn't hit me since Austin, but I feel the weight of that punch in her grab.

"No, Mom. I didn't." Getting annoyed she's not hearing me, I point to the money in her hand and speak slowly, like I'm explaining it to Bephens. "There's forty dollars. I shopped clearance. Let me show you—"

She shoves me against the back of the couch. Over my shoulder, I see Bephens giving Dara, almost one, Cheerios. Bephens takes a step toward me, and I shake my head *no*, then turn back around. "Mom, stop!" I yell and stand up—now six inches taller than my mom's five-four—and look around for Danny, but the car is gone. "I told you, I'm paying you back."

"You *fuckeeen betterrr*!" She lunges with a right hook at my face, but instinct throws my forearm up, and her fist hits the bone. "Don' chew block *meee*!" She swings again, nailing me in the shoulder.

I push her against the wall—only inches from the heater where Al dragged her body up and down seven years earlier. "Why are you doing this?" I ask, looking in my mom's eyes and seeing that she's looking through me at someone who isn't there.

She knocks my arm down and almost falls but grabs my waist to catch herself. Climbing her way up, she pulls on my sweater, moaning and wailing. "I hate *youuu*!"

I realize she's not fighting me; she's fighting *them*—Danny and Al—but she doesn't know it. I twist out of her grip and run around

the corner to my room, sliding under my bed and backing myself into the corner in the way I taught Bephens to do.

My sisters' plastic farmhouse slams my metal frame, ringing in my ears. "Mom! It's me!" I cry to her. "I'm not them! I'm not him!" From under my bed, I hear drawers opening and see my clothes raining down on the carpet. I scoot out a bit to see what she's doing as she grabs my stack of Duran Duran records off my dresser. "No! You can't do that! Please stop, Mom!"

"What the fuck are you doing?" Danny hollers. His black boots walk past my bed, and I hear him grab my mom, then see her bare feet sliding across my carpet as he pulls her to their room.

"Don' chew do *thisss!*" she screams.

"Stay in here and don't fucking come out!" Danny slams their bedroom door, and his boots are once again in front of my bed. He leans down and looks at me, huddled in the corner—terrified and embarrassed. "Come on and get your coat. Let's get outta here." His voice is strangely gentle and calm.

Not caring where we're going as long as we leave her, I slip out from under my bed and grab a sweatshirt off the pile Mom made on my floor. "One sec, and I'll get the girls." I pick up my Duran Duran records and my *PSAT Study Guide* and hide them in the back of my closet.

Danny gets Dara into her car seat, and I help Bephens put on her coat, wiping her tears with my sleeve. "Everything's okay. We're just gonna let Mom get some sleep. Don't cry."

Driving down the highway, it's the first time since the Narcotics Anonymous meeting that we've been alone, and I don't know what to say. Danny does, though. "Do you see now, Bridey? It's not all me. It's her, too."

Bridey. He said my actual name. My heart is racing, and I need to throw up. This isn't right. He's not supposed to save me from her. He's the bad guy—the one I hate. *Oh, God. Are we on the same side now?* I pull Bephens onto my lap and try thinking of something to say. "I know. Tonight was bad. I didn't think she was gonna stop." I want to cry, but I can't—or won't—with him.

We pull into a campsite where Danny's buddy lives, and Dara sleeps in the car while Bephens and I warm up by the fire. "Tomorrow is the first day of school, so we better get home," I say to Danny after a while. "Bephens is starting kindergarten, aren't you, big girl?" I pick her up and nuzzle her under the chin.

Tossing and turning as I go through everything that happened tonight, it takes me forever to fall asleep but not because of what my mom did *to* me as much as what Danny did *for* me.

TO CHEER MYSELF UP THE NEXT morning, I dance with Bephens around our room to Duran Duran's "Careless Memories" popping my hips and pointing like Simon—not giving a crap if we wake up Mom and Danny.

Before Heather comes to get me, I spray another layer of Aqua Net on my perm and check my makeup in the bathroom mirror. Running my finger over the light and dark purple bruises on my arm the way I used to trace the stars the Sandman left on my face, it's hard to believe how my mom continues to outdo herself when it comes to letting me down. "Happy fucking birthday to me."

I can't find my new clothes and figure Mom has them in her room. Rather than risking another fight, I put on some favorite jeans and a white long-sleeve shirt to hide my bruises.

Heather—who used to come over when we were little and sleep on the roof of our Datsun in the backyard—picks me up for school and listens quietly as I tell her what happened.

"I'm so sorry," she says. "You know it's not your fault, though."

"I know, but it's hard. She hates me."

"She hates herself." Heather rubs my shoulder, then smiles. "We're gonna have a great first day!"

"It's good to be back," I say, seeing the South Tahoe High School sign. "Weird I haven't been here since freshman year."

"Everybody is gonna be excited to see you," Heather says, parking her Subaru.

"Let's go, Class of '89!"

HEATHER DROPS ME OFF AFTER SCHOOL, and my mom waves from the porch.

"Oh, my god! What is she doing?"

Mom shouts, "Heather, come inside!"

I pick up my backpack and open the door. "Sorry, Heather. I don't know what she wants. You don't have to come in."

Heather's never been afraid of my house and turns off her car to prove it. "It's your birthday. Of course, I'll come in."

I raise my eyebrows. "Bring the ticket."

She grins and pats her purse. "It's in here."

"Happy Birthday!" Mom and Bephens shout as we walk in the door. They're standing next to a cake with the candles already lit and a stack of presents wrapped in newspaper.

Mom waves us over. "Hurry and make a wish before the candles melt!"

"I don't want anything." I roll my eyes at Heather and throw my backpack down. "Here, you blow out the candles." I lift Bephens to sit in my chair. "And you can even have my wish, but don't tell anybody, or it won't come true."

Bephens blows a few times to put out all the candles—although I never count to check if there's actually seventeen. "Here, open it." She hands me a present and gives my mom a smile, like they're sharing a secret. "You're gonna love it!" Bephens claps and jumps around.

I squish the present.

"Open! Open!" Bephens squeals.

Ripping one strip of comic, I recognize the red trim of the new sweater I bought yesterday. I glare at my mom. "You really wrapped my new clothes?"

She shoots a looks to Heather, then to me. "I thought it'd be fun for you to open them."

"These are my birthday presents? The clothes you beat the crap out of me for?" I drop the unopened present on the chair. "I can't believe you."

"Oh, don't be ridiculous. You want your new clothes or not?"

"Not." I motion to Heather to hand me the ticket.

"Here's your birthday card," Heather says. "Hope you like it."

I open the card and don't even pretend to be surprised. "A ticket to see George Michael? I love it!"

"We can stay at my dad's place in San Francisco," Heather adds.

"Mom, look! Isn't it awesome?"

It's her turn to glare at me. I see her biting the inside of her cheek. "I know you two planned this."

"Planned it? It's a present." I shrug my shoulders, acting confused.

"Don't think for a second I don't know what's going on here, you two," she says, still biting her cheek. Her eyes narrow on me. "You're pulling some shit right now."

I smile and put my hands up. "It's my birthday, and it hasn't been great so far."

Mom picks up the cake I didn't touch. "Sure, you can go. Why don't you leave now and celebrate your birthday with people you actually like?"

I spend the night at Heather's house.

IT'S EARLY OCTOBER WHEN HEATHER pulls up to my house again to drop me off after school, and we see my mom carrying black garbage bags to our truck.

"What is she doing now?" I exhale, exhausted from trying to answer that question all the time.

Heather laughs. "Call me later when you find out."

"Mom? What's going on?" I ask, following her back into the house.

"We're moving to Phoenix for Danny's school."

"When?"

"Now."

"Like today now?" I ask, even though it's obviously happening because there are boxes and bags packed and stacked everywhere. "You did this all while I was at school?"

"I don't have time for this." She shoos me away. "Get packed." She hucks a garbage bag across the living room. "And help your sisters. We're leaving when Danny gets back."

Already knowing I'm not going with them—even though I don't have a plan because I just found out five minutes ago—I head to my bedroom to find Bephens and Dara.

"Hey, you need help?" I ask, seeing Bephens stuffing toys in a bag as Dara pulls them out.

"No, I got it." I want to ask if she said goodbye to her kindergarten friends or her teacher, but I don't because I'm sure she didn't know this was her last day of school, either.

In the kitchen, Mom has her head deep in a cabinet, pulling out pans. "I'm not coming with you," I say behind her. "It's my senior year, and I wanna graduate with my friends."

She looks over her shoulder and says, with all the affection of a landlord evicting a tenant who's months behind on rent, "Well, where are you gonna live? You can't stay here. We're selling it." She goes back to digging for pots.

Shocked that she's selling the house—and not putting up a fight about me staying—I keep my mouth shut and walk into the living room to call Heather.

Mom hollers from the kitchen, "You're taking Moose with you!"

I holler back, "You want me to take a Great Dane to someone else's house? I don't even know where I'm staying!"

"Well, we can't take her."

"Fine," I agree just to shut her up.

Heather's mom says I can stay with them, so I pack my wicker hope chest with clothes, my Duran Duran records, the *PSAT Study Guide*, diaries I would die if anyone read, and a couple photo albums of friends I never had time to say goodbye to.

"I love you. I love you," I whisper to Bephens, dotting kisses all over her face and trying not to cry. "I'm so sorry I'm not coming, but I'll come visit for Christmas."

"Promise, sister?" she sobs, holding my face in her hands.

"Promise." I hook my pinky around hers. "Pinky swear." Dara is already asleep in her car seat. I kiss her forehead and whisper, "I love you."

"Be good," Mom says, hugging me. "And make sure to call and check in. And keep your grades up because if they go down, you're moving to Phoenix."

"Got it." I nod and smile, counting down the seconds until they leave.

"See ya, *Birrrd*." Danny lifts his chin and grins. "Don't get knocked up!" He laughs, and I laugh, too, feeling weird that I kind of like him now—sometimes.

The truck rumbles down Osborne Street, clinking and clanking all their crap as the black ears of tied-up plastic bags wave goodbye from the back.

They turn the corner, and they're gone. Moose and I are all alone in the front yard of the blood-red house that I painted when I was ten and hated ever since. Heather pulls up in her Subaru. "What's with the dog?"

"Oh, yeah, that's Moose. They didn't want to take her. I'm not bringing her to your house, though, don't worry." I pat Moose on her shiny black head. Stealing my mom's line when she opened the corral gates for Chester and Mama, I wave my hands in the air and say, "You're free! Go on, now!" Because we both need to hear it, I add, "Good luck!"

Heather and I drive away as Moose takes off running in the other direction.

"COME ON IN AND TAKE A SEAT," the principal says, shuffling through his papers. He pushes his glasses up and reads. "Bri-dey." He glances at me over his lenses. "Did I pronounce that right?"

"Yes," I answer, wondering what his name is because I've never been called to the principal before. I sit up straight, thinking I must be getting an award or something.

"I'm Dr. Anderson. It's nice to meet you." He looks down at a paper in his hand. "Your grades are excellent."

"Thank you."

"And you're in the National Honors Society."

"Yes, since last year." *Okay, here comes the award!*

"It also says here you've missed over fifty days of school this year?" He looks up. "That's quite a few days you've been out."

"Really?" I shake my head, confused because it sounds like I'm in trouble and not getting an award. "I don't remember missing that much."

"Well, unfortunately, we have a policy about absences. Do you know what it is?"

"No, I don't. Sorry."

"For every eighth absence, your grades go down by one letter."

"One letter?" I repeat, doing quick math. "That means I'm failing everything."

"Yes, it does." He sets the paper down. "Would you like to tell me why you've missed so much school? I'd like to know because as of now, you won't be graduating with your class."

I scoot forward in my chair and smooth my hair behind my ears, trying to bide a few seconds to figure out what to say, but he beats me to it.

"I called your house earlier to speak to your parents, but it said the number has been disconnected. Is there another number to reach them?"

There's no way I can let him call my mom because she'll kill me. My brain quickly flips through my Rolodex of sad memories because I know crying is the only way out of this. Saying goodbye to Bephens does the trick. Tears roll down my cheeks.

"Oh, don't cry," Dr. Anderson says softly, handing me a tissue. "We'll figure this out."

Making it up as I go, I piece together the school year and try to figure out what I can tell him. Instead of playing the game most people know called "Two Truths and a Lie," we're about to play my version, which is "Two Lies and a Truth."

I clear my throat and wipe my eyes. "I'm sorry. There's no number. We couldn't pay the phone bill." Sighing loud enough that he knows I'm about to share a heartfelt secret, I look down at the carpet and think about Bephens again. "Dr. Anderson," I say, looking up, "I know I've missed a lot of days, but I'm a good student as you said. I've had to work nights to pay for everything because I'm staying with friends while my mom is away."

Truth.

He's saying something, but I'm too focused on my next lie and looking pitiful to hear anything but the teacher's voice from Charlie Brown—"*Wah wah wah wah wah waaah?*"

I nod to show I'm listening and fold my hands in my lap to prove how sincere I am. "I haven't told my teachers why my mom is away because I don't want them feeling sorry for me. But [*sniffled tears*] the truth is that my mom has cancer and is getting treated in Arizona."

Lie (except for the part about Arizona).

Again, I hear Charlie Brown's teacher—"*Wah wah wah wah wah waaah?*"—but my ears perk up when he asks about calling my mom.

Accepting another tissue, I dab my nose. "No, I'm sorry, you can't call her [*more tears*] because she's too sick to talk on the phone."

Lie.

Dr. Anderson looks like he's about to cry. I sniffle, clear my throat, and swallow my tears visibly to convince him that I'm *really* sad—then lean closer to his desk and beg him with my eyes to be the hero and save the day.

He wipes his eyes and comes around his desk to sit on it. "Well, Bridey, I can see how difficult this has been, and I applaud you for keeping your grades up. I think we'll be able to make an exception this time." He shakes my hand, then wraps both of his around it. "Please let your mom know I hope she's doing well and look forward to meeting her at graduation."

"If she makes it." I sigh—loudly.

CHAPTER 29

Come Undone

Portland, Oregon 1993

The hospital ward smells like a soup of rubbing alcohol and Pine-Sol, but I've never felt dirtier.

"Can you tell me, again, exactly what your mom said?" It's nearly three in the morning, and the police officer is asking the same question I've already answered for a doctor, a nurse, and two cops who were in my mom's driveway when my roommates and I pulled up.

Looking across the ward, I see my mom through the window of the hospital room where they're holding her. She's slumped over in a chair. Even though she's not looking up, I don't care if she sees me because I've spent my life rescuing us from monsters she's moved in, and now she's one of them. I can't rescue her from herself and don't want to anyway. To make sure the officer writes down every word this time, I speak slowly and leave out the contractions. "My mother said, 'I am going to fucking kill them. Then myself. We are all going to die tonight.'"

The officer looks up from his pad and breathes an audible inhale and exhale, like he's both taking in and letting out what I

said. "Okay, I got it. Thank you." His voice has softened. "Go ahead and sit with your friends while I see how the doctor is doing with your mom—"

"You mean Frankie," I correct him.

The officer nods. "Right. Frankie."

I'VE SPENT THE PAST THREE YEARS trying to forget she was my job—I mean, my mom.

Because I had zero plans and zero money when I graduated from high school, Mac—Mom's friend who gave me the *PSAT Study Guide*—let me live in his garage apartment in San Luis Obispo, California, while I went to Cuesta, a cheap community college that was tough enough to get me ready for a four-year school. The study guide worked, and between good grades and a solid SAT score, I got into Lewis and Clark College, a private school in Portland, Oregon—and almost for free because of my zero-money situation.

Mom and Danny now live in Seattle, three hours from Portland, and far enough away that she can't call for immediate rescue, but I might make it if someone is dying a slower death. Because I'll only talk to my sisters on the phone, my mom devised a bait-and-switch sales trick to get me to talk to her. She baits me with my sisters' little *Who's-down-in-Whoville* voices, pleading, "Come visit! We miss you!" then snatches the phone to ask for what she needs—money for the girls' school clothes or extra presents at Christmas.

I've avoided her, ignored her, and didn't even know her address—until tonight when she called my house a few hours ago.

"Bridey, I think it's your mom." Emily hands me the phone in the dark. "And she's crying."

"Thanks, Em." I sit up in bed and take a deep breath to get ready for whatever bomb my mom is about to drop. My other roommate, Kit, is standing behind Emily, and my best friend, Ilka, is in bed next to me. My roommates are wide awake because they know enough about my life that any call from my mom—let alone one at midnight—is bad news. "Hello?"

"Bridey!" Mom screams. "Come now! You have to come right-fucking-now!"

Thump! She drops the phone.

"Mom? Pick up the phone! Mom!" I hear her fumbling with it. "Mom!"

She cries, "Bridey . . . hurry . . . can't do this . . . anymore."

"Do what? Mom, what the hell is going on? Where's Danny?" My heart is pounding.

"Gone . . . he's been gone . . . I'm all alone, baby . . . please come."

"Get Bephens on the phone! Where are the girls?"

Suddenly, she shrieks, "Come get the girls! I'm gonna fucking kill them! Then me! We're all gonna die tonight—"

"Mom!"

"I slip off the bed onto my knees. "No! No! No!"

She hung up.

I punch in her number.

Busy.

I push redial, crying. "Answer the phone, goddamnit!"

Busy.

I look at my roommates huddled around me, and my chest heaves. I'm gonna be sick. Ilka takes the phone from my trembling hands and pushes redial.

Busy.

Curling into a ball, I rock myself and whisper—*Hold it together, Bridey. You can do this.*

"Breathe into this." Kit puts a paper bag in my hands, and the girls help me sit up.

As I try to slow my breath, Ilka rubs my back. "I'm so sorry, Bridey."

"She said she's gonna kill them? I have to call the police, right?"

Kit hands me a sweatshirt. "Here, put this on. We'll go get your sisters. I'll drive."

Emily puts her arm around me. "You can bring them here, okay?"

"Really?" I look at the three of them. Their beautiful, protected lives haven't prepared them for this. "We can't go. You don't know what she's like."

Ilka says—in a more serious voice than I've ever heard from the girl who laughs as often as she breathes—"Bridey, we love you, and we're coming with you."

I grab a letter from my sisters with their address on it, and Ilka helps me into my jeans and sneakers. "Thank you." Kit's worried brown eyes are trying hard to be brave. I take her hand. "Kitty Kat, you're a goddamn debutante. You sure about this?" I laugh.

"Hell, yeah." She smiles.

Emily says, "I'll grab some blankets for the car."

"Okay, and I'll be right there. I just have to pee." I lock the bathroom door and run the water faucet—something I haven't had to do in almost three years. Stomach emptied and teeth brushed, I look at myself in the mirror. *Everything's gonna be okay.*

THREE HOURS, TWO COFFEES, AND one McDonald's Filet-O-Fish later, we turn onto my mom's street. Flashing lights from two police cars blanket the neighborhood.

"This must be it." I tighten my shoelaces and my ponytail. "Here we go."

Ilka rubs my knee. "It'll be okay. We're with you."

As I get out of the back seat, an officer walks over. "Hello, Miss. Can you tell me who you are?"

I point at my mom crying in the back seat of his patrol car. "I'm her daughter. I go to school in Portland."

My mom sees me and pounds the glass. "Bridey! Don't let them take me!"

I turn my back to her. "Officer, do you know where my sisters are?"

"Your mom's cousin came—"

"A cousin?" I cut him off. "She doesn't have a cousin here! Who'd you send them with? Where are my sisters?"

"With your mom's cousin, Frannie," the officer explains in a

steady voice I know is meant to calm me down. "She lives about thirty miles away, and your mom apparently called her to come get your sisters."

"Oh, okay. I know who that is. I've just never met her. Thank you."

"I have her number and address. You can call and get your sisters."

Mom told me on the phone Danny is gone, so I don't bother asking about him.

"Okay, your mom called you? Can you tell me what she said?" the officer asks with a pad of paper out.

It got quiet, and I figure my mom must've passed out behind me. I tell the officer what she said when she called.

He takes some notes then says, "Because of her threat of suicide, we're taking her to the hospital to get evaluated."

"And the threat of homicide? She threatened to murder my sisters. You wrote that down, right?"

The officer nods. "I need you to come to the hospital and sign some paperwork."

"Let me go in the house first, and then I'll be there."

THE OFFICERS DRIVE AWAY WITH my mom, and my roommates get out of the car. Freezing, I point with my hand mittened in my sweatshirt to the steep set of stairs leading down to the house. "Wanna come inside? I have to get the girls some clothes, but I've never been in this house and have no idea what we're gonna find. Okay?"

The front door is unlocked. We only take a few steps inside before the smell of garbage stops us. The living room and kitchen have an eerie amber light because every bulb is almost burned out. The couch cushions are all over the living room floor, a chair is flipped over, and there's broken glass everywhere. "Jesus, it looks like someone robbed the place." I rub my arms to warm up.

Kit opens a pizza box in the sink. "*Ewww*, it's moldy. What do you think the girls have been eating?"

"I don't know," I say, embarrassed by my answer. My sisters have been living like this while I've been in Portland pretending

they don't exist—making myself believe I fit in with the kids who went to summer camps and boarding schools, have trust funds and passports, and parents who send care packages and tell their kids how proud they are of them. "Ready to go upstairs?" I flip a light switch that doesn't work.

Winding our way up the dark spiral stairs, we hold each other's waists like the victims in scary movies always do before getting hacked to pieces. The lights in the two bedrooms on the second floor are just as dim as downstairs. "I don't see my sisters' stuff. Maybe their rooms are on the next floor?"

"How many rooms are in this place?" Kit asks.

"I don't know, but this house is huge." I turn on the light in a bedroom, and the same amber glow shows drawers pulled out of a dresser and clothes thrown everywhere. "I think this is the little girls' room," I say, seeing toys scattered all over the floor. Dara is about five now, and Fiona—who was born my freshman year—is three and a half.

"All the books are ripped up," Ilka says, pointing to the piles on the floor.

I've seen enough and am ashamed my friends are seeing this, too, because I've worked hard to keep this life separate from mine. "Let's go. I'll just buy the girls clothes and toothbrushes."

AT THE HOSPITAL, THE OFFICER HANDS me papers to sign. "If she's not still threatening suicide when she sobers up, we have to let her go."

I stop signing. "What? You're really gonna let a woman who threatened to kill her children leave?"

He hands me my mom's purse and nods to the doctor standing next to him who says, "I'm sorry. I know this is hard, but we can't keep her against her will."

The doctor looks across the emergency room at my mom who's finally calmed down enough to sit. "We'll at least keep her until the afternoon to let you get some rest before you pick her up."

"Pick her up?" I shove the papers at him. "You think I'm coming back to get her? Frankie can walk home for all I care."

IT'S ALMOST SUNRISE WHEN WE FINALLY find Frannie's trailer. After a somewhat awkward first meeting with my second cousin, we get my sisters into Kit's car and head back to Portland.

"Don't let Francis find you for a while," my grandmother warns when I call to tell her what my mom did. "I wired you five hundred dollars. Get a motel room and take the girls shopping."

"Okay, thank you, Grandmother."

"I talked to her, and she's pissed that you took the girls, but I told her she needs to cool off for a few days because you all need a break."

My sisters come to campus and hang out with my friends while I go to class to discuss Beowulf as a hero and the plight of women during the Victorian era—conversations that feel like total bullshit given my reality that I can see playing tag on the grass outside my classroom. We sneak into the school's outdoor pool for midnight skinny dips and have nightly slumber parties. Hoping their snapshot of college life will inspire them the way the PSAT book did for me, I avoid my mom's calls for as long as I can to keep the girls in my world and away from hers.

After about a week of avoiding her calls, I get nervous she's gonna show up and start breaking windows, so I answer the phone.

"Hello?" I ask, even though I know it's her.

"Bridey?" she asks, even though she knows it's me.

"What?"

"Who the hell do you think you are?"

"Who do the hell do you think *you* are?"

"I want my fucking purse! You have my wallet, keys, everything."

"I have your kids, too. You don't want them?"

"You bitch! You bring them home—right-fucking-now! No bullshit!"

"No."

"What do you mean, no? You kidnapped them! I should call the cops!"

"Kidnapped? Really? You called me—or don't you remember?"

"Bring my girls home, *now!*"

"You can come get them if you want them, but I have school."

"Fuck you."

"Okay. Is that it?"

Click.

MOM PULLS INTO OUR DRIVEWAY the next day. I shout to my room-mates, "Oh, shit! She's here! Keep the girls upstairs if you can!"

My sisters are packed, but I want to talk to my mom first. I take a deep breath, stand up straight, and head outside to meet my maker. We both know I'm not scared of her anymore, but her fist is still no joke.

Mom gets out of the car as I drop her purse on the trunk. She steps up to me and jams her finger in my chest. "Don't ever take my kids again. You kidnap my girls then call *my* mother to help you? Stupid bitch."

I hold still and keep my eyes locked on hers. "Kidnap?" I scoff. "You were going to *kill. Your. Children!*"

Suddenly, Dara runs up and wraps her arms around my mom's legs. "Hi, Mommy!"

Fiona is right behind her, reaching up to be held because even though she's three, she still breastfeeds, and it's been over a week. Bephens, now ten, walks straight to me. She brings me down for a hug, crying as she whispers, "I wanna stay."

"I know. I wish you could. I promise to call more and come see you, okay?"

"Get in the car, Bephens!" Mom yells.

The girls get in the back seat of the clunker, and Mom sits but doesn't shut her door. "We're done, Bridey."

I lean down to keep the girls from hearing. "Tell yourself what you want about this, but I remember everything you don't because I was sober," I say, pointing to myself. "And we're done? Great. I'm happy to have my life back."

My mom's beater car peels out of the driveway and tears off around the corner. Staring down the street and wondering what happens next, everything in me wishes what she said was true—that we really are done—but we both know we're not because she has my sisters, the bait that I take every single time.

CHAPTER 30

Pomp and Circumstance

"*M*om! Put her shirt down!" I push my roommate's redheaded friend behind me. I don't even know her name, and she just got felt up by my mom. As the poor girl shuffles her Birkenstocks out to the party in our backyard—hopefully to take a shot of tequila—I turn to my mom. "I can't believe you did that!"

"She's a lesbian, isn't she?"

"What? Even if she is, what does that have to do with anything?"

"Isn't everybody here a lesbian? Don't you see boobs all the time?" She laughs into the beer she carried in with her. "How did I raise such a miserable fucking person?"

"You didn't raise me. I raised myself."

"Good. Then it's not my fault." She sticks out her tongue.

"This is why I didn't want you to come. I knew we'd fight."

"Quit being so fucking dramatic, Bridey. Have a drink." Mom turns on her dirty sneakers and heads to the backyard where I'm positive she's about to wreak havoc on the graduation party my roommates and I are having together.

Behind me, Danny is posted up on our couch with a few beers, staring at our TV that doesn't work. I guess he's back from wherever he was, and everything has been *hunky-dory* since "the kidnapping"—as Mom calls it.

I wish I didn't have to invite them, but I wanted the girls to be here because seeing me graduate from college might make them believe they can do it, too. Grandmother sent a FedEx envelope with a thousand dollars cash in it, and my cousin Katrina is flying in from Juneau. I'm hoping she can keep my mom from causing too much chaos tomorrow.

Through the kitchen window, I watch my mom skulk around my roommates' parents, trying to find a way into their conversations. Since she hasn't bought me so much as a textbook, I doubt she'll be able to relate if they start celebrating about being done with paying tuition or the cost of grad school.

"Don't you love the piñata Gillian hung up for you?" I ask my sisters, already whacking the papier-mâché donkey with a stick.

"I'm giving the girls turns before I smash it wide open!" Little Danny says, jumping around, excited for his turn. Danny's son is from his first marriage and about the same age as Bephens. He's apparently been visiting a lot since I've been in college.

"So, is your daughter a lesbian, too?" I hear my mom asking on the other side of the yard.

Shit.

My friends' parents, dressed in pastels and golf shirts, are ignoring her question by being overly interested in their cocktails, but my mom fills the awkward silence. "But *lez-be-honest,* I've known since Bridey was little. Did you know about your girls?"

Torn between refereeing this ridiculous conversation and probably making things worse or hiding under a table until it's over and everyone leaves, I stand still and wait to see if the grown-ups can handle my mom themselves. Although I'm grateful my mom is excited about Ingrid—a witty girl with a gorgeous smile I've been dating for four months—her bragging to everyone about her "homo-daughter" who's "a lezzie" is also pretty embarrassing.

"Oh, I get it! You're a bunch of stiffs! Lighten up and have a couple more drinks!" Realizing the parents don't think she's as

funny as she does, Mom sets her empty beer can on their table and heads back into the house.

I follow her.

She opens our fridge.

"You need something?"

"Yah, this." She pulls out a beer. "Your party sucks."

Knowing I should keep my mouth shut because she's about two swigs of beer away from starting a fight, I can't help myself. "You're welcome to leave."

Mom squares up on me—most likely calculating how hard to smack my mouth—then seems to change her mind and says to Danny, still staring at a black TV screen because I think he's terrified to interact with the parents or the lesbians in the backyard, "Go get the kids. Bridey wants us to leave. She thinks she's better than us now."

"That didn't take long." He gets off the couch and walks by me, mumbling, "Ungrateful bitch."

"What did you say?"

Danny laughs.

Mom shoves me against the kitchen counter. "Way to ruin it for your sisters."

Catching my hip on the tile, I rub it a few times to stop the throbbing, then see my mom rifling through her purse to find her keys. Outside, Danny is helping pick up piñata candy, trying to impress his son with how great a dad he is, while parents raise glasses to their graduates, probably saying things like, "Cheers to our wonderful Gillian!" and "Woodland, you never cease to amaze us!"

Meanwhile, my mom would rather hip-check me than tell me how proud she is that I've put myself through college. Standing in my kitchen, I realize what's happening right now is a first: I've fought Danny, I've fought Mom, and I've fought Danny for Mom. But they've never been on the same side—against me.

When I was six, I had a red plastic 3D Viewmaster that flipped through slides when you dropped in a story disc. "Disneyland" was

my favorite because the picture of Cinderella's castle was so vibrant, it felt like I was actually standing in front it, then I'd press the plastic lever that went *ca-chunk!* and I'd be in riding "It's a Small World."

Watching Mom taking beers from our fridge and shoving them in her purse, *our* story disc drops in front of my eyes.

Ca-chunk!—I'm seven, smoothing her hair back, while she cries about Jeff.

Ca-chunk!—I'm ten, wiping blood off her face after Al leaves her on the floor.

Ca-chunk!—I'm twelve, watching her wave my winning essay in the air.

Ca-chunk!—I'm thirteen, cleaning up my sister's Burger King barf.

Ca-chunk!—I'm fifteen, calling my dad to break his heart, then putting out her fire.

Ca-chunk!—I'm twenty-one and being accused of kidnapping instead of a thank-you.

"You know what, Frankie?" Stopping her as she heads to the front door, I push her against the wall at the top of the stairs leading down to my room. "I am better than you. I did *all* of this by myself. You did nothing to get me here. All you did was make it harder."

She pushes me back, poking her finger in my chest. "I made you. *I* am the reason you're here. I've given you everything I have."

"Lucky me." I grab her finger and shove it hard enough that she loses her footing and grabs my shirt. I pull her off me and she slips down the stairs but grabs me, again, taking me with her. We hit the landing at the bottom, and as she tries standing, I shove her into the unfinished drywall—denting it with her hip.

"Fuck you!" She stands and holds the handrail, hauling herself back upstairs.

Shaking with adrenaline and more anger than I've ever felt, I get to the top of the stairs. My head is spinning. *What have I done?* I've tried so hard not to be like her, but what I just did—raging out of control—*is* her. I'm gonna be sick.

Behind me, a backyard full of people watch as my mom slams the front door. I look out the window onto the driveway, and the kids are crying in the car. Danny sees me and grins, waving his cigarette the way he did in Austin when Mom was flailing all over the hood. He loved parading her crazy, and now she's paraded mine.

I crank open the window. "Don't come tomorrow! I don't want you there."

Mom yells back, "Not a problem. And fuck you, very much."

BAKING UNDER BLACK GOWNS AND mortarboards, we chug champagne bottles being passed down the rows, while the speaker on stage floats inspirational clichés into the air for us to catch—"next step," and "journey," and "hard work," and "support."

Over my shoulder, I spot my cousin Katrina's bright blue dress because she's waving to get my attention. My sisters and Little Danny jump around next to her to make sure I see them. Mac drove up from San Luis Obispo and is sitting next to my mom. I don't see Danny.

An usher signals our row to stand, and we rise, spacing ourselves like a row of black dominoes. Drinking champagne all the way to the stage, I forget to pass it behind me when they announce my name: "Bridey Martha Thelen."

The college president laughs as we jockey the bottle back and forth before handing me my diploma and shaking my hand. "Congratulations." He smiles.

Standing at the edge of the stage and seeing the graduates' families, I look across the field at my mom who forgot she wasn't invited or thinks I didn't mean it because, of course, she deserves the *thank-you wave* that all the other graduates are giving their parents.

I raise my right hand high in the air and give her the "*Birrrrd*."

No, Mom. Fuck you, very much.

CHAPTER 31

Sunrise

San Luis Obispo, California 1995

"*H*ello?" I ask, knowing it's my mom because it's the middle of the night.

"Danny hit Bephens! He punched her in the fuckin' mouth! Come get us!"

Of course, I take the bait.

I THINK IT'S AROUND MIDNIGHT WHEN the train from San Luis Obispo pulls into the Amtrak station outside of Seattle. Light snowflakes are falling as I cry in a huddle with my mom and little sisters under rows of fluorescent lights. I'm not sure why they're crying, but my tears are relief because I've wanted Danny gone from our lives since I was twelve and left him wasted and waiting on our porch at Coho Park. "Take us away, Bright Eyes," Mom cries.

Her U-Haul is nearly full when I get to their house. "I live in a studio apartment. You can't take everything."

"I'm not leaving that son of a bitch one goddamn spoon!" Mom dumps the silverware drawer into a pillowcase.

"Okay, but there's only five of us, so maybe five plates and not the whole shelf?" I laugh, trying to lighten the mood. "I'm gonna tuck in the girls. It's late."

Fiona and Dara are already asleep with the puppy they got for free outside the grocery store. I kiss their foreheads. "Night, sweet girls. Love you."

I scoot over to Bephens and sit on the edge of her bed, brushing back her bangs. "It's okay, don't cry." Her teary eyes gaze up at me, and I whisper, "We're leaving, and you never have to see him again."

She hugs me. "I'm so happy you came. We got your postcards from your trip."

The light coming in from the street makes the dark circles under her eyes look even deeper. Smoothing my finger gently over them, wishing they could be erased, I ask, "Isn't the Eiffel Tower amazing? And I learned how to make Greek food. I'll make you some when we get to my house, okay?"

"Okay."

"So, he punched you?"

Bephens nods and points at a shadow on her cheek—the evidence that, once again, I've been gone too long. It's been eight months since graduation, and while I backpacked around Europe, this exhausted eighth grader has been raising her sisters, saving her mom, and suffering a stepfather who's always hated her. She's run herself ragged on the same hamster wheel I did—chasing our mom around and around—hoping she'll eventually slow down so we can all stop running. I wipe her tears and kiss her forehead. "It's over now."

"I love you," she whispers.

"Love you more."

AS I HELP MY MOM GRAB A FEW LAST things in her room, she says, "I made him leave when he punched her, but I don't know where he is."

"Let's hope he doesn't show up now. We need to hurry!" I pick up a small trunk next to the bed.

"No, not that." Mom points for me to set it down.

"Why, is it your hope-less chest?" I laugh.

"Just leave it." She starts to walk out of her room but stops in the doorway and looks at the trunk, giggling. "Wanna see what's in it? You're gonna fuckin' die!"

Not totally sure I do, I love that she's laughing about whatever it is. Nervous that plastic snakes are going to jump out like the gag ones in cans, I open the lid slowly. The trunk is piled high with my mom's lingerie—lace panties and bras in blues, pinks, and black. "Gross! Why would I want to see your underwear?"

She raises her eyebrows and shakes her head. "It's not mine."

My mouth drops open. Processing what she said, visions of Danny dance in my head—the badass biker who beats his wife then slips into something a little more comfortable and sashays around the bedroom in frilly underwear. As long as I've known Danny, I've always pictured him as the middle-school menace who burned bugs and tormented smaller kids—which he probably did—but now I see him hiding in his Catholic mother's closet, posing in her underwear.

"I actually kind of like him now." I laugh, tempted to leave a note inside.

Peek-a-boo, I see you.

Love, Bird

In the garage, Mom leans a piece of wood against the back of the U-Haul like a ramp.

"What's that for?" I ask.

She grabs the Harley's handlebars. "We're taking this."

"Mom, no." I back up.

"Danny's goddamn motorcycle has had a better life than any of us, and you know it."

"We can't. He'll kill us."

She tries to push the Harley-Davidson by herself, but it's too heavy. She cries, "It's all I have, Bridey. Do you understand me? I have nothing."

I don't move to help her because taking the motorcycle means he'll follow us. Danny won't come for her or the girls, but he'll come for his bike.

Mom smacks the metallic purple gas tanks. "This is yours, too, you know. These tanks are the braces you didn't get—the fucking spacer that stayed in your mouth for five more years!"

Hearing that reminder, I grab the handlebars on my side and heave with her. It's halfway up the ramp when we hear Danny's truck pull up.

"He's here! *Fuck. Fuck. Fuck.* What do we do?" I want to let go of the motorcycle, but if it falls on the cement, he really will kill us.

Mom grunts. "Keep pushing. He can't have it!"

Danny shouts down the driveway, "What the fuck are you two doing?" He grabs the handlebars from me. "Get the hell away from my bike!"

Mom keeps pushing. "Bridey came to get us! We're leaving!"

Danny jerks the handlebars. "You're not taking this, you crazy bitches!"

Mom stumbles into his work table and grabs the hammer next to her. She cocks her arm back the way he has a hundred times before knocking her out. "If you're keeping it, then it's not gonna be worth much!"

"Don't you do somethin' stupid!" he shouts, rolling his motor-cycle back down the ramp before she can hit it.

Mom looks at Danny and must realize she can't win because she drops the hammer and shrieks, "You have everything, and I have fucking nothing! Give this to me!"

He drops the kickstand. "I'm calling the cops."

Confused because I've never heard him say that before, and he's clearly already won, I keep packing and stay away from both of them. In the surreal minutes we wait for the police, Danny stands by his truck to make sure he tells his side of the story first, while Mom dumps his tools into pillowcases and stuffs them into the back of the U-Haul.

The cops show up and buy whatever line of crap Danny tells them. They stay while he loads his precious motorcycle into the back of his truck, like he's the one needing protection from us. I'm almost shocked when the cops don't flip on their lights and sirens to give him a police escort out of the neighborhood.

The next morning, Mom sings, "Off to California!" She pulls out of the driveway with four girls and one puppy all squished together in the cab of the U-Haul. I was up at sunrise to finish packing, but we waited to leave until school started this morning because the girls needed their transcripts. "You never had yours when you changed schools," Mom says.

"That's why we're getting theirs."

A DAY LATER AND A THOUSAND MILES away, I unpack an overstuffed U-Haul, two slightly confused little girls who keep asking about their dad, an eighth grader who won't stop looking over her shoulder because she can't believe her luck, a hyper puppy who pees on everything, and a mom who's bitten her nails to bleeding and can't stop crying. Somehow, we're all supposed to live happily ever after in my studio apartment above Mac's garage because we've gotten rid of the big, bad wolf.

Mom gets a job at a shop downtown, and the girls start school—including Fiona, who's old enough in California to be in kindergarten but who never went to preschool and still takes an occasional sip off the boob because neither she nor my mom has the energy for weaning.

"She's hiding under my desk and won't come out," the panicked kindergarten teacher says when she calls midway through Fiona's first day. "And she cried when I made her stand in line to take turns at the water fountain."

"Okay, I'll be right there," I say.

"And she doesn't understand she has to raise her hand and wait to be called on."

"Yep. Got it. On my way."

Dara does better in her second-grade class because she's friendly and loves making people laugh. Bephens, however, matches her black clothes to the dark circles under her eyes and doesn't seem too interested in school or anything else.

"Cheer up, Morticia!" Mom teases. "The Addams family called and wants you back."

"Don't call her that. It's mean," I say, wondering if our mom forgot she's the reason Bephens is a few years behind on sleep.

A COUPLE WEEKS LATER, I GET ANOTHER call, only this time it's from my mom's boss who sounds both worried and annoyed. "Can you come get her? She passed out on the floor when she came back from lunch."

"Again?"

"Yes, again."

"I'm so sorry, and I'm on my way."

Mom's part-time job downtown interferes with her full-time job mourning Danny—who might as well be dead for all the wailing Mom does as she drinks herself to blacking out. Day after day, she eulogizes him, like some prophet she sacrificed her life for, then glares at me like I'm the agent who raided his compound and stole her away without making sure she wanted to go.

When I find a job taking care of adults with special needs, it's a nice break from taking care of my mom. I bathe adults and change their diapers, watching in awe as they hold down full-time jobs and have loving and successful relationships. Then I come home to my able-bodied mother who needs help getting dressed and sometimes must be fed to make sure she has food in her belly to barf all over me.

"He's never coming to get you," I say, handing her a plate of food.

"Yes, he will. You'll see."

"No, he won't."

"Just stop. You don't know what you're talking about." She takes a drink of the cooking sherry she stole from Mac's house

because I keep dumping all the real alcohol down the sink as soon as she brings it home.

Seeing how fragile she is right now—with barely enough strength to sit up and chew her food—I decide to ask the question out loud that I've been hearing in my head forever. "Mom, why do you drink so much?" I sit down on the bed next to her. "I mean, I got you out of there, and there's nothing to worry about now. We could be fine—like *really* fine. Why are you so unhappy with us that you can't stop drinking?"

She sighs, and her pink, puffy eyes I've seen too many times search mine for the answer. "Oh, baby. You can't imagine what I see when I close my eyes. It's ugly and awful."

"What do you mean?"

"I have to drink to fall asleep and, hopefully, not have any dreams." She hangs her head. "A mother shouldn't have the dreams that I do."

"Like what?"

"Sometimes I dream about killing you girls—and how easy it would be."

"Oh, my god, Mom. How scary." I set her plate on the floor and hug her. "But we're okay because it's just a dream," I whisper, wondering if she thinks the night the police took her to the hospital is a dream and knowing there might come a time when I'll need to remind her that it wasn't.

DRIVING HOME FROM WORK ONE NIGHT in late April, I hear someone say, "Your whole life is waiting for you in Tahoe."

"Tahoe?" I hear myself repeat it—and even though I've obviously lost my shit because I'm not only hearing voices but talking back to them—there's no way Tahoe is where my life is supposed to be. Other than running Valet for a few weeks to make money for Europe, there's nothing in Tahoe except horrible memories lodged so deep in my belly I've never been able to throw them up. While in Europe, I'd gone to Spain to see Ingrid who moved there after we

graduated, and we made plans to move to New York City and get jobs at magazines when she gets back. *If I'm going anywhere, it's to New York to be with her.* I blow off the stupid voice and head home to make dinner for the girls and clean up whatever my mom broke or threw up on while I've been at work.

But the little voice doesn't give up. I hear the message about moving to Tahoe again the next day—and the next, and the next—until it finally shouts, "*Just go!*"

Without telling my mom anything, I call my old boss at the casino in Tahoe where I ran Valet. "We'd love to have you back, Bridey. You can start May first," he says.

Mom smiles and hugs me when I tell her what I'm thinking about doing. "It's time for you to live your life. Maybe if you go, it'll force me to get my shit together?"

Caught off guard by my mom being logical and reasonable, I panic and think of all the reasons why I can't—and shouldn't—leave.

SIX DAYS LATER, MAC HANDS ME THE keys to his 1968 metallic-gold Ford Mustang. I think he's giving me the car for the same reason he gave me the *PSAT Study Guide* twenty years ago: He knows I need a way out. Because I'll be staying with a friend's parents until I find a more permanent place to live, I pack only the essentials—clothes, shoes, a toothbrush, and the wicker chest Mom gave me when I turned sixteen that holds my Duran Duran records and my hope.

At sunrise, I pull out of the driveway. In the rearview mirror, Dara and Fiona are jumping around and flapping their arms to be sure I see them, Mom and Mac are waving goodbye, and Bephens is sitting on the curb, with her head between her knees. I'm leaving again, and they're a mess. I've tried to fix everything for them, but my daily disappointment and heavy judgment has only made things worse. I'm gonna try to fix myself for once. I promised the little girls I'd call, promised Mom money, and pinky swore to Bephens I wouldn't disappear again.

Although leaving is what I have to do to save myself—and Mom even agreed—glancing in the rearview mirror a last time before turning the corner feels like the scene in the movie *Mad Max* when he drops his match in the gasoline and casually walks away from the exploding cars and bodies burning in an inferno.

CHAPTER 32

What Happens Tomorrow

Lake Tahoe 1995

"*J*esus, Bridey! Your bra isn't holding anything up!" Shannon heckles my frayed bra. "Why are you even wearing it?"

"Whatdaya mean?" I look down and see my boobs are where they always are—resting on my freckled chest while my nipples keep an eye on my feet in case anything tries tripping me.

"Heather, grab the other side and pull!" Shannon calls out, and the two of them laugh their asses off playing tug-of-war with my bra straps. Heather has been my friend forever, and both of them saved my ass my senior year when they let me live with them, so they've earned the right to tease me about my boobs that I know look like sock puppets.

I check out my lifted profile in the mirror. "Wow, they do look better!" Ready to dance my ass off because all I've done is eat, sleep, and work since I got back to Tahoe five days ago, we head out.

The nightclub is packed for Cinco de Mayo. Clusters of twentysomethings bump and grind under strobing lights and clouds of cigarette and clove smoke. Margaritas in hand, the three of us point out cute guys in the crowd to each other. When Tupac's

"California Love" starts, vibrating the giant speakers next to us, Heather squeals, "Oh my gawd! This is my jam!"

A few sweaty songs later, Shannon points to the exit. "I'm gonna go, but I'll get a cab because you two should stay."

"One more drink?" I ask, not quite ready to go. "Then take my car, and we'll get a cab."

"No, I'm tired." She shakes her head and gives some other reason Heather and I don't hear because we're busy scanning the crowd for a hot guy to keep her here longer.

I nudge Shannon's shoulder. "Just grab a guy and ask him to dance!" To prove how easy it is, I tap a shaggy blond standing in front of me. The cute surfer kid turns around. "You wanna dance?" I shout over the music.

He looks around, like I might be asking someone else. "Uh, no, thanks."

Shannon busts up laughing and opens her palm for my keys. The blond boy stammers, "I, uh, have something to do, but I'll be right back."

I roll my eyes because we both know he won't.

The girls and I are having a last drink when someone touches my shoulder. Wearing jeans and skater shoes, the cute blond boy is back. "You still wanna dance?" he asks.

TURNS OUT THAT AARON IS A SKIER, not a surfer—and obsessed enough with it that he's still finding snow to ski on when everyone else is at the beach. He's so sweet and easygoing, I don't believe it's real and spend the next month trying to shake him loose—even pointing out other girls he should date instead of me. "See, like that girl over there with the braids under her beanie."

"What are you doing?" he asks.

"She looks like someone you'd have stuff in common with."

"Don't we have stuff in common? I mean, you said you ski?" He smiles. "I don't want to go out with anyone else, okay?"

"Okay," I say but continue to find ways to test him.

"ARE YOU TRYING TO START A FIGHT?" he asks one day while I'm following him around my apartment, nagging him about anything I can.

His question stops me because I am. Aaron's calm and quiet nature feels too much like the silence out in Austin that made me nervous because I knew the storm that was my mom and Danny was eventually going to come. And it did. But if I start the fight and create the storm myself, it won't catch me off guard. I also haven't told him much about my family because that's baggage I can barely hold myself, and he's too nice to have to carry that weight.

Too nice.

My mom said that about the Marlboro Man, then broke up with him.

Shit.

WHEN AARON MEETS MY MOM AT the end of the summer, the only thing I've really told him is that she's raising my sisters by herself because she's separated from their dad.

I've made sure to call my sisters and know that things are going okay since I left. After we hug—and the little girls climb all over my new boyfriend they tell me is cute—Bephens hangs out with them in my yard while I stand guard, making sure Mom is on her best behavior.

She cracks a Budweiser in my kitchen. "Want one, Aaron?"

"Sure, thanks." He smiles and takes it from her to be polite, but he'd rather smoke pot than drink beer, and I'm glad about that.

My stomach is in knots, and I'm pissed at her for doing this. She smirks at me, happy to push my buttons. "Isn't Bridey a pain in the ass? So fuckin' picky and—"

"Mom!" I cut her off. "What kind of question is that? Why don't you ask him something normal like, 'Where did you grow up? What do you do for fun?'"

She rolls her eyes. "Well, I'm not asking him what he does for fun because he's with you and having fun is against your rules."

Aaron laughs, thinking she's kidding. "Bridey's always fun."

Mom pretends to gag, then pulls a clump of my hair.

"Ouch! Why'd you do that?" I ask, smoothing my hair back down as Aaron leans over and tugs on a piece.

"Stop! What are you doing?" I smack his hand away.

Mom loses her shit, laughing.

"Oh, no! I'm so sorry!" Aaron says and starts rubbing the spot where he pulled, like it's an owie he's trying to make feel better. "I did it because she did. I thought it was a joke."

I stand up. "She wasn't trying to be funny."

"Lighten up, Bridey," Mom says, tossing her empty beer can in my kitchen sink.

"Good visit, Mom. I have to go to work."

"We're leaving anyway. Maybe come by the motel later to see your sisters."

Aaron gets up to leave, no doubt confused at how quickly my mom set me off. "Nice to meet you, Frankie." He smiles. "Thanks for the beer."

"Yep." She nods. "Good luck. She won't be easy on you."

Aaron heads to my car as the girls get in with Mom. Standing at the driver's side window, I ask her quietly, "You can't ever be nice to me, can you? Not even now when you know how nervous I was for him to meet you?"

"Jesus Christ, give it a rest, Bridey. Does that poor boy know how miserable you're gonna make him?

"Do you know that it might only be you who I make miserable?"

"Well, you're both pretty fuckin' boring, so maybe you're perfect for each other."

Boring? Did she just say the "B" word?

If this were an episode of *Sesame Street*, BORING, BORING, BORING would be floating in the air around me, like the magic word of the day.

I might have to marry this boy.

TWO YEARS LATER, AARON'S family flies out to Tahoe for our wedding.

I met the Heidels last summer, and they were everything I've dreamed about since appearing on the short-run sitcom "Meet the Roses" in Austin. The Heidels check every box from my perfect-TV-family list: They live in a two-story house in the suburbs, his parents are best friends who've been married forever, his young brother is too bright for school and has the perfect amount of teen angst, his beautiful sister has boundless energy and adores her parents, and—as a bonus—his grandma is English and sounds like the members of Duran Duran.

"Did you bring the tranquilizers?" I ask as soon as I see Uncle Killian.

"Yep. Your grandmother sent enough to knock Frankie out until you get back from your honeymoon." He laughs. "She said to tell you she was sorry to miss this but figured it'd be rough with your mom if she came so better to let Lynne come."

Auntie Lynne hugs me. "We'll keep an eye on your mom and make sure she doesn't start acting up. You don't have to worry about a thing."

My wedding is perfect.

The only people I wish had come were my first dad and Rhonda. I haven't really talked to them since Mom told me Cargill wasn't my real dad and didn't want me around, but I think about them and wonder if they think about me. The day after my wedding, Auntie Lynne gets their phone number from a friend in Juneau. Turns out, they live in California, too—and only a few hours away.

It takes me another day to talk myself into calling because Cargill has his own kids now and might not want me to bother him. Then I dial his number.

"Hell-o?" It's the low, Eeyore drawl I haven't heard since I was seven.

I open my mouth, hoping words will fall out. "Hi. I'm looking for Jim Cargill."

"Yes, that's me."

I swallow to keep from bursting into tears, then rush my reply before I lose my nerve and hang up. "My name is Bridey—I don't know if you remember me—but I used to be your daughter."

"Bridey?" I hear surprise in his question. "Of course, I remember my daughter!"

I cover the receiver and cry.

"Well, this is a surprise. I've wondered about you but heard through people in Juneau you're doing good."

I wipe my nose and try pulling it together. "Yes, I'm good. I actually got married yesterday and was wishing you and Rhonda were there."

"That's great. Congratulations."

"Thank you." Relieved he sounds happy to talk to me, I keep going. "I hope it's okay I called because I know you have a family now. I just wanted to thank you because I have a lot of good memories of us together—on the school bus and all that."

"You could never bother me. I'm just sorry it's been so long. I do have kids now—my twins, Jimy and Tryphena, and a little boy, Joey. They know all about Bridey."

"They do?"

"Yeah, and they're excited to meet you. Where you livin' now?"

"I'm actually in California, too—Lake Tahoe."

"You moved there with your mom when you left Juneau, right?"

"Yeah."

"Well, me and the family will be there tomorrow."

I cover the receiver and cry, again.

CHAPTER 33

Ordinary World

December 6, 1997

"Can you believe you're finally getting to see them, Bride?" Andy asks as we show our tickets at the door. "Feels good to be grown-ass women who can do what we want and finally afford concert tickets, right?" She laughs, but we both know seeing Duran Duran is much deeper than just a concert for both of us.

"I'm actually dying thinking about the fact that Simon Le Bon is *literally* on the other side of that wall!" I squeal and point at the stage.

Thirteen years after seeing "The Reflex" video on *MTV* and watching my childhood hopscotch over me while I pretended to be an adult, I'm now standing in the Sacramento Memorial Auditorium with a few hundred other die-hard Duranies who've stayed loyal through the band's breakups and shakeups. Andy and I pose in our Duran Duran T-shirts, now considered "vintage," and giggle like twelve-year-olds while waiting for Simon and Nick—the two original members still touring as Duran Duran—to take the stage. Simon starts singing, and it's the voice I've danced to, fallen asleep to, and filled a dozen diaries writing to. A time-warp trick pulls me back to Coho Park with Missy and MTV on full blast. I'm twenty-six

230

but reaching my hand out for Simon like the spellbound twelve-year-old who reached for the TV screen, believing she might make it to the other side.

I want to tell her we finally did.

"THOSE WHO CAN, DO. THOSE WHO CAN'T, teach," Mom had said during my first year of college when I told her how much I loved my Ecology professor.

I hear her say this every time a school secretary hands me keys to a classroom where I'm substitute teaching for the day. Mom didn't like teachers and avoided coming to my school events, probably because she knew she'd get busted if they figured out what a crappy parent she was. "Do you know about Ms. Cowen's class?" the secretary asks, handing me roll sheets.

"Only that it's sixth grade."

"It's called 'Challenge Class' because the students have pretty rough lives and have been through a lot. They're good kids, but they might test you. Joy will be there to help. She's the aide and knows how to deal with the ones who'll give you a hard time."

As students file in, some smile, some scowl, and some couldn't care less.

"You can be honest with these kids," Joy says as the final bell rings. "They'll respect you for it." Her New York attitude makes me feel safe, like she doesn't take any shit. She adds, smiling, "And it's okay to have fun with them, too."

The students quickly hijack the schedule by asking me a million questions, obviously trying to get out of doing worksheets, but I play along and answer what I can—

Are you married?
—*Yes*

Have kids?
—*No*

Did you go to college?
—*Yes*

Do you want to be a teacher?
—*No*

Who's your favorite Spice Girl?
—*Sporty Spice*

Why?
—*Because it's cool she wear sneakers instead of heels*

Where'd you grow up?
[pause]

I look over at Joy, sitting on a desk and grading papers. She said to be honest.

—*I grew up in a lot of places—here, for one.*

Where'd you live?
—*The first place we lived was the Bee Vee Motel, which is now the Nickelodeon.*

Kids who've been playing with the Tamagotchi toys hidden between their legs look up.
"I live in a motel," one kid blurts out.
"We used to, but we got a house," another kid says.

What'd your mom and dad do if you had to live in a motel?
—*My mom had boyfriends—no dad around.*

They nice?
—*Nope.*

"Mine, either," a girl says.

"My mom's boyfriend sucks," another girl says and rolls her eyes. They start scooting their chairs closer to me.

To be a teacher, you gotta go to college. How'd you do that if you lived in motels?

—*If you get good grades, schools give you scholarships. I was about your age when a family friend told me I was smart enough for college. No one had ever said that to me before.*

"I'm going to college," a boy says.

"Me, too," a girl says, snapping in the air above her head. "I'm gonna be the first."

Eventually, we get back to the work Ms. Cowen left, and the awkwardness we all felt at the start of class seems to be gone. When the bell rings, a few kids hug me, and others ask when I'm coming back.

"I'll tell your teacher that I'll sub for her anytime." I smile.

Returning the key to the office, I run into Joy. "How'd you like today?" she asks.

"The kids were great! And some of them came around by the end of the day."

"Ms. Cowen will love hearing that." Joy smiles. "Are you trying to get a job?"

"Teaching?" I laugh. "No, I don't want to be a teacher. This is part-time, while I figure out what to do with my English degree."

Joy's round brown eyes soften behind her glasses, and she gently cups my face with her hands. "I watched you with our kids today, and whether you know it or not, this is the thing you *must* do. You know those kids because you were that kid. They need you, and you need them."

Like the voice in my car that told me that my whole life was waiting in Tahoe, Joy's words feel like another nudge from the universe. It was right about Tahoe, so maybe it's right about this, too?



Two years later

ANDY AND I MAKE IT TO ANOTHER Duran Duran concert. It's still just Simon and Nick—with a guitarist from another band—but the crowd is bigger than before. They didn't play "The Reflex" at the last show, so when Simon starts singing it, Andy and I duck around security and rush the stage. Simon smiles right at me—at least I think he does.

"Mom, guess what? I saw Duran Duran again!"

"That's great, Bright Eyes. I know how much you love them."

"Then I drove back to Tahoe super early because I had an interview for a teaching job."

"You want to be a teacher?" she asks, sounding confused.

"Mom. I *am* a teacher! I got the job! I get to teach seventh-grade Language Arts this year!"

"I thought you wanted to work at a magazine?"

"I did, but I've been subbing, and I'm really good at it. The principal, Mr. Greenfield, even gave me a job without a credential and said I could go to school while I teach. Isn't that cool?"

She sighs, letting me know she's totally unimpressed. "I've always said, those who can, do. Those who can't, teach."

I START SCHOOL, AND AARON AND I CLOSE escrow on a house with a white picket fence. Even though the fence is only a foot high, it's a symbol of the normal life I've dreamt about since I was little. And, in what can only be described as serendipity, the house is down the street from my childhood friend Nikki, who never knew what happened to me that morning when she came to pick me up for the school bus.

When my mom graces my classroom with her presence, she brings with her yards of ugly green-and-yellow John Deere–printed fleece to help me with a community service project my seventh graders are doing.

"It was only a buck a yard, can you believe that?" She shows off the fleece to Paula, a student's mom who came to help.

"What a deal," Paula says, sounding sincere. "How many hats are the kids making?" she asks me.

"As many as we can. The kids will use ours as examples then sew their own to give to people this winter."

Paula turns to my mom. "How cool you came to help your daughter."

"Oh, I've always loved sewing, and what a great skill to teach kids," Mom says, sounding so normal it makes me nervous about what she's going to say next. "Are you a teacher?" she asks Paula.

"No, I'm the PTA president. Your daughter teaches my son, and he loves her class."

"You're the what?" Mom looks disgusted, then points her scissors at me. "Did you do this to me on purpose?"

"Mom, be nice," I whisper through clenched teeth.

"The goddamn PTA president, Bridey? You've got to be kidding me!" She drops her scissors and storms out.

"I'm so sorry, Paula. I can't believe she did that," I say, lying.

Sweet Paula smiles and continues cutting fleece. "Oh, it's okay. Maybe she's having a bad day."

"More like a bad life." I laugh. "But I am sorry and thank you for helping me."

Poor Paula is paying penance for all the "do-gooders" my mom can't stand—the moms who own more than one "school bra" and bring cookies to bake sales.

MOM ONLY CAME TO MY CLASSROOM because she's in Tahoe to drop Bephens off to live with me and Aaron. Mom and Bephens have been fighting, and Bephens is starting to win. Barely in high school, Bephens is scrappy—standing up to anyone who looks at her the wrong way. I can't blame her, though. Her life has been spent with her fists her up, protecting her body and shielding her soul.

After a few months of hoping she'll settle down and appreciate our calm and quiet life Bephens says is "boring," I realize she's addicted to our mom's chaos the way I used to be. I remember

feeling like life with my dad was boring, too, and I've always wondered how different things would've been had I not blown it and moved to Austin.

"Hit me! I know you want to!" Bephens shouts.

"Did you really just say that to *me*—of all people? Why would I ever hit you?"

"Because I stole your fucking car!" Bephens hits herself in the face, and my stomach knots, remembering our mom doing the same thing with Danny's fist.

"Stop that! What are you doing?" I yell. "Yeah, I'm pissed you took those kids to Taco Bell because you don't even have a license, but that's why you're grounded, dumbass. I'm not gonna hit you for it."

Her rage is getting harder to manage. As patient and sweet as Aaron is, we're newlyweds and I feel terrible bringing all my shit into our new marriage. We pack Bephens up and take her to Mom's house, which we discover is still being built.

At the top of a steep hill with a view of the valley below, we find Mom and her new boyfriend mixing buckets of cement in the middle of a mud pit the size of a small house's footprint. Fiona pops her head out of a tent I can see has a mattress in it, and Dara comes out of the tiny trailer, carrying a chicken. "Did you see Cookie?" Fiona asks, pointing to the obvious cow next to the tent. "She sleeps on the mattress in the tent!"

Aaron and I give each other sideways glances then look over at Bephens, who's staring at the scene in front us and probably regretting everything she said to me. "Come see!" Mom waves us over.

"You ready for this?" I ask Aaron who laughs because he's not shocked by my family anymore.

"We're building our own foundation. Isn't that cool?" Mom stirs a soup of cement, rocks, and twigs that look like she's borrowed building plans from the three little pigs. "And we're putting up Plexiglass walls, so we can see the whole valley."

"Pretty easy to pour a foundation, I guess," Aaron says, trying to be positive about their crazy idea.

"It can't be that hard." Mom shrugs her shoulders. "Come see the rest!"

She shows us the cast iron tub heated by a wood fire underneath it and a rope bridge connecting two trees for no reason at all. Aaron whispers, "We can't leave Bephens here. She'll be good now, I'm sure."

Bephens finishes tenth grade with us. By the time she moves back in with Mom, it's into an actual house—a double-wide trailer with guinea hens running on the roof, a ten-foot-high circus elephant fountain that sprays muddy water into the air, and Cookie the cow—who now has her very own couch.

CHAPTER 34

Hannah

"\mathcal{H}i, Grandmother."

"Hi, baby," she says in a weak voice that's hard to believe is hers.

"Everything okay?"

"You tell Grandmother about you first. I hear you bought a house?"

"We did! I can't wait for you to see it."

"That's wonderful. I'm proud of you."

"How are you feeling?"

"Well, it's worse than they thought. I think it's time to come say goodbye to your grandmother, baby." She exhales into a coughing fit.

I cover the receiver to keep her from hearing me cry. "I can't come. I'm sorry. I know Mom probably is, and I just can't handle her anymore—"

Grandmother finds enough breath to interrupt my crappy excuse. "Bridey, this is about us. She doesn't get to keep you from me." Her voice trails off, and someone hangs up the phone.

"I'M NOT GOING BECAUSE SHE ISN'T really dying. She was here last summer, and nothing was wrong with her."

Jensen—my vice principal who everyone calls by her last name—looks confused. "What do you mean you're not going—and why aren't you already gone?"

"Someone will call when it's really time to—"

She cuts me off. "Bridey, your grandmother told you to come, right?"

I nod, feeling like I'm about to get detention.

She turns to her assistant, Judy. "Can you please get Bridey a sub for the rest of the week? She's going to Alaska."

Rushing home from school to pack as quickly as I can, I open the door to a decorated Christmas tree and immediately cry. "I can't believe you did this!"

Aaron looks up from the present he's wrapping. "Oh, no. I didn't mean to make you sad. I just figured you wouldn't be back in time for Christmas, and it's our first one in this house, so I wanted to celebrate before you left."

IT'S DECEMBER, AND MY GRANDMOTHER'S hospital room is freezing. My Auntie Lynne gets up from her chair and hugs me. "I'm glad you made it."

She's the sister I should've been born to—the woman you want around in an emergency, but I got stuck with the other sister—who *is* the emergency. "Your mom and the girls are coming on the ferry later." She looks down at Grandmother. "You have some time with her." She puts my hand on my grandmother's. "It's okay to talk to her. Her eyes are closed, but she's awake."

The chemo and radiation have taken every wisp of my grandmother's dyed auburn hair, and the cancer has consumed her to the bone. Her high cheekbones—a family trait—look even more regal because her face is sunken around them. I hold her freckled hand in mine—her skin like tissue paper—and kiss her forehead. "Hi, Grandmother. It's Bridey. I'm here."

Her eyes flutter open, and without lashes or brows, she looks more shocked than she probably is. I can see she's working hard to figure out who I am. Suddenly, she grips my hand, and her strength takes me by surprise. "Oh! Well, there you are," I say, laughing softly.

Her hand moves up my arm and tugs at me to help her sit up. "Okay, I've got you." I lift her as my aunt takes her other hand to be sure she doesn't fall back.

I bend down to meet my grandmother's wide eyes fixed on mine. She inhales a breath that fills her hollowed-out body, then exhales what she wants to say. "Grandmother loves you. I'm glad you're here." She closes her eyes and leans on me, weighing nothing. Easing her back onto her pillow, I tuck the hospital's thin blanket under her chin, like a little girl at naptime.

For the next ten hours, her eyes stay shut. She doesn't speak again—even when my mom shows up and throws herself on her mother's fragile body, hysterical. "Mama! I want my mama! Why did I always disappoint you? Why couldn't I make you proud—of something—of anything?"

Standing with my back against the far wall to give my mom room with her mother, I can't help but wonder if one day I'll ask her dying body the same questions.

It's not long before my grandmother's breathing slows and begins sounding like each breath is catching in her throat then waiting to be released. I've been rubbing her feet under the blanket, hoping she feels my love and hears the words I'm not saying out loud because my mom is wailing and throwing herself around to make sure we all know her grief means more than any of ours.

A chill wraps around me, and I look to see if someone opened the window. My grandmother's bed is against the wall with no room for anyone to stand on that side, but I sense at least two are there— her sister, June, who died twenty years ago, and her big brother, Bob, who I only know from photos. Somehow, I can hear them say, "We've come to get you, Martha."

The room is even colder, like someone has taken the roof off, and I swear I can see a sky full of stars above us. I know it's not real, but it's something.

The rattle of Grandmother's breath pulls me back, and every-one—aunts, uncles, cousins, my sisters, and my mom—crowd her

bedside. Silently, we watch Mad Martha—the woman who raced her way through life—cross the finish line way too fast for all of us.

My mom sobs over her mother's body, and my uncles and cousins cry in the hospital room and out in the hall. Tears stream down my cheeks, and I whisper *thank you, thank you, thank you* because whatever fear about death that forced me to memorize that prayer I used to say every night has left with my grandmother.

GAZING AT THE FULL MOON OUT THE window of the airplane, I finally let myself cry. Cleaning myself up in the bathroom, I hear a question Aaron's mom, Moira, asked me recently, "*Can* you have children?"

"*Can* I?" I had repeated her question because she's the sweetest woman in the world and would never want me to misconstrue what she was asking.

"I'm sorry if this is too personal, but you and Aaron have been married for a few years and seem happy. I hope nothing's wrong—"

"No," I interrupted her gently, "nothing is wrong. My body works." I laughed to be sure she knew her question didn't upset me.

What I didn't share with her was that my body isn't the problem. It's my brain. I had an abortion at nineteen because even though the boy was sweet and said he was ready, I wasn't. My mom got pregnant with me at nineteen, and the thought of our history repeating itself sent me straight to the clinic.

Had Moira used a different verb in her question, she might've gotten closer to my truth. *Can you have children?* is not the question to ask people who've grown up like me. *Should you have children?* is the question. A different verb gets a different answer.

Two years into my beautiful marriage with Moira's son, my answer is still no. *No, I should not have children because I'm terrified of being like my mother.*

I've looked in bookstores for the answer, and there are shelves packed with advice for parents—those who are expecting, have newborns, have children who tantrum or are gifted, have ADHD, autism, allergies, and so on. There's a book to answer every question,

except mine: *Should kids of fucked-up parents have kids of our own? And if we do, are we bound to fuck them up because we don't know how to parent?*

I even went online to "Ask Jeeves," but all that came up was dealing with dysfunctional parents or children of dysfunctional parents–not the children *of the* children of dysfunctional parents.

My grandmother's last gift was making sure I was there when she died. She wasn't religious, and only got baptized in her final days because my aunt is Catholic, but the love that showed up to help her cross over to the other side showed up for me, too. Watching the full moon from the plane, I hear that little voice—that nudge—again. "You *should* be a mom. You'll be a great one. And I'll be with you."

Thank you, Grandmother.

OUR DAUGHTER, HANNAH, IS BORN on October 27, 2001, and shares her birthday with Jim Cargill's wife, Rhonda, and the lead singer of Duran Duran, Simon Le Bon!

Mom and I hover over the baby's bassinet, smoothing the white lace, straightening the satin bow on the front, and counting her tiny fingers for the hundredth time. "She has my nose and mouth," Mom says, dotting Hannah's button nose and pink lips with her finger.

My mom arrived yesterday to be with me while I delivered Hannah. For twenty-one hours, she's been supportive, encouraging, and sober. When she looks up from Hannah and gazes at me, I smile back, ready for her to tell me how proud she is of me—finally.

"Are you ready for Hannah to like me more than she likes you? You know, the way you did with my mother?"

"What did you say?"

She brushes her finger over Hannah's cheek. "Because someday, she's gonna hate you as much as you hate me."

Wondering where the hell this came from, I see the answer on the table behind her—an open beer bottle. It's not even ten in the morning.

Mom sees me eyeing the bottle and guzzles the rest of it.

Soaked in breast milk and hormones, I'm not sure if I want to cry or puke. "I can't believe you said that."

"Yes, you can." She snickers. "I'll go pack because I know you want me to leave."

It's been a rough pregnancy, and she knows it. Between her drunk phone calls that sent me to the toilet, puking up her insults I wish I didn't still swallow, and a sinus infection that almost killed me and Hannah, her ability to be cruel still blows me away.

So does my stupidity, thinking she'll ever change.

HANNAH'S FIRST BIRTHDAY IS THE NEXT time I see my mom. Everyone sings "Happy Birthday," and I put a piece of blue-frosted birthday cake on Hannah's high chair tray. She touches it with her pointer finger, not sure what it is.

Mom pushes me out of the way and digs her hand into the cake, breaking it up into smaller pieces. She puts a tiny piece into Hannah's mouth. "Here you go, baby, let Grandmother help you. Your mama gave you too big a piece, didn't she?"

As Hannah smears blue frosting across her face and giggles from her first sugar buzz, I want to slam my mom in the face with the rest of the cake for all the triggers she just pulled—calling herself "Grandmother," making a dig about me being a shitty parent, and ripping through Hannah's cake the way she tore through mine looking for the keys on my sixteenth birthday.

Thinking about my birthday in Austin reminds me of the day Mom opened the corral gates to set Chester and Mama "free," but they didn't leave because they didn't know how.

I've stood at those same open gates a dozen times but never left her because, like the ponies, I didn't know how—and until Hannah—I didn't know I could.

CHAPTER 35

Two Memorials

My bags are packed for San Francisco when my first dad, Jim Cargill, calls.

"Hey, Dad. I was gonna call you. I'll be there around lunchtime tomorrow, okay?"

"Yeah, sounds good," he says in his usual low, slow drawl. "We're all gonna go out for a nice dinner, and try not to worry too much about this whole thing."

"Okay." Because he's a man of few words who doesn't love talking on the phone, I'm confused why he called. "Dad? You nervous?"

"Well, that's the thing. I wanted you to know the doctor said the cancer is aggressive but so is the surgery, and I might not survive it."

I start crying, wishing I wasn't because he's been so strong for all of us.

"It's okay, kid. I'm sorry I had to tell you, but I thought you should know." He pauses. "I also wanted to get some things cleared up between us, just in case. You have time to talk?"

His question makes me laugh, interrupting my tears. "Of course, I have time to talk to you, Dad."

He clears his throat. "I wanted you to know I stayed with your mom as long as I did because of you. We hadn't been in love for a long time, and she wasn't coming home much. It was usually just the two of us on the bus at night." He sighs. "And sorry for all the liver

244

you had to eat. I know you hated it, but we were pretty poor, and it was full of vitamins. I always made sure you had ketchup, though."

We both laugh. "*Ewww*, I hated liver! Remember when I spit it out on my plate?"

"I think you threw up." He chuckles. "Now, I know you only have a few good memories of your mom, and I've never wanted to take those away from you, but I feel like you should know the truth about some other things, too."

I sit up on the couch. "Truth about what?"

"Well, your mom didn't bake your birthday cakes. I did."

"The pink elephant with rainbow sprinkles? That was you?"

"Yep."

"No wonder my birthday cakes looked weird when we moved to Tahoe."

"Guess it's good she tried." He chuckles. "I was also the one who taught you how to read."

"You did?"

"Every night, we sat at the table with your *Dick and Jane* books because I wanted you to be able to read before kindergarten."

"But I remember her reading with me?"

"Well, she probably sat with you a couple times."

"Maybe after I learned how?"

"Probably so, because you were smart and learned those books fast."

MY DAD SURVIVES THE SURGERY THAT removes the cancer from his kidney but not the stroke that follows. His memorial is on my thirty-third birthday, August 31, 2004.

Grieving him is the most violence I've ever committed in my life: I smash planters in the front yard, break glasses and plates, and scream at the night sky—begging the stars to explain why such a good man had to die, while Frankie gets to live.

It's been two years since Hannah's first birthday, and the last time I saw or spoke to Frankie—which is what I call her now. I

found out she stole the inheritance my grandmother left me when my aunt sent me the cashed check with my signature on the back in my mom's handwriting—that I know well because I forged her name on all my school paperwork. The check didn't seem like enough to file a police report, but the amount was ironic because it was exactly what we needed for the down payment on our house. Aaron's parents ended up giving it to us, which Frankie resented.

In my mind, she might as well be dead, so I decide to bury her—alive.

Wrapping my arms around the toilet, I purge our life together—the mother she was, the mother she wasn't, the mother I tried to turn her into, and the mother I have to let go.

For good.

CHAPTER 36

(Un)Forgiven

I'm thirty-four with the innards of a senior citizen: My dentist tells me she's never seen someone my age with such advanced periodontal disease; the second time my gastroenterologist scrapes scar tissue out of my esophagus so thick I can barely swallow food, he warns that my body won't handle a third; my gynecologist suggests a hysterectomy to remove tangerine-size cysts crowding my uterus; and then my gallbladder fails.

The acupuncturist I see about healing my gallbladder asks about my other illnesses. "Is there a chance you're holding on to any anger? Maybe trauma in your past you haven't let go of?"

"Probably."

THE ACUPUNCTURIST'S ADVICE TO HEAL MY gallbladder works, so I follow his advice about forgiveness, too—which he believes will heal the trauma stored in my guts. Watching *Oprah* as I do every day after school, I think she must've planned this week for me because all the episodes are about forgiveness.

"Thank you *for* giving me the experience," Oprah says to her audience who are as rapt as I am to hear the magic forgiveness formula she's come up with.

"Thank you?" I say to the TV, grateful Oprah can't hear me because I'd never be rude to her. As I'm trying to wrap my head

around thanking Frankie for being—quite possibly—the world's worst mother, Oprah continues.

She explains it might be difficult for some people to accept her idea, but she believes we are who we are because of the experiences we've gone through—even the shitty ones.

I love Oprah, but I'm not thanking Frankie for anything.

Oprah then has on the tender-hearted, soft-spoken spiritual teacher Eckhart Tolle. He suggests, "We can learn from those who we need to forgive."

"Yes!" I shout at the TV again. "I can learn—to say *fuck off, forever!*"

Another guest, Iyanla Vanzant—the badass guide to all things self-love—gets closer to something I can actually use. "You have permission to be pissed at those who've hurt you."

Great, because I'm *smash-my-car-in-Frankie's-face* pissed. "Is that too much, Ms. Vanzant?" I ask the television.

Not finding the answer on *Oprah*, I end up on the couch of a frizzy-haired therapist who hands me a foam bat. "Hit the chair as hard as you want. Let all your anger out."

Poor woman thinks I'm a normal case and knows nothing about me almost whacking Danny with a bat, or how terrified I am of unleashing the violence my body has locked up then thrown away the key. I set down the bat and hand her the check I've already written because I knew this wouldn't work. "Thank you. It's not you. It's me."

Rereading a couple of books by the psychic-mediums John Edward and Sylvia Browne that I read after my grandmother died—and then kept talking to me—I find a few passages about forgiveness. Both Edward and Browne suggest forgiving people in this lifetime or running the risk of living with those same souls in your next lifetime, too.

Oh, hell no *am I doing another lifetime with Frankie!*

SIPPING MY WINE AND SOAKING IN MY nightly bubble bath, I hear my grandmother's voice. *"Let me show you a movie."*

I close my eyes and see a film strip, like the ones in round cannisters that they used to show us in elementary school. Faded, scratched, and weathered photos flip silently in front of me.

The film strip stops on a photo I've seen before. Frankie is five or six, wearing a lacy white dress and standing next to her sister and their cousin. Frankie's blonde pigtails are as cheerful as her smile, which makes me wonder what that little girl wants to be when she grows up? I get a little sad because I know whatever it was didn't come true.

The film flickers and jumps to Frankie and her sister, cheering at my grandmother's stock car race. The two of them share the weight of their mom's trophy as they hold it up in the air, proud to be Mad Martha's daughters. My heart aches seeing the love Frankie has for her mom that's going to change so much it will be unrecognizable to both of them.

The next photo is Frankie on her grandparents' homestead in Kenai, Alaska. She's not yet a teenager, and I know this is when my grandmother left her and her sister and went to Juneau to start her career. Even though they'll move to Juneau in a couple years, they'll always know their mom could leave them. Maybe that's how Frankie learned she could leave me, too.

The film skips a year or two ahead, and Frankie is pointing to four guys with brown bobbed hair on the television. Her mouth is wide open, like she's screaming. She fell in love with The Beatles at the same age I fell in love with Duran Duran.

Her senior picture is next, and she's bobbed her blonde hair like The Beatles. She's wearing a cheerleading uniform and might've just performed the cheer she'll teach me in twenty years. Her smile is bubbly and energetic and makes me wonder if we would've been friends had we been in school together. She's only a couple of years away from going to dental school in Seattle where she'll meet my *real* dad.

The film flips to a white apartment building on Queen Anne Hill in Seattle. Frankie is standing in the window, looking down at my dad walking across the street. She once told me that she saw his ass before she saw his face, then ran downstairs to meet him. I didn't see Aaron's face before asking him to dance, either.

The film flips to Frankie, pregnant and alone on the grass in front of the white building.

The movie reel sticks here.

She doesn't want to be pregnant because my dad is already a drug addict. Abortion is still illegal for another year, so she can't make the choice I did. She's nineteen and trapped. She'll leave dental assisting school and move back to Juneau to get away from my dad.

The movie fades to black. I open my eyes and realize I've been in the water so long it's gotten cold. I dry off quickly and gulp down the rest of my wine.

In my towel, I sit on the toilet and watch the flickering candlelight, crying because I feel sorry for my mom—for what I know and don't about what happened to make her hate herself enough to stay with men who beat her—and then to beat me, too.

I have to forgive her because it's the only way I can heal my body and my soul. I'm not telling her, though, because this isn't about her. It's about me letting her go and releasing us both. Maybe some night as she's drifting off to sleep, she'll feel my release—or maybe she'll be too drunk and sleep right through it.

HANNAH IS FIVE WHEN I TAKE HER to Juneau for my uncle Killian's wedding. Although I beg Killian to keep Danny away when I hear that he's part of the wedding, it doesn't work. Danny comes up and stands at the edge of my table. Honey takes Hannah away immediately.

"Go away, Dan," Auntie Lynne warns. "You promised you wouldn't do this."

"This is between me and Bridey, Lynne," he says.

My heart is pounding, but I'm more excited than scared because he isn't the burly biker he used to be. He's pickled and weathered, with a face sagging as much as his gut.

"Hey cunt, you gonna talk to me?" Danny asks.

I take a deep breath and stand up. Because he's left me no room, I have to slide up his body until we're nose to nose—our nostrils flaring and eyes glaring, like two fighters facing off before a bout. "What do you want, Dan?"

"I want you to fuck off, *Birrrd.*" He exhales Budweiser, breathing me back to being fifteen in a house with no neighbors, no phone, and no rescue.

I inhale, letting my breath bring me back to here and now—facing one of my monsters. "Walk away, Dan."

"I know you wanna make a scene like your mom would—show everybody you're just like her."

I look into his stoned, red eyes. "I've fantasized about how you're going to die a thousand times. You're old and broken and alone. And here are you are. I dreamed this death for you, Dan. You're welcome."

"Stupid bitch."

"You didn't win." I smile. "And you didn't break me. Look at me, Dan." I wave my hands down my dress. "I'm amazing, and you're dying."

"You're fuckin' nuthin.'"

I turn to my aunt. "Let's go. This is over."

She stands up. "Dan, I'm so disappointed in you. We thought you changed. I will never speak to you again at church or anywhere else. Shame on you for doing this."

"Fuck off, Lynne."

I don't worry about forgiving Danny because I don't care enough about him. My aunt tells me Al is in prison for rape. I let myself off the hook for forgiving that monster, too.

Healed.

CHAPTER 37

The Ellen DeGeneres Show

September 22, 2015

"Please be sure not to touch Ellen when she's next to you." The usher is polite but not kidding as he points to our seats in the front row where Ellen always dances at the beginning of her show.

"OMG! Can you believe this?" I squeal, flapping the VIP lanyard around my neck.

Shannon squeezes my hand. "It's happening! You're finally meeting Duran Duran!"

"It's crazy! I'm trying not to cry because I can't meet Simon with mascara running down my face!"

We giggle like excited middle schoolers and dance in our seats as the show starts.

NINE YEARS EARLIER, I'D SEEN *My Date with Drew*, a documentary about an adorable twentysomething named Brian Herzlinger who has thirty days to get a date with his childhood crush, Drew Barrymore.

My high school students who watch the film love that Brian doesn't give up—even when he could and probably should. "Ms.

Heidel, you have to do that with Duran Duran!" they insist because—like every student I've ever taught—they know how much the band means to me.

Inspired by Brian and a quote from Drew Barrymore that he sees at the exact moment when he's thinking about giving up—"If you don't take risks, you'll have a wasted soul"—I start a Facebook group called "Get Bridey to Meet Duran Duran!" and add everyone I know to it.

Over the next several years, the group name changes, as I use every trait of manifestation to close the gap between me and the band: "Get Duran Duran to Reno," then "Get Bridey to *Ellen* to Meet Duran Duran!" By the time the group includes the band's upcoming appearance on *Ellen*, it's ten years and sixteen hundred people later. Dozens of friends and former students tell me they've written to Ellen with all the reasons why Ms. Heidel should meet Duran Duran.

"What's this about the *Ellen* show? I can probably help!" is the message from my beautiful—and well-connected—friend, Heather Auble (not the same Heather I grew up with).

Heather gets me two VIP passes for the September 22 taping airing on September 23 with Duran Duran as the musical guest. There are no promises I'll meet the band, but—fingers and toes crossed—I might.

Paula Peterson, the same sweet PTA mom who Frankie freaked out on in my classroom, is now a reporter and writes an article about my journey to meet the band on her news site, *South Tahoe Now*. The local TV station also interviews me. It feels like the whole city of South Lake Tahoe will be watching to see if I meet Duran Duran on *Ellen*.

THE SHOW BEGINS AND ELLEN—who's half my size—dances in front of me. I *don't* touch her.

She chats with several guests, and Shannon and I are exhausted from all the standing, clapping, and screaming the audience is required to do. I whisper, "They're on next!"

Ellen breaks for the last commercial before Duran Duran performs, and crew members begin jockeying cameras into position—all pointed at me. My heart is racing because those cameras must mean the show wants a good shot when Simon and I meet. My sweaty palms slip off my handrest. "Oh, my god! This is it!" I shake Shannon's thigh.

Ellen holds up Duran Duran's new album, *Paper Gods*, and the opening notes of "Pressure Off!" begin. The audience stands and claps while the cameras seem to zoom in on my seat. I look up the staircase, expecting a face full of Simon Le Bon, but it's the singer and actor Janelle Monáe, who is featured on the song with him. The cameras are for her.

Simon is dancing down the steps on the other side of the audience. He sings his way down my row, until he is only six people away from me. For a moment, I imagine scooting past the six and grabbing Simon, but it would most likely get me kicked out and ruin my big moment—the one that's going to happen at the end of the song when Ellen calls me to the stage.

"I'd like to thank Duran Duran, Janelle Monáe, and all my guests for being here today!" Ellen says when the song ends.

The audience claps, the band walks backstage with Ellen, and the crew starts moving the cameras. The show is over. Frantic because it can't be, I look around for anyone who might be walking toward me to usher me backstage.

SHANNON AND I DON'T SPEAK UNTIL we're in the car. I burst out into tears. She says sweetly, "Something must've happened. I'm so sorry. Are you okay?"

I sniffle and nod yes, feeling embarrassed for crying about all this but also bummed because I know my students are going to be devastated.

The next day, my classes console me, and I console them. "I got to dance with Ellen, which *is* the dream for some people!" I say. "And I'm an optimist, you guys. If my life has taught me anything,

it's to have hope and be grateful for everything that comes. And John Taylor, who plays bass in the band, always says to 'trust the process.'"

A girl asks, "Ms. Heidel, what's the next step?"

"Well." I grin. "I'm seeing Duran Duran in a couple days, so wish me luck!"

Another kid cheers, "It's not over yet!"

My friend Nikki and I carry signs we made like the old-school '80s concert posters into the venue. We made sure the letters are big enough for Simon to read from the stage.

Poster #1: *I WAS JUST ON ELLEN WITH YOU!*

Poster #2: *YES* (the answer to Simon's question—Is anybody *hungraaaayyy?*—that he's been asking lately before singing "Hungry Like the Wolf")

"Oh, my god! He wants the sign!" I scream when Simon spots the *YES* sign from the stage and waves for Nikki to pass it to him. A few rows of Duranies pass it to the stage. Simon holds it up and says, in his adorable British accent, "I just love the word *yes*, don't you?" He winks at us and sends the sign back.

Nikki and I jump around, screaming and waving the flimsy piece of paper that is now priceless because Simon touched it!

That same *YES* sign goes with me to several more concerts over the next few years—each time getting noticed by Simon. In San Francisco, he sees it and points to me. "There's my *YES* girl!"

Then . . . 1,436 days after *The Ellen DeGeneres Show* . . .

CHAPTER 38

Simon Says . . . *YES!*

*I*t's late August when I run into the editor of *South Tahoe Now*. "Hi, Paula! How are you?"

She grins. "You must be excited about your band coming! Bought your ticket, right?"

"Months ago!" I laugh. "I still can't believe they're coming to Tahoe!"

Paula gets a little twinkle in her eyes. "I'd love to do a follow-up article to the piece I wrote about you going on *Ellen*."

"Really?"

She raises her eyebrows like my question surprises her. "Yes, really. The announcement about Duran Duran coming to Tahoe has been the most shared story this year—and everyone shared it with *you*! People are going to love reading that you haven't given up!"

"Well, you've been so sweet about all this. I can't thank you enough for everything." I hug her, then roll my eyes. "I'm sure the whole town is ready for this to finally be over!"

Paula smiles. "You've taught all our kids, and they love you. People are excited to help because of everything you've given to all of us. I'll write it and let you know when it's ready."

September 2, 2019

SOUTH TAHOE NOW POSTS A VERY thoughtful piece about my journey to meet Duran Duran—mentioning how their music helped me through my rough childhood, and how the community has supported my dream to meet the band for almost fifteen years. At the bottom of the article is a photo of me and my Duranie bestie, Andy, holding the *YES* sign at a Duran Duran concert.

I immediately share the article on Twitter and ask friends and Duranies to retweet it.

The next day, my students and I chat about the band coming, and I show them the clip of me standing a few feet from Simon Le Bon on Ellen's show. I confess, laughing, "It was rough. Basically, the whole town watched me *not* meet the band."

One of my freshmen asks, "How long have you wanted to meet them?"

"Thirty-five years!"

Their eyes roll back in their heads as they calculate the math. "That's older than my mom!" a kid shouts.

I chuckle. "Yep, I know. I guess the lesson is to never give up, right?"

The class makes their own *YES* signs to film a TikTok video they post to the band.

September 3, 2019

LESS THAN TWENTY-FOUR HOURS AFTER sharing the *South Tahoe Now* article on Twitter, I'm tagged in a "tweet"—

Duran Duran ✔
Replying to @brideyHeidel @Simon JCLeBON and @CleverKaty
So . . . we're waiting for you to email Katy, she has something to tell you . . .
^DDHQ

My hands shake as I read the tweet again. *Ohmygod, ohmygod! IdiditIdidit!*

I yell to my husband who's in the living room. "Aaron! I think I did it! I think I fucking did it!"

He comes to our room and reads the tweet, hugging me. "That's amazing! I'm so happy for you!"

We dance and raise the roof, chanting, "Duran Duran! Duran Duran! Duran Duran!"

"Oh, my god! I have to call Andy! She's gonna lose her shit!"

"Hey, Bride! What's up? You okay?" Andy sounds surprised I'm calling so late.

"Are you sitting down?"

"Should I?"

"You're not gonna fuckin' believe this!"

"Okay, I'm sitting."

"Andy, it worked! It fucking worked! Duran Duran just sent me a tweet!"

"No, Bride! No!" she hollers. "Really? I'm so excited for you!"

"Me?" I laugh. "You mean *us*! I'm not going without you!"

"Oh, my god! Really, Bride? Are you sure? That's so rad! Thank you!"

Two hundred miles apart, Andy and I dance in our own houses but sing together—at the top of our lungs—the way we have at Duran Duran concerts over the years.

September 13, 2019

1,447 DAYS AFTER THE *The Ellen DeGeneres Show* . . .

Howie Nave, a popular radio host in Tahoe, has me on as a guest that morning and asks, "So what do you think is gonna happen when you meet them?"

I shrug my shoulders. "I honestly don't know. My only hope is to meet Simon, and beyond that, I guess we'll just show up and see!"

Howie messes with the dials in front of him, then says into the mic, "Well, I'll be at the concert along with the rest of Tahoe because everyone is gonna be there to see what happens! We're all really excited for you, Bridey!"

After *Howie's Morning Rush*, Andy and I grab breakfast. "So, really," she asks, "what do you think you're gonna do when you meet Simon?"

Another shrug. "It's crazy that after all this time, it's really gonna happen, and I keep trying to picture it in my head—what I'll say to him, and what he'll say to me—but I can't see it. It's all a black wall, like it's too much to even imagine."

"I know, Bride, but it's gonna happen." Andy smiles like she sees what I can't. "You did it. You never gave up."

I look out the window of the diner, tears welling up in my eyes as I remember the night I fell in love at first sight with Duran Duran on MTV. I wipe my eyes and whisper to that girl—who I see when she was twelve, fifteen, seventeen, and twenty-one—"You made it. It's okay now. Just breathe."

Andy squeezes my leg. "This is big, Bride. It's okay to cry."

"You know, it's weird. I've always seen myself meeting the band here in Tahoe—like seeing their picture on the marquee and everything."

"Really?"

"Yeah. Maybe that's why I didn't get too bummed after the *Ellen* thing. Somehow, I knew it wasn't supposed to happen that way."

Andy laughs. "Well, this is gonna be way better than meeting them on *Ellen*. I mean, you're in your hometown with all your friends."

WALKING INTO THE CONCERT IS SURREAL. Even though there's a sold-out crowd of seven thousand at Harvey's Outdoor Arena, it feels like Andy and I are the only ones here.

Before heading to his seat, Aaron kisses me on the cheek. "I'm so proud of you and can't wait to hear all about it! You look beautiful!"

Flashing our VIP wristbands to security, Andy and I make our way backstage. From all around us, we hear the shouts from security guards, food vendors, ticket takers, and casino employees—all former students I've taught over the past twenty years—"Congratulations, Ms. Heidel!" "So excited for you!" "You did it!"

"Here we go, Andy." I remind myself to breathe.

"It's gonna be great!" She squeezes my hand.

A young brunette with a clipboard sees us and waves. "Hi, I'm Orly. I must tell you," she says, smiling, "we've all been really excited about this! We're so happy you're here!" She hugs me.

"Thank you very much. It's a dream come true, for sure."

"You can both sit there." Orly points to a green velvet couch long enough to seat ten people. "It's Elton John's couch. He left it when he performed here." She nods to a man standing close by. "He'll get you some water while I get Simon, okay?"

While I get Simon. Holy shit. Did she just say that? The whole world falls away—no couch under me, no music pulsing in the distance, no one around. My eyes lock on the corner of the building where Orly just disappeared because Simon-*fucking*-Le Bon is about to come around that same corner any second.

Andy's voice brings me back to the couch. "You really can't see what's gonna happen? You always have such a clear sense of shit like this." I look at her squinting at me, like she's trying to solve an equation in her head.

"I know. Weird." Nervous, I fix the French tuck of my Duran Duran shirt the way *Queer Eye* taught me and—for luck—click the heels of my red "Reflex" boots that I nicknamed because they reminded me of the music video when my mother-in-law bought them for me.

Orly comes around the corner, pointing behind her and mouthing, "*He's here!*"

And, just like that, Simon Le Bon is walking toward me and smiling with his arms open. "Oh, hello!" he says—in a voice I've heard since I was twelve. His hug is sincere and unrushed, like he

knows how long I've waited for this. "Oh, that's a nice cuddle, isn't it?" he says, and I melt.

He hugs Andy, and they both make the same squishy face that she does when she's nervous.

Simon picks up the *YES* sign. "This is it? This is *the YES* sign?"

"Yep!" I nod. "It's the one you held up in Reno. Then you called me your '*YES Girl*' in San Francisco. Do you remember?" I ask.

Simon takes my hand and smiles. "Of course, I do." He turns to the photographer and says, "It's a rather cheeky thing being a 'YES' person, isn't it?" and hugs me again.

Simon signs my *Seven and the Ragged Tiger* album cover and says to me, "You can't believe how many people sent me your story." He gives me a sweetly suspicious look. "Quite honestly, I felt a bit maneuvered."

Although I can't believe *I* maneuvered Simon Le Bon in any way, I laugh and apologize. "I'm sorry. I guess a lot of people wanted this to happen."

As if he knows his comment made me nervous, he takes my hand. "You've got a lot of people fighting in your corner, don't you?"

"Yeah," I chuckle, "like the whole town. They've been waiting a long time for this."

Simon signs the album cover Andy brought for her girlfriend and tells her how proud he is that she's living her truth. It's a sweet moment I know she'll never forget it.

"You know we were on *Ellen* together!" I laugh. "You were only six people away from me. I almost reached for you, but they told me not to touch Ellen, so I figured I better not!"

Simon winks. "Oh, you should've grabbed me!"

As we chat, he tells me the concert is sold out, and the band thinks I had something to do with it. "There are a lot of people out there that want to see you on stage with me."

"On stage?" I repeat to be sure I heard him right.

"Yes."

"But you don't do that."

"We are tonight." He smiles and hugs me. "I've gotta go have a chat with the others to see when we'll bring you out, so I'll see you soon!" With that, Simon Le Bon disappears around the corner.

Drunk in disbelief, I turn to Andy. "Did that really just happen?"

She shakes her head. "We just met Simon. He loves us, Bride. Like really." We fall back on Elton John's green velvet couch—giddy girls who can't believe their dream came true.

"Oh, my god! Where's my phone? I have to tell Aaron!" My fingers fumble, trying to text him:

I'M GOING ON STAGE WITH SIMON!

OH MY GOD! WHEN?

I DON'T KNOW BUT SOON!

YEAH! I'M SO HAPPY FOR YOU!

When Simon returns—with his hand in the pocket of his white jeans—he's clearly more relaxed than me or Andy. "Okay, here's the deal," he says to me. "You're going to be down in front, and when we play 'Come Undone,' security will bring you backstage. Alright?"

I nod that I understand, careful not to say anything to jinx this moment.

We follow Simon and security toward the stage, passing Nick Rhodes, the platinum-blond keyboardist who looks like he's planning something in a binder. He sees us and smiles. At a table behind him, John Taylor—the bass player with the bleached bangs I've copied since I saw them on "The Reflex" video—waves at us. There's no time to do anything but wave back, but Andy and I both know we'll lose our shit as soon as we can.

Security motions us through a curtain, and Simon waves goodbye. Standing against the stage, the guard tells me he'll signal when it's time to go. I'm suddenly grateful I didn't eat much because I'd hate to barf all over the very large, very nice man.

Excited Duranies who have zero idea who we've just met or what is about to happen dance to the venue music while we all wait for the concert to start. Looking behind me at the audience, I search for my husband and my friend Liz, who he's sitting with.

The concert begins, and the crowd sings every word as Simon gyrates his hips, Nick nods cooly, Roger flips his drumsticks, and John plays to the screaming fans on his side of the stage.

"Come Undone" begins, and the security guard waves for us to follow him.

The stage manager leans in to be sure I hear him over the music. "How are you doing?"

Yelling louder than I need to, I answer, "Um, I'm not sure! So, what do I do?"

He shakes his head. "I don't actually know! We've really never done this before!"

Andy nudges my side and points at the stage. "Look, Bride! They're all right there! You're about to be on stage with Duran Duran!"

Suddenly, I wish I had a chair because my knees feel like they're gonna lock or give out. Not only is the band right here in front of me but so are seven thousand screaming and singing people. *Hold on*, I tell myself. *Here we go.*

A minute later, the band finishes "Come Undone," and the manager gives me the sign that I'm about to move—although when or where exactly, neither of us is sure.

The crowd quiets as Simon asks, "Has anyone here been taught English by Bridey Heidel?"

Hearing Simon Le Bon say *my name* in his British accent—and pronounce it correctly—I squeeze Andy's arm.

The stage manager and Andy decide that was my cue and shout together, "GO! GO! GO!"

YES sign in hand, I step carefully over a maze of taped-down extension cords because I'd die if I tripped right now. As I walk to Simon, he asks the crowd, "Do you know this story?"

There's some clapping and cheering, probably people who know me.

He shouts, "Do you *want* to know this story?"

The place erupts—shaking the stage under my red boots—as their collective voices answer, "YES!"

Simon sees me and looks surprised—I obviously missed whatever cue he meant to give. "Oh, there you are." He takes my hand while he finishes telling the audience about seeing the *YES* sign over the past few years. "The sign now says *Simon loves Bridey.*" He kisses my cheek.

The audience replies with a sweet and collective "*Awww.*"

My eyes dart across the front rows, and I see a few Duranies I know from Facebook groups. I smile and point to them, hoping they know this moment is for all of us. When Simon lets go of my hand, I assume it's my cue to leave and literally run off stage—until his voice stops me. "Hey, wait! Come back here!"

Andy yells, "Go back! He wants you to come back!"

I spin on my red heels and turn to run back but am stopped again—only this time by a voice in my head. *Look up! Take it all in! YOU'RE ON STAGE WITH DURAN DURAN!*

Slowing my stride, I look around the stage. Nick smiles from his keyboards, Roger pops up from behind his drum set and waves with his drumsticks, and across the stage, John gives me a Billy Idol–curled lip and mouths, "*YEAH!*"

Simon takes my hand and tells the audience, "We're going to sing a little song called 'Da Reflex'!"

Again, the time-warp trick pulls me back to that Friday night in the spring of 1984 when Missy and I heard the opening notes to "The Reflex" for the first time—"*Na na na na . . . Na na na na . . . Na na na na . .*"

A few *YES* signs wave in the audience. One of them is my friend Emma, and the others are people in this amazing community who have rallied behind my dream for years. I'm hoping they feel my gratitude because they brought me from a pink house, a silver

school bus, motel rooms, and homes with monsters to this stage with Duran Duran.

As everyone sings with us—echoing their collective love and energy onto the stage—it feels like they're saying thank you to the band for the songs that also found them in their own dark places and dark spaces.

Walking off stage, my knees buckle, and I collapse—sobbing at the enormity of what just happened. Andy lifts me to sitting, and I see Nick's girlfriend in a chair next to me. I wipe my snot and smile. "Sorry. I've just been waiting my whole life for this."

She nods sweetly and waves her hand to let me know it's okay.

AFTER THE CONCERT, AARON AND I sit in our car—too stunned to drive. I call Hannah, who's going to college in San Francisco, and tell her everything.

"Oh, Mom! I'm so happy for you!" she cries. "You did it! I wish I was there!"

"Oh, believe me, you're here."

At home, Aaron and I are still dazed and confused. "Did it really happen?" I ask.

He nuzzles my cheek and sniffles some tears. "I can't believe it, but I'm glad I was there. I'm proud of you for making your dream come true."

A shower and a large glass of chardonnay later, I replay the night—over and over—wondering how I'll ever be able to fall asleep. Then I see my friend Krista—the girl who visited me in Long Beach. It's only been a couple of months since she lost her battle with a brain tumor, and the heartbreak is fresh. Tears slip down my cheeks, until I remember how pissed she was when I didn't get to meet Simon on *Ellen* and laugh because I can hear her yelling and see her pointing at Ellen on the TV. "*I'm never watching her show again! You will meet Simon Le Bon! We're making that happen!*"

When Krista died on a sunny July afternoon, I wasn't with her, but she was with me. That same night, drifting off to sleep and

telling her how much I loved her, I heard her contagious, full-body, teeth-baring laugh. I asked her, *What's so funny?*

You just wait! You're not gonna believe what I can do from here! You're too much! I love you and already miss you.

TWO MONTHS LATER, ANDY will ask me what I think is going to happen when I meet Simon Le Bon, and I'll tell her I can't see anything.

But Krista can.

I still hear her laughing.

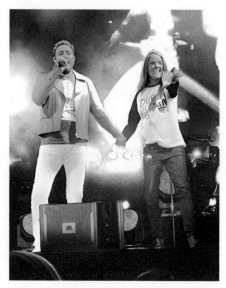

On stage with Duran Duran September 13, 2019, Lake Tahoe.
Photo by Stephanie Warren

Epilogue

I've read my share of abusive-alcoholic-mother-codependent-daughter memoirs and always find myself wondering, *WTF is she doing, and why hasn't she left?*

Writing down my own story and reading the chapters over and over, I kept thinking the same thing about myself.

I'm sure experts have a million reasons why we stay in abusive relationships with family, but I think it's the myth of family that keeps many of us stuck. We've romanticized loyalty—the blood is thicker than water bullshit—then painted it on wooden signs they sell everywhere, reinforcing the message that family sticks together—no matter what:

Family—We may not have it together, but together we have it all.

Family—Where life begins and love never ends.

Being a family means you will love and be loved for the rest of your life—no matter what.

Some call it chaos, we call it family.
—You get the point.

I'll admit the signs are adorable, and I know families for whom these signs are true. They are lovely people who have annual traditions, photo albums full of happy memories, and adorable Instagrams. But my years of teaching, and my own childhood, have taught me to be wary of these slogans that perpetuate the idea of family before self.

Of course, in my case, I would replace the word *family* with *Mom*, and that would get me closer to the reason I stayed for too long—closer to why I didn't tell anyone what was really going on, didn't ask teachers (any of the dozens I had) for help, didn't tell neighbors or police, and didn't even confide in the friends and family I loved and trusted—and who might've suspected what was going on but could've never imagined the truth.

Like the smart, resilient, and brave women memoir writers who stayed with their families way, *way* too long (yes, Tara Westover, I screamed, *Why hasn't she left?* twenty chapters before you finally did), I didn't leave when I could have or should have.

Because leaving is hard.

Staying is hard.

Not knowing what to do is hard.

When I finally chose my hard, it was the least popular decision I've ever made—and I am someone who likes making popular decisions. I got called selfish, inconsiderate, ungrateful, a pain in the ass, rude, high and mighty, dramatic, someone who thinks her shit don't stink, and—of course—a bitch.

But what I didn't get called was *back*.

No one asked me to come home. No one called to apologize. No one admitted there might be a reason I left. No one wondered what I was thinking—because they all knew.

I stayed too long because I was terrified that the world I'd been holding together—like one of those monkeys that carries a dozen instruments and plays them all—would stop or fall apart when I left.

And it kind of did.

IF YOU'RE GOING TO LEAVE, YOU'RE going to lose something—maybe a lot of somethings—but you're also going to find the most important something of all.

You.

And once you find you—the real you that isn't stressed, sad, depressed, anxious, barfing, bleeding internally, or jacked-up on adrenaline because you're on call to save everyone—then you get to live happily ever after.

What if this book is your nudge from the universe?

Gratitude

*B*rooke Warner, Addison Gallegos, and my bold and beautiful sisterhood at She Writes Press are the smartest, most encouraging, and kick-ass community of women to publish with. Marissa DeCuir (a Duranie!), Layne Mandros, and the publicity team at Books Forward have been fabulous cheerleaders.

Duran Duran's music gave me a soft place to land when life was hard. The band and their management, including Katy Krassner, have been generous with their support and allowing me to use "The Reflex" gave this story its fairy-tale ending. Simon Le Bon's kindness and sincerity when we met meant the world, and I hope he understands why now. Garry Lee and Showdown's version of "The Rodeo Song" gave me their words when I was speechless, and Tom Lavin believed in my story enough to let me use the song.

Mary Palin and Kathi Jensen, my DSky tribe, there wouldn't be a *Bright Eyes* without your friendship and willingness to read every draft a dozen times! Bruce Rettig and Tahoe Writers Works told me my writing "isn't shit" (Randy Mundt) and my story was worth telling; Lisa Michelle's "Holy shit!" and Tim Hauserman's "Can't wait for you to sign my copy," convinced me someone might actually read this book. Suzanne Roberts taught me how to dive deep enough to recover what I'd buried at the bottom; Alice Anderson's developmental edit rocked my world in all the best ways;

Mike Filce showed up everywhere, every time (and even bought a new TV); and Janna Gard, who taught me how to use my red pen, held my hand across the finish line.

The Heidels have supported every step I've ever taken and are the loving family I dreamed of having as a little girl. My sweet dad reminded me not to "sugarcoat shit," and my Thelen-McClellan-Rangel family (who share my ridiculous optimism) are the raddest humans and most amazing kind of crazy. Rhonda (Wonder Woman) and the Cargill kids let me call him "Dad" and called me "sister." My Juneau family is my North Star and my first love.

My incredible friends read early (terrible) drafts and helped with adventures surrounding this book. Thank you, Heather Simmons-Almy, Ilka Bailey, Beth Kluender, Ingrid Eberly, Gillian Polk, Liz Wallace, Christi Butler-Fee, Nikki Moultrie, Sebastiani Romagnolo, Becca Kushner, and Ethan Niven.

To my wildflower sisters and chosen family—Cynthia, Nikki, Stephanie, Aimee, Casie, Becca, Coral, Bailey, and Emma—thank you for a lifetime of dancing, laughing, and picking me up when I trip.

Paula Peterson and the nurturing communities of Austin, Juneau, and South Lake Tahoe made my dreams come true. The thousands of students I've taught are the funniest, most challenging, and totally wonderful group of humans. *Love makes you.*

To everyone mentioned in *Bright Eyes* by name or likeness, I appreciate you allowing me to tell your story as it came into mine and can't thank you enough for being in my life.

To my little sisters who were too young to understand, maybe you'll read this and see how hard I tried to stay. I love you. Hannah and Aaron, you listened, edited, cried, and did "the happy dance" with me as I brought the chapters of my past into our present. Even though the life on these pages was hard to write, and even harder to share, it led me to both of you.

And they lived happily ever after.

About the Author

*B*ridey Thelen-Heidel's chaotic upbringing meant changing schools between Alaska and California more than twenty times. A Lewis and Clark College graduate, she lives in South Lake Tahoe with her husband and daughter and teaches high school English at her alma mater. A TEDx speaker and frequent podcast guest, Bridey performed in *Listen to Your Mother NYC* and has published in *MUTHA Magazine*. A fierce youth advocate who's been voted Best of Tahoe Teacher several times by her community, Bridey's work with LGBT+ students has been celebrated in *Read This, Save Lives* by Sameer Jha and the California Teachers Association's magazine, *California Educator*.

Author photo © Hannah Heidel

Looking for your next great read?

We can help!

Visit www.shewritespress.com/next-read
or scan the QR code below for a list
of our recommended titles.

She Writes Press is an award-winning
independent publishing company founded to
serve women writers everywhere.